9 8 1 4 3 5 C

POSTMINIMALISM

ROBERT PINCUS-WITTEN

OUT OF LONDON PRESS

POSTMINIMALISM

Published by Out of London Press, Inc., New York - Norristown - Milano
First printing, December 1977.
International Standard Book Number: 0-915570-07-6
Library of Congress Catalog Card Number: 77-77010
Printed in Italy - S.G.S. Torino

To LEON HECHT

For whom a decade of ideas
is insufficient tribute

CONTENTS

ILLUSTRATIONS

21. Bruce Nauman, My Last Name Exaggerated Fourteen Times Vertically, 1967. *Neon tubing, 63" × 33".*
22. Bruce Nauman, Hologram, 1969. *Image on glass, 8" × 10".*
23. Lucas Samaras, Untitled (Face Box) [Self Portrait], 1963. *Wood, pins, yarn, 10½" × 15" × 8½".*
24. Mel Bochner, Three Ideas & Seven Procedures [3 Ideas + 7 Procedures], 1971. *Felt pen on 1" masking tape on wall.*
25. Mel Bochner, Room Series: Eyelevel Crossection, 1967-71. *Blue and brown pencil on wall around room.*
26. Sol LeWitt, 47 Three-Part Variations on 3 Different Kinds of Cubes, 1968. *Ink Drawing, 24" × 18".*
27. Sol LeWitt, 46 Three-Part Variations on 3 Different Kinds of Cubes, 1968. *Flat white baked enamel aluminum, 45" × 15" × 15" (each unit).*
28. Mel Bochner, Measurement Series: Group « B » (1967). *Installation, 1969.*
29. Mel Bochner, Seven Properties of Between (1971). *Installation, 1972.*
30. Barry Le Va, #10, April 1967. *Felt, wood, ball bearings, 20' × 25' area.*
31. Barry Le Va, Untitled (Layered Pattern Acts), detail, 1968-72. *Glass, 25'×85'.*
32. Jackie Ferrara, Untitled, 1970. *Cotton batting, rope, cord, 78" × 40" × 22", work destroyed.*
33. Jackie Ferrara, A, ¼A, A5, C, 1976. *Birch Plywood, 15" × 68 5/8" × 34 7/8"*
34. Vito Acconci, Seedbed, 1971.
35. Marcel Duchamp, Wedge of Chastity, 1951. *Original plaster from which metal and dental wax work was fashioned, 2 3/4" × 3 7/8" × 2½". The 1954 date on work refers to the moment when Duchamp gave the model to the dentist who fabricated the piece*
36. Bruce Nauman, Wedge Piece, 1968. *Painted steel.*
37. Robert Morris, Untitled sculpture, 1966. *Fiberglass, 2' × 1' × 16'.*
38. Lynda Benglis, For Darkness: Situation and Circumstance, 1971. *Phosphorescent pigmented foam, ca. 35' × 50' × 15½'.*
39. Lynda Benglis, Exhibition Announcement, 1974.
40. Lynda Benglis, Now, 1972. *Color Video.*
41. James Collins, Teaching Notes: Synectics-Line as the Articulation of Surface, 1967-69.
42. James Collins, Watching Leslie, 1975. *Color photographs each 30" × 40".*
43. Robert Morris, Exhibition Announcement, 1974, detail.
44. Scott Burton, Pair Behavior Tableaux, 1975-76. *Performance work.*
45. Scott Burton, Bronze Chair, 1975. *Bronze, 42" × 18" × 20".*

INTRODUCTION

This collection of essays postulates a history of American art of the decade between 1966 and 1976. Written as independent acts of critical advocacy entailing the intercession between critic and the private art of the studio or the public art of the gallery, they form the history of a shifting temper in the appreciation of formal values in America. At least I hope so.

The pinched scholarly mode of the earlier essays reflects the mandarin tone characteristic of critical writing in the sixties, especially at *Artforum* (where most of the earlier essays of the present volume first appeared).*

The early-to-mid-sixties was marked by a striving academically oriented critical style epitomized by the younger school of Harvard critics, notably Michael Fried. That tone — often inflated to the pompous — corresponded to a closed formalist machine of judgment from which personal reference and biography were omitted. This occurred not only because formalist critics imposed an apersonal, hermetic value system on their writing, but because the artists

* Richard Serra: Slow Information, *Artforum*, September 1969; Keith Sonnier· Materials and Pictorialism, *Artforum*, October 1969; Eva Hesse: More Light on the Transition from Post-Minimalism to the Sublime, *Eva Hesse· A Memorial Exhibition*, The Solomon R Guggenheim Museum, December 1972-February 1973 [a text by Linda Shearer, who organized the exhibition, appears in the catalogue as well]; The Art of Richard Tuttle, *Artforum*, February 1970; Bruce Nauman: Another Kind of Reasoning, *Artforum*, February 1972; Rosenquist and Samaras: The Obsessive Image and Post-Minimalism, *Artforum* September 1972; Bochner at MoMA: Three Ideas and Seven Procedures, *Artforum*, December 1971; Sol LeWitt: Word↔Object, *Artforum*, December 1973; Mel Bochner· The Constant as Variable, *Artforum*, December 1972; Barry Le Va: The Invisibility of Content, *Arts Magazine*, October 1975; Jackie Ferrara: The Feathery Elevator, *Arts Magazine* November 1976; Vito Acconci and The Conceptual Performance, *Artforum*, April 1972, Lynda Benglis: The Frozen Gesture, *Artforum*, November 1974; Benglis' Video: Medium to Media, Fine Arts Center, State University at Oneonta, January-February 1975; James Collins: The Erotic and The Didactic, *Arts Magazine*, January 1976; Scott Burton. Conceptual Perfomance as Sculpture, *Arts Magazine* September 1976; Theater of the Conceptual: Autobiography and Myth, *Artforum*, October 1973.

insisted on it as well. Formalism became, at its crudest, an elaborate Wölfflinian discussion of self-evident, wholly tangible visual priorities. Equally apparent today is the style that I characterize as Post-Minimalism, which actively rejects the high formalist cult of impersonality.

By the end of the sixties it was clear that formalist abstraction had been challenged by a new set of formal and moral values, imperatives tempered by despair over the conduct of American politics (Viet Nam, Watergate etc.), and energized by the insurgency and success of the Women's Movement. High formalist art seemed to have become the objective correlative, a fitting decor to the glass and steel-enclosed corporate complexes that profited from the war (though "seeming" and "being" are not necessarily the same).

What formalist sensibility would have considered eccentric processes, substances and colorations, were assimilated to emerging social and aesthetic imperatives. More recent artistic emphasis is almost directly opposed to the formalist values of the mid-sixties. It is revealed in those art activities stressing autobiography, the artistic persona and psyche, stripped bare is it were, layer by layer.

Despite this apparent reversal of values, an essential constancy of modern art — the uniqueness of personality — persists: no longer manifested through facture, the individuality of touch, but through an unrepentant autobiographical confession or fantasy concerning those areas of human activity in which the artists are most singularly personal—their literally private lives.

As they stood, the earlier essays were either double-bound or double-blessed (depending on one's vantage); couched in a formalist jargon, they championed an anti-formalist art. For the most part the essays dealing with the later, more conceptually-oriented aspects of Post-Minimalism reflect a shift from a jargonized and opaque writing to one more accessible to the reader; in part this resulted from the fact that opacity and jargon were no longer central critical desirables, a position concomitant with that of the artists who no longer insisted on formalist impersonality.

But to reedit the earlier essays to correspond to more immediate

inflections of speech in critical writing would falsify the historical typology of critical writing itself. Thus, this anthology reveals two histories—one that identifies major figures and shifts in artistic values; the other that duplicates in art criticism these very same shifts in artistic priorities, from an inert witholding stolidity to a more ingathering declamatory mode.

To this end, perhaps, a rough scheme of the decade will be helpful. The years 1966-70 mark a watershed in American art, ending the decade that derived its options, by and large, from a still earlier parent style, Minimalism. Minimalist forms reflected a geometric abstract style based on a "pre-executive inner necessity." What the phrase means is that the rigorous external geometry of Minimalism attempts to be congruent with the logic of the style, a logic concluded even before the paintings were begun or the sculptures made. Of course it is obvious that to think through an argument is not the same as to make an object; the actual doing of things provokes myriad formal interventions and discontinuities upon engaging concrete matter. Such encounters constantly alter and redirect the act of making: thus where painting or sculpting may lead can never be where the argument had gone. Numerous paths radiated from Minimalism's stylistic nexus: some maintained the fixed, reduced geometry innate to Minimalism; others moved off in paths seemingly at odds with the style of the matrix.

A simple comparison: between 1880 and 1900, there developed in parallel avenues (though one might think of them as osmotic laminations) the classicizing Divisionism of Seurat, the proto-Cubist spatial ambiguities of Cézanne, the Symbolism of Gauguin, and the Expressionist options of Van Gogh. These trends huddle together beneath the blanket term Post-Impressionism. The derivation of some of them from Impressionism is easily perceived; in other instances, less immediately so; yet all derive from the formal inquiries posed by Impressionism. Certain aspects of Post-Minimalism are also readily seen to derive from Minimalism's essential reductive and analytical character, others less immediately so. The term, then, is useful in a broad way—the way the term "Post-Impressionism" is useful—a term covering a multitude of

15

stylistic resolutions preceded and posited by an apparent generative style.

The first phase of Post-Minimalism is marked by an expressionist revival of painterly issues. This was occasioned by a reaction to the taciturn inexpressivity and absence of chromatic appeal typical of Minimalism. Equally striking was the application of this expressive painterliness, not only to painting itself, but to sculpture. Such manifestations then may be said to mark a revival of gestural Abstract-Expressionist attitudes after a long hiatus during the fifties and early sixties. This expressive painterliness was accompanied by a refreshed focus on personality and colorism, and on a highly eccentric dematerialized, or open form. These are features, say, of the work of Eva Hesse, Lynda Benglis or early Barry Le Va and Keith Sonnier. Often the eccentricity of the substances they used was a means whereby the artist could be identified, a "signature substance": Serra's lead, Sonnier's neon, Benglis's foam, Le Va's felt.

The new style's relationship to the women's movement cannot be overly stressed; many of its formal attitudes and properties, not to mention its exemplars, derive from methods and substances that hitherto had been sexistically tagged as female or feminine, whether or not the work had been made by women.

This early phase peaked in 1968-70 and is here referred to as "pictorial/sculptural." I noted its emphasis on the process of making, a process so emphatic as to be seen as the primary content of the work itself, hence the term "process art." When this occurred, as it did in the lead tossings of Richard Serra, or in *The Drawings That Make Themselves* by Dorothea Rockburne, to cite but two examples, the virtual content of the art became that of the spectator's intellectual re-creation of the actions used by the artist to realize the work in the first place.

The nerve center of Minimalism was its attachment to the "pre-executive," the intellectual. This rationalistic strain maintained and generated on ever more sharply honed, up-front intensification of the theoretical and analytical bases of art. In certain cases, such theories led to the production of visible or tangible forms, whose primary content maintained parity with an analytical logic, be it

16

linguistic, mathematical or philosophical. Sol LeWitt and Mel Bochner are noteworthy examples. In others, theory appeared to usurp the visual, to become, as it were, the formal embodiment itself. Here art and language grew interchangeable.

The grand intuition of this strain of Post-Minimalism was the adumbration of new methods of composition that were no longer based on the Realist's mirror of nature, or the Expressionist's empathetic distortion, or the Surrealist's gestural automatism, but rather on organizational principles derived from information-centered theories of knowledge (theories "out there" in the world), from epistemology.

Thus there emerged, around 1970, an information-oriented abstraction, one that loosely honored, say, mathematical set theory, 0 to 9 formulas, Fibonacci series, "Golden Sections" or spectrum-based color sequences with their contingent analytical systems emphasizing red-yellow-blue primaries (rather than a sensibility-based choice of color). In this, the work of Sol LeWitt, Mel Bochner and Dorothea Rockburne are exemplary—although earlier, Ellsworth Kelly and Jasper Johns formed bridges between the Abstract Expressionist generation and the Post-Minimalists. Mondrian, Malevitch and Barnett Newman were newly reassessed as models.

The epistemological trend paralleled a widespread invocation of the role of language either in terms of its own science—linguistics —or, somewhat later, as a kind of loosely applied metaphor. The stress on the role of language triggered wide reaches of the conceptual movement, a name by which the broad front of the art of the early seventies is now known. Aspects of the conceptual movement addressed art wholly as a function of linguistic systems replete with philosophical and political ramifications. This tendency has now splintered into subsequent evolutions instigated by neo-Marxist critiques of capitalist culture, or lured by extremely individualistic confrontations between word and image. (The typology most often encountered today might be described as an extended captioned photograph).

The epistemological examination of "pure knowledge" continues apace; however, work produced as a function of such closed

17

systems may be said to be, by this moment, less an urgent matter than it once was. First theory was honored; then it was honored in the breach. Honor in the breach, especially in terms of its broadfront appeal today, indicates the receding interest in a purely theoretically-based art. Then again, honor in the breach is itself a Romantic update of a theory of art—one leading to a revived interest today in sensibility.

The rejection of "epistemology" was met from the very first—from 1968 on, in terms of a revival of Dada principles first broadcast in New York City by Duchamp, Picabia and Man Ray around 1915. Paraphrasing New York Dada's ontological concerns, many aspects of Post-Minimalism emphasized temporality and a theatrical cult of manneristic personality in which the artists themselves became the malleable raw material of their art, as well as their own myths and products. A reinvigoration of temporal and theatrical issues led to the development of the conceptual theatre—Body Art and the like as seen in later Benglis, Chris Burden, Dennis Oppenheim and Vito Acconci.

Thus, an extremely spare scheme of the last decade can be read as 1) the advent of the "pictorial/sculptural" mode; 2) the emergence of an abstract, information-based epistemology; and 3) its counterpoises, body art and conceptual theatre.

I hope this brief scheme will simplify matters, providing the reader a framework within which to place the individual examples to be discussed, a generalized model to which the work of the individuals may be referred. The issues are perhaps better stated in their initial presentation, in the essays themselves; to further elaborate here skirts redundancy. By and large, the essays are reproduced as they first appeared. When small excisions occur, I do so to avoid reiteration.

New York, April 1977

PICTORIAL/SCULPTURAL

RICHARD SERRA:
SLOW INFORMATION

I

Although our social relations were almost entirely limited to chance encounters at Queens College (we were both members of the art department), I recall once meeting Richard Serra at the Guggenheim Museum at the time of the Sculpture International in 1967. I was examining the works in preparation for a review and we toured the exhibition together. The idea of Serra's which struck me most was his observation that Robert Morris' untitled floor piece [1] was an extension of a Cubistic grid idea — a notion regarding the principles of serial structure and Minimalist ontology ᕁ that is now generally accepted. At this point I still had no idea what Serra himself was up to as an artist although I was well aware of the nature of his teaching. I now regard this part of his career as an important pedagogical contribution.

Serra's teaching is neither directive nor judgmental. It deals with an elementarist analysis of the physical properties germane to any given material. It minimizes — almost to extinction — any valorized finished product, but instead stresses those issues and procedures which are central to the execution of any specific act, or set of acts, in as clear and didactic a way as possible. Since the stress is on the executive act and programmatic clarity, the resultant experiences tend to be simple, and frequently repetitive. The implication of this in terms of many of the features of Serra's own works is self-evident.

[1] The Morris piece is reproduced in exhibition catalog, *Guggenheim International Exhibition, Sculpture From 20 Nations* (New York, 1967).

ᕁ *the study of being, or the essence of things, or being, in the abstract.*

Serra's teaching, at least at first, seemed at odds with the studio methods then fostered. These methods tend to be post-Cézanne-like in character, stressing dimensional forms in locatable spaces; post-Hofmann-like, asserting the "push and pull" of color areas; and post-Albers-like, emphasizing a "less is more" color-scientism. And, of course, there is an emphasis too on a more or less direct transcription of nature. I think, in fact, that such a characterization holds true for all art schools throughout the country at the moment and it is not my intention here to disqualify such principles. I only mean to indicate that Serra's indirection and elementarism was, at the time, at odds with the highly evolved and final-object-oriented nature of prevailing teaching practice. The object orientation of such teaching implies that an evaluation of student work is both desirable and feasible because it is related to a determinable quotient, one based on previously achieved standards.

I was grateful that Serra's courses were accessible to the students, if only because they were "antidotic" to the esthetic predeterminism which, of necessity, emerges out of the evolutionary teaching method which I have so briefly characterized. I recall several chance meetings with Serra's students' work, in which basic pictorial and structural properties appeared to be the "subject" of primary importance: images of stroking, counting, forms which leaned, forms which fell, scatterings, mural scale compositions of pasted paper in which at each moment that a focal center "appeared" so was it "displaced"; student films in which moving objects were shot so that they appeared to be still while the static environments appeared to move. I cite these only as memories of things representative of the work done in Serra's classes.

A critical problem is brought into play by Serra's teaching, namely, that all such exercises tend to look equally "good" (though this is, in fact, untrue). The reason for this is, I imagine, because no *a priori* criterion is in evidence. Such exercises were "bad" or "good" or "indifferent" only within an evaluative scale predicated on the conditions of the problem it sought to solve, one which may or may not be in evidence when faced with the final thing one is regarding. In the end, too, "elementarism" can itself become an "imitable" style. Since there was no "perfect" model against

22

which the student production could be gauged, a radical aspect of Serra's teaching was that the notion of "Excellent," "Good," "Fair," or "Failing" was expunged. In short, the entire notion of "Art" did not arise.

What appears to have happened is that Serra realized that his teaching was, in fact, being used "antidotally" within an established pedagogical situation — that is, it became, in a short while, another *a priori* option and therefore, another standard academic tool. Recognizing that the strength of his radical teaching may have been weakened by its absorption within an academic setup, Serra has, at least for the moment, abandoned teaching (although the necessity of team assistance in the execution of his most recent work will, in some way, ultimately affect the thinking of his assistants, as it only recently profoundly marked a restrained and very fortunate body of students).

II

In my view, the earliest problem of sculpture was to reproduce the verticality of the human being in contrast to the horizontality of the earth. I don't mean to say that the problem was to reproduce the human image, although our first great sculptures, the "Venus" fetishes, the Pharaoh portraits and the Greek *Kouroi,* do so. What I am trying to get at is that they are vertical — not that they are anthropomorphic. An urge toward verticality which characterizes the history of sculpture became further energized through such intermediary assists as bases or through technological processes, such as bronze casting or metal forging or new plastics, which permit heavy masses to be supported at elevated heights from slender shafts, as our legs carry our torsos. By extension, sculptures which are supported by architectural elements other than the floor are by their sheer perversity a testimony to the traumatic grip of the pervasiveness of the idea of verticality and its correlative dependence upon the floor. What then of horizontality? We have seen, in the past two years particularly, an almost concerted assault on the axiomatic verticality of sculpture in favor of horizontality. There is, of course, a kind of familiar horizontal form which,

23

although not called by the name of sculpture, has always insisted on certain sculptural qualities — furniture. When Brancusi made horizontal sculpture, he justified himself by regarding the results not as "sculpture" but as "furniture," calling such sculptural artifacts "Bench," or "Table," stressing by such appellations a functional rather than horizontal connotation.

In this respect, that Carl Andre's floor-bound square modules should be called "rugs" seems less fortuitous than may appear at first hearing. Carl Andre, perhaps, may be regarded as an intermediary between Brancusi and Serra in that his work stresses a furniture-like horizontality and focuses on elemental material properties, both features shared by Serra. Andre's works are admittedly a case apart. He is taken to be a figure central to Minimal and geometrical sensibility. Yet, there is a "dumbness" and "inertness" in his work that somehow marked him as different from the general run of antiseptic purveyors of three-dimensional geometric propositions. His most recent exhibition at the Dwan Gallery, presenting grid configurations of elemental metals selected from the chart of atomic valences, indicated that we were meant to compare the differences, visual and extra-visual, between elemental substances in identical figurations. Serra's relationship to Andre is one of focusing on the properties of the material. Andre appears to be interested in the inert surface qualities of the material and Serra in the intrinsic structural potential of the material. However, the modular characteristics of Andre's work disaffiliate him from Serra and link Andre to the prevailing geometry which is a cardinal feature of the Minimal mode against which Serra and numerous associates can only, at this moment, appear to be pitted, whether or not this is their stated intention. The Minimalist's source is the module, the unit, the one; Serra's is the verb form.

It would be tempting to erect an analogical structure comparing the aims of Serra and those of Ludwig Wittgenstein, about whom Serra often spoke. Such a method is bound to fail from the outset as the dynamics of one species of inquiry are hardly interchangeable with those of another. The most abject art criticism has traditionally been predicated on the dynamics of poetry: *ut pictura poesis*. But a certain harmony of interest is evident, especially in

Serra's early work. In a memoir on Wittgenstein, written by one of the rare intimates of the philosopher, is the following characterization of Wittgenstein's quest:

> ... according to him, complex propositional forms are merely functions of simple propositions, and therefore cannot express anything not already stated by the latter. The existence of causal or teleological relations between the facts, however, transcends the realm of facts and cannot, therefore, be expressed in meaningful propositions.[2]

Serra is involved with the elementary components or the processes of building, as distinguished from the expression, visual or otherwise, of a finely turned pun. The impetus to work derives from a simple proposition of a verb form: to roll, to tear, to splash. On the bluntest level, Serra is interested in the problem of what sculptural properties may encompass. The problems Serra attacks are structural in nature, problems which have scarcely any linguistic correlation, except possibly as highly extenuated syntactical or grammatical analogies.

The first body of Serra's pieces seen in New York City were exhibited by Richard Bellamy in February, 1968. He appeared in a group show with Walter de Maria and Mark di Suvero (who, for many years, was Serra's neighbor in California). The works shown were largely made of rubber materials and neon tubing. The contrast of material partly impressed me because the tubing exploited both the coloristic immateriality of light and the hard, cold surfaces of glass. The rubber was used either bluntly as a broad surface, hung into swags of crumpled, kneaded erasers or as lengths of belt-like harnesses, which, although flaccid, were joined into fixed positions by bent industrial staples [3] (Fig. 1).

Subsequent to the rubber and neon pieces and as party to a broad offensive against verticality, Serra undertook numerous exercises in horizontality, in "floorness." The piece that I am going to characterize as "bench-like" (over Serra's reservations), is *Candlepiece,* shown in the St. Louis *Here & Now* exhibition of January

[2] Paul Engelman, *Letters from Ludwig Wittgenstein with a Memoir*, trans. L. Furtmüller (New York: Horizon Press, 1968), p. 105.
[3] "New York Reviews," *Artforum*, vol. 8, April 1968, p. 65.

1969. It consisted of a length of timber drilled at equidistant intervals along a horizontal axis. Into these apertures were set a row of ten burning plumber's candles. The unfinished surfaces, the thick candles, the constant equidistant holes are all related to a kind of physicality that one recognizes as a central characteristic of Serra's work, as it was long before in Brancusi's wood carvings. In this sense, the *Candlepiece* conveyed many of Serra's basic interests. As to what Serra has called a "time piece," however, the work later struck him as "illustratively simple-minded." Clearly in this work there are several "clock-like" clues. As we shall see, other apparently formal conceptions are often shot through with a relationship to the problem of time. This piece "fails" for Serra in that it remained primarily "an on-going visually illustrational process which smacks of the permissiveness of Happening and Theater."

In the same exhibition, a vast expanse of floor itself was covered by three loosely overlaid rubber sheets. The surface of these sheets was formed by spreading a layer of latex rubber mixed with orange paint across the face of corrugated roofing from which the sheets were then lifted and spread upon the floor. The corrugated surface was a device used to "hold the expanse to the floor," as was the orange color. For Serra, it was incidental that the orange color was the color of anti-rust paint, or that corrugated construction siding is itself a common and offensive structural material (at least insofar as it has generally been employed by the American middle class).

III

At the same time that the horizontal floor pieces were undertaken, Serra was attracted by the possibilities of lead, a material which he employed for its weight, malleability, entropy, inelegant lack of sheen and other properties which one recognizes as directly opposed to the chromium steel and polished glass which has dominated "good taste" for at least three decades.

Among the activities Serra investigated were tearing exercises such as the methodical ripping away, by hand, of successive edges of a lead

square (Fig. 2). One is tempted to point to the square, concentrically structured paintings by Frank Stella of the early 1960s for the "diagrams" of Serra's exercises — although, for Serra, they are parallel to "the concerns of Anton Ehrenzweig, such as 'dedifferentiation,' 'scanning,' 'scattering,' and 'synchronistic vision'." The formulation of the image of Stella's painting assumes its total meaning when an inevitable sequence, adumbrated by the support, has been carried to its completion and becomes itself the final image. Serra's lead sculptures, on the other hand, reject the final image, for, were the work carried to its inevitable conclusion, it would arrive at a point and an instant in time beyond which further tearing is impossible. Serra brings our attention to both this sense of time-shift and to the physical procedure itself. The inevitable sequence of the "tearings" is also very much akin to the sequence of constant chamfers in Brancusi's *Endless Column*. Both works are marked by constant repetitive and artisanal actions. "The many versions Brancusi carved of *Endless Column* make it clear that the motif had a special place in his affections... Once the proportions are established it is only necessary to lay them out on the beam of wood and proceed almost automatically; the work goes on like a litany, with no need for invention. Every new *Column*" — like each new tear piece — "seems to develop its own individuality. From a relatively small effort there is here a great poetic yield." [4]

What then is important: the statement of the process (place, time, procedure), or the accruing pile of crumpled lead "tearings" which accumulate during the execution of the piece? It would seem that the answer is both of these, or, as Serra states, quoting Whitehead, "process and existence pre-suppose each other." The crumpled "tears" of lead in their chaotic accumulation, were also related to the subsequent lead splashings, though certainly the molten

[4] Sidney Geist, *Brancusi, A Study of the Sculpture* (New York, Grossman, 1968), p. 73. With regard to the temporal implication of such constantly decremented tearings, again Geist supplies us with deep insight: "A mnemonic system in art that does not imply the world is an ornamental frieze or fretwork, which is a metaphor of memory and its opposite, anticipation. In this respect it is worth noting that the *Endless Column* of Tirgu Jiu (a kind of vertical frieze), is sometimes called "Column of Endless Remembrance." pp. 174-175.

condition of lead (by its very familiarity) would have suggested itself as an expressive means to Serra, quite independently of the "tearings." [5]

The first lead splashing was seen at the Castelli *Warehouse Show* of December, 1968. The spattering of lead, which had been tossed into the juncture of floor and wall, was made again at the Kunsthalle in Bern, in front of the Stedelijk Museum in Amsterdam and received still further elaboration at the *Anti-Illusion: Procedures/Materials* exhibition at the Whitney Museum (Fig. 3). There, one of Serra's pieces was a floor work of thirteen such tossings, twelve of which, after having cooled and hardened, were pried away from the corner and laid one after the other in sequence. The work affords the possibility of the sequential visual reconstructions of its making, which parallels the purely visual aspects of the piece. In this sense Serra designates such works as "slow information" pieces. The material condition of this sculpture — something which was once molten and is now solid, revealing the potential of the material — reminds one of the earliest neon pieces which dealt with antithesis between luminosity and glossiness. Moreover, the viewer recreating the acts leading to the piece cannot fail to sense the time increments embodied in the twelve tangible "splashes."

The torn lead and splash pieces point to a two-and-one-half minute film made by the artist. The film concentrates on a single image, Serra's right hand attempting to catch and release a piece of lead which was dropped in front of it. One saw neither the source of

[5] It goes without saying that the piles of lead "tearings" share many characteristics with the work of a broad wave of young artists who are involved in a rudimentary return to the pre-vertical condition of sculpture. I know that the distinctions between each of the following figures are telling, but I cite, only in passing, the sweeping compound and graphite scatterings of Bill Bollinger, the colored mesh unravellings of Alan Saret, the mounds of broken stone of Robert Smithson, the piles of earth and crank grease of Robert Morris, the floor flockings of Keith Sonnier, the random distributions of Barry Le Va, the displays of plasticized containers and sheets of Eva Hesse, the "rugs" of Carl Andre, not to mention the pile of colored rubber strips of Richard Serra himself, shown at the Castelli *Warehouse Show* of December 1968.

It is perfectly obvious that this list is far from complete and that each of the figures mentioned are working in sculptural areas that can hardly be viewed as congruent either esthetically or qualitatively except insofar as they are all producing antivertical, low-lying experiences. The interrelationships between these figures, particularly with regard to their attitude towards color is especially critical.

the falling fragment, nor the pile-up of pieces on the floor; one saw only the artist's hand catching the scrap of lead or missing it, its muscles straining to adjust to this mechanistic role. The film points up the ultimate inability of the hand to function as a tool, for, were it able to have successfully carried out such an *a priori* task, one would have witnessed a theatrical performance. Instead, the film concerns itself with the breakdown of a positivist assumption because the hand after a moment is physically unable to negotiate the predetermined demand. Thus, the value of the film lies in its clear indication that all assumed or received systems — linguistic, esthetic, experiential, formal — are in themselves subject to breakdown. In short, the breakdown is as much a part of the context as the structuring of the experiment.

IV

In my view, Serra's loose lead work can be associated with a shift in modernist sensibility, omnipresent throughout the winter of 1968 and spring of 1969. This was attested by the number of exhibitions devoted to so-called process artists, conceptual artists, earthwork artists, and artists, particularly sculptors, who stress horizontality and "floorness" in their work. This new sensibility tends to be anti-precisionist and anti-geometric. It once again fosters values connected with Abstract Expressionism, that is to say, it sponsors the sensibilities covered by Wölfflin's term *malerisch*. In this respect Serra's lead splashes and "tearings" are almost the *sine qua non* of the new sensibility. But while being related to the widespread revival of painterliness, Serra's pronounced constructivism is also in evidence.

At the same time that splashing was employed as a device, Serra was examining lead for its more obvious structural possibilities. (Seven such preeminently didactic works were exhibited as part of the Theodoron Foundation exhibition at the Guggenheim Museum in June-July, 1969 (See Fig. 4). Serra was interested in the idea of lead which had been tightly rolled into a column and which in its solid columnar state became the object of elementary building

29

procedures: to roll, to saw, to divide, to rest, to lean, etc. More complexly elaborated works, held by their weight and the pull of gravity, support additional rolls or plates of lead held up flush against the wall. Each solution clarifies the physical limitations of the same material in different situations.

The idea of propping massive forms together by sheer weight and gravitational pull became more visually engrossing when the leaning elements gradually approached the vertical. This was effected through the introduction of additional elements that were supported by the leaning column itself. Gradually, the column was forced to a "vertical" upright by introducing median horizontal "pins" which extended out from the wall and which were supported there as autonomous elements by the slight tilt of the lead column. Eventually broad sheets of thick lead supplanted the rolls in such structural experiments.

In rejecting welding, which he calls "stitching," Serra employed the first method of raising forms from the ground, that of leaning and propping, as a child leans cards one against the other. The device of propping or leaning forms leads to several issues of importance. Through this device Serra is able to indicate an affiliation with David Smith without any concomitant copying; that is, Smith's arrogant cubic forms could be retained without recourse to Smith's oxyacetylene torch, the first tool to which the confirmed Smith imitator would turn. Smith, our greatest sculptor, could vertically raise cubic configurations high in the air, predicated on a "pictorialism" and "false weight" which are virtually impossible without welding (they could, of course, have been carved). Serra raises forms that are only possible through propping. Hidden in this distinction is the time-honored argument surrounding "integrity" and "truth to materials" which, in our time, are almost exclusively associated with Brancusi.

The idea of utilizing the wall as a correlative support was for the moment put aside, and the lead elements were used to support themselves autonomously. The most representative work of this kind is the *One Ton Prop, House of Card* (Fig. 5), shown at the Whitney Anti-Illusion exhibition. Each of the four faces of the sheets is held by a slight incline of the lead plate "arrested" at

each corner by a repressed pinwheel configuration. The work was colloquially spoken of as "getting Carl Andre up off the floor," which is to miss the point. For, in both works, the gravity as well as the material is "compressed downward."

While such a notion is in fact extremely simple, its execution is less than easy. This difficulty, however, is not a criterion for its effectiveness as a work of art, while its massiveness and weightiness most certainly are. A film by Robert Fiore (shown, by the way, over Serra's objection), recorded the first studio experiments with such a structure prior to its execution and installation at the Whitney Museum. The film shows Serra and his team dollying the quarter-ton plates across the studio floor and leaning them one into the other until the final aperture was produced. The film records the extra-visual sensation and recalcitrance of the heavy lead, as registered in the physical gestures and responses of the artist and his team.

In this respect such films, like articles or journals or manuscripts or photographs or tape-recordings, may in turn aspire to the condition of works of art. The acceptance of such views tends to render expendable the product on which they are based, so much so that many new works may exist only as literary ideas or possibilities in the artist's mind.

On one hand, it would appear then, that part of the new sensibility is a kind of nihilism, an impulse to supplant a work of art with its own adumbration. Such is the case of artists of more Dadaistic or linguistic turns of mind. The difference between Serra and these figures (as has been often indicated in this essay), despite whatever parameters and proximities there may be, is that there is no literary focus at all in Serra's work. Therefore, its meaning cannot be supposed on the basis of concomitant documents. For a Dadaist of the new sensibility, such a record will in time become the central emotional repository, which is nothing more than "self-conscious history-making." The art of Richard Serra is not in a snapshot; it is in the viewer's ability to reconstruct, on the basis of the work's clear exposition, the artist's undisguised step-by-step intentions.

KEITH SONNIER:

MATERIALS AND PICTORIALISM

Keith Sonnier is 28 and was born in Mamou, a French-and-English-speaking town in Louisiana. The unassimilated Frenchness of Sonnier's background — he speaks with no Southern accent — partly made for an unregretted childhood, and one which was open to the arts; at least it was not hostile to personal eccentricity. His father ran a hardware and electrical supply store. At 12 he drove. He went to Mamou High between 1955 and 1959. Nothing deeply disrupted this Southern rural picture except when, at 15, he had an inkling that "there had to be something else."

From high school, Sonnier went to the University of Southwestern Louisiana, 1959 to 1963, where he became the central figure of a small body of art majors.[1] Color slides of Sonnier's student works indicate that they were paintings of high quality revealing an awareness of the 20th-century European tradition. They are marked by a heady sensuality and the easy, natural color of a native painter who was early in control of his color and medium. These convasses of female nudes, half drawn, half painted, are lyrical and shift in a Soutine-like way from wet impastoes to thin washes of a generally muted, dank tonality.

In 1963, Sonnier went to France, starting out in Normandy — "just another peasant culture, no communication" — and then to Paris, ending in the working class district of Clignancourt in the *rue du Poteau*. He continued to paint between 1963-65 in an erotic

[1] Sonnier especially recalls the teachings of Calvin Harlan as helpful. Harlan is a New Orleans painter of clear and rigorous color principles, in nature akin to Albers and the Yale Art School and who also had an "in" to what was happening in recent English sculpture.

"mystical" way, but saw his work slowly transform into something that was "considerably more abstract."

After working in isolation in France he acted on impulse and communicated with the Rutgers University Art Department, where he was offered a teaching assistantship beginning in 1966. The return was critical. Among his colleagues there were Robert Morris, Robert Watts and Gary Kuehn. Through them, Sonnier was introduced into the New York art world, as part of the "Rutgers Group." His medium shifted from paint to vinyl and other prefabricated plastic substances such as vacuum cleaner coils. These materials tended to be comparatively soft. They adopted forms of a loose geometry—hollow rectangular forms, cones, pyramids, supported on the inside by hidden air blowers. Often such forms were set into tables and surfaces that toppled slightly. The change in the medium was more radical than the shift in the metaphor, which remained sexual in its connotations. The central figure, for better or worse, was Oldenburg, who, at the time, had engendered a wide range of funky, soft sculpture, though Sonnier's pieces were not necessarily imitative of the Pop sources of Oldenburg's imagery.

In the fall of 1966, Lucy Lippard introduced the work of Keith Sonnier in a group show held at the Fischbach Gallery, called "Eccentric Abstraction." It also included the work of Bruce Nauman, Gary Kuehn, Eva Hesse, Frank Lincoln Viner and several other artists who had assembled earlier in the year at the Graham Gallery under the banner of "Abstract Inflationists and Stuffed Expressionists." Lucy Lippard's early essay touched on many serious features of these young artists who were already attracted by a new range of sensibility — one connected both with the idea of procedure ("process art") and ideation ("conceptual art"). Such options as were taken by these artists seemed particularly laughable at that moment, for so much of what was being taken seriously in art was still vitally Minimalist in character. It seems a commendable critical feat that Lippard should have observed that these works were "non-sculptural"; that they presented "indirect affinities with the incongruity and often sexual content of Surrealism"; that the "increased influence and participation of painters

has undermined sculptural tradition, producing a non-sculptural or object idiom that looks to formalist painting rather than to previous sculpture for its precedents." Of Sonnier, she observed that he "presents two apparently contradictory states as parts of a single phenomenon. A boxy but soft form slowly inflates and deflates in comparison to its hard, inert counterpart. The rhythm is mechanical and voluptuous, barely active, offering change and subsequent return to the first state until the two become one physical sensation."[2] Works of this nature were also shown at Douglass College, Rutgers University, in 1966.

At this time, Sonnier began to be handled independently by Richard Bellamy of the Goldowsky Gallery. As has been the case with each successive wave of new sensibility, especially since the triumph of Rauschenberg in 1964, the more daring German dealers have endorsed young American artists by creating platforms for them, often long before their being widely shown in this country. In 1967 Rolf Ricke of Cologne gave Keith Sonnier his first one-man show, which was sold out, two works entering German museums.

It is not my intention here to describe Sonnier's career in terms of a "suite of triumphs." What interests me more is that Sonnier's work is central to a broad shift in sensibility, which was marked in the period of 1967-69, and which by the spring of this year had become so pronounced as to be virtually recognized as a distinct new style—yet one so disparate as to defy a single specific cognomen like Pop Art or Minimalism.

Since formalist art tended to be grounded in geometric appearances and permutations (it was an art which stressed "formal" rather than "contentual" values), an anti-geometric bias became visible and endemic in the new sensibility. Of necessity, formalist criticism, which tended to focus on determining the nature of geometric relationships through Aristotelian description, had to have been placed in jeopardy. These rejections, both on the part of artists and critics, were, of course, carried out in many quarters in a vindictive spirit occasioned by the false belief that formalist criticism had

[2] Lucy Lippard, "Eccentric Abstraction," broadside to an exhibition organized for the Fischbach Gallery, New York, Sept. 20-Oct. 8, 1966.

become the exclusive mouthpiece of Minimalism. What was overlooked in the new attack on formalism is that formalism as a visual and critical tool had arisen in the late 1930s in the social criticism of Clement Greenberg out of a need to expunge literary issues from the arts — those issues which were either politically slanted or Surrealistically biased. In short, formalist criticism arose out of a need to rid art of the debasing features of late Surrealist poetics and die-hard Stalinist polemics. To achieve this end, Greenberg placed new emphasis on those problems which were immediately bound to artistic procedure and the nature of the medium. He viewed successful solutions to these problems as "formal" and distinguishable from those issues which were either a hangover personality charade or those which had been tied to a deplorable and hypocritical social ethic.

The clear manifestations of new sensibility during these past two years may be divided into three streams, a bifurcated formalist stream, and a literary one. The last stresses "poetical" values and deals with image/word transfer play, which, if it is not Dadaist in nature, is nothing else. Its primary exponent and most vertiginous promoter is Bruce Nauman. The second stream is entirely Constructivist in character. It emphasizes elementary structural issues, that is, problems of joining, standing, raising up. It is clearly a sculptural and architectural style marked by an ambitious scale. Its primary exponent is Richard Serra. As counterpart to the Constructivist stream is a group centered about the issues of color. Their productions are marked by a desire to create forms related to and perhaps which more readily evolve out of painterly issues. Several young artists meet here — though they are yet of unclear positioning—Alan Saret, Bill Bollinger, David Novros, Eva Hesse, and Keith Sonnier.

Throughout 1967 Sonnier was attracted by lowlying, floor-bound assemblages which — despite structural premises centered upon long, perverse beams and "links"—also spoke of a new breadth of sensitivity and suggestibility. Sonnier's critical piece along these lines took the form of a thin loaf. It is made of foam rubber padded

over a wooden core. The rubber in turn has been covered with glistening pink satin which, because of a fairly equidistant set of "pullings" and "tightenings" formed a sequence of twenty-three units. The divisions were established "by feel" and not based on an *a priori* mathematical ratio. Other works by Sonnier of a similar and equally evocative nature were foam rubber "tubes" resembling satin-covered links, which were then laid over with "blankets" of cheesecloth, a highly modifying, disembodied substance, which in its shroudlike character acts in a way similar to a broad "wash" of color. Several trough-like works were also covered with cheesecloth, or were presented at rest upon such "beds." At this point Sonnier felt that he too "was an artist, not just saying something about myself as an adolescent but saying something to everybody." These would be the last "constructed" sculptures until 1969—although the act of covering such forms with semi-transparent rags brings up considerable issues connected to color as well as "poetical" ones, such as disguising, hiding, covering: covert versus overt.

Before attacking such a problem, let me indicate that the "tiny module"—as Sonnier characterized the diaphaneity of cheese-cloth—and the high gloss of the pink satin had its counterpart in several sculptures of 1968, made of window screening. This is a more tensed-up, resistant material, one which was also shiny and composed of minute crosshatchings of wire once again forming "tiny modules." The use of window screening led to several bulging works (now destroyed) of eccentric proportions — long, wall pieces, in which the wiry sheen was stressed, as well as the capacity of the substance to lend itself to *repoussoir*. Other experiments with screening were several floor exercises of elementary pleating and folding. In 1967, Sonnier began to incorporate a further range of materials: rags, torn patches of tinted silks and disembodied, delicately colored remnants.

The new tremulous substances and hesitant colorations led Sonnier to be interested in broad sprawls of latex, often heightened with "flocking," that is, of colored powdered rayon, a substance employed in the manufacture of wallpaper (Fig. 6). The act of spreading the latex on the wall or floor has superficial resemblances

to the flooding of colors in field painting—think of those by Morris Louis, for example. But the bleeding of thinned out paint into unprimed canvas is much faster, much more flushed than the comparatively resistant stickiness of the thick and pasty liquitex substance. Moreover, there is no absorption into the ground as in the case of thin paint on unprimed canvas. Instead, the spread latex remains on the surface and dries into distinct figure-ground relationships. The dusting or flocking, is an attempt to modify the color and shape problems caused by a layer of rubber contrasted against the color of the wall. Perhaps the use of rubber is similar to Richard Serra's rubber spreads of 1968, although his was used even more thickly and in a more shredded, tire-like fashion. Sonnier instead emphasized the membrane-like nature of rubber and its potential for thinness and fragility.

The flocked latex works measure Sonnier's refined sense of the whole environment, not only because of the coloration and tonality of the pieces themselves but also because they are so affected by the stray elements of the studio; a chair, a wall, a table, an electrical circuit box, a nest of cables. By peeling the latex membrane from the wall other issues were brought into prominence. The latex pulled down halfway in a more or less rectangular sheet related to issues of limpness as well as surface subdivision: arrangements of flocked surface, naked latex underside, the color of the wall, and the smudged original edge of the latex rectangle would result. These were further dilated upon by tying the peeled edges or levels away from the wall and by holding these projections out into space by thin, improbably weak strings or cords, which were sometimes fixed to the floor at some distance from the wall or which were themselves allowed to dangle limply. The tentative sculpture that results is a kind of muted memory of the edges of loose collage or Cubist grids. The strings tying all these limp substances into twisted rectangles tended to project a collage-like appearance into space, as if palely colored rectangles had been projected off the paper and their edges, now transformed into strings, were tied to the ground, or the floor, or the wall, or simply left to the mercy of gravity.

At this moment, too, the materials employed were enlarged to include neon tubing which was industrially molded after templates

37

fashioned out of copper tubing by the artist. This kind of gestural neon is peculiar and idiosyncratic rather than commercial in character. It may be that Richard Serra's rubber and neon pieces of 1968 helped to confirm Sonnier's decision to introduce luminous and gestural components although in the latter's work, the materiality of the substance was underplayed in favor of its role in the pictorial and coloristic vocabulary [3]. Neon assumed the role of line and gesture in contrast to the flocked latex and rags which were in this context identifiable as transparent planes, washes and patches of color. It would be interesting to know to what degree James Rosenquist's *sui generis "Tumbleweed"* (1963, Fig. 7), a construction of wood, barbed wire and neon, affected both Sonnier and Serra, since both expressed admiration of this work to me.

What I have been trying to show is that the latex, the flocking, the neon, the rags, the cheese-cloth, were, in Sonnier's case, substances analogous to the painter's palette, which he superficially appeared to have abandoned at the time of the "inflatable sculptures." These substances mark, then, in 1968, a return toward painterliness and colorism, a rejection of his "sculptural phase" which had been touched by the prevailing Minimalist mode, however eccentric its forms may have appeared. It is evident that Sonnier shared several coloristic premises with a body of young artists working in New York City, who gravitated to the Bykert Gallery. Foremost among these were William Bollinger and Alan Saret, the latter particularly. Saret's colored wire sculptures, limp rubber sheetings and mounds of powdered chemicals share with Sonnier both an intense feeling for color, which itself is unusual, as well as a revival of certain features connected with Abstract Expressionism, notably a gestural focus and an allover dispersal of energy. These Abstract Expressionist qualities are more Saret's than Sonnier's, who in all of his work has rejected the Abstract Expressionist infinite screen in favor of a configuration based on a viable internal structure of shifting weights and balances. That is, there is no "figure" in Saret; there is a kind of oriental or cal-

[3] Sonnier has acknowledged that Bruce Nauman's neon pieces were instrumental in bringing him to this material.

ligraphic "figure" in Sonnier. This orientalism is particularly noticeable in the *Neon with Cloth* of 1968.

These coloristic attitudes were especially evident in the "Here & Now" exhibition held at Washington University in January, 1969. Commenting on the similarities between Saret and Sonnier I observed at the time that in addition to its relation to Abstract Expressionism, the new colorism possibly may relate

> ... to something older... there are qualities relevant to late Monet [I mean after 1890], in the kind of unravelling that one sees in the later paintings of Monet. And this is sensible in the kind of colors that Saret is using, a highly lyrical, perfumed and confectionery range, equally relevant to the painting of late Monet. That kind of color is also... in the fine color selections that we see in the works by Keith Sonnier: pale pinks, pale greys. Utilizing the pale beige of the wall is a very conscious coloristic reference back to issues that deal with late Monet.[4]

It is apparent that the range of color favored by Sonnier is of a wistful, greyed-out range. The emotional tenor of the color, and the insubstantiality of the material in which that color is embodied, led me to a dangerous area of "poetical" speculation, although I am not yet willing to abandon this attitude entirely. At the same panel, I went on to speculate that the kind of forms taken by such limp materials

> ... enter a very remarkable area of subjectivity... that is a kind of funerary, shroud-like, dispiriting ... association. I think that the shroudiness is perfectly easy to see, or is visible in that enormous pile of dusty rubber... by Saret, in a certain sense there is also, in the pink shroud floor piece by Sonnier, a kind of delimited, funerary site, the grey flocking covering an abandoned bed.[5]

The piece I was referring to was specially made for the St. Louis exhibition. It was executed on the beige linoleum tile floor. A "bed" of latex was spread and flocked over with grey. A pink rectangle was fixed along the lateral edge, like a gauzy blanket.

[4] "Here and Now" exhibition, symposium transcript of a panel held in St. Louis on January 12, 1969, p. 4. I would like to extend my appreciation for the copy of the transcript to Joseph Helman, President of Steinberg Art Gallery Associates (SAGA), and Robert T. Buck, Jr., Director of the Washington University Gallery of Art.
[5] "Here and Now" exhibition, symposium transcript, *op. cit.*, p. 13.

The latex and flocked pieces on which, I would say, the present reputation of Sonnier has been built vacillates between the two poles of an art predicated on fine color plays and insubstantial materials, and a desire for clear, expository effects such as elemental examinations of surface peel. But the latter area, rather than existing for its own end, accompanies the refined, pictorial sensibility to which these remarks have largely been addressed.

Throughout the remainder of 1968 and into 1969, Sonnier's "palette" of materials remained fairly constant. However, in the spring of 1969, when an international interest in the new sensibility had already been stimulated — with many exhibitions held in St. Louis, Bern, German private galleries and the Whitney, for example —a change in Sonnier's work became evident, one which is still very much in the process of realizing itself. Instead of utter bonelessness and depletion, Sonnier's objects are now tending toward a fresh tenseness. This evolution is being accompanied by a greater reliance on elements of industrial prefabrication, particularly on thick sheets of glass squares and circles. Their role is largely to modulate light and, therefore, they can be related, startlingly enough, to the swathes of cheesecloth of the earlier work. The neon gestures have also been expanded to include specific geometrical elements such as arc-sections and straight "lines." Moreover, "real" elements, such as shaded light bulbs, light sockets, movie and slide projectors, and strobe lights, which had modestly functioned at the "edges" of the earlier assemblages are here being directly incorporated into the "calligraphic figure," with passages of neon tubing "lassoing in," so to speak, such real electrical appliances. Such environmental clues were, in the earliest latex pieces, first experienced tacitly and unapologetically. By now, such material has become almost a special area of exploration. In this sense, the latest works carry in them a heavy residue of Happening, Theater and Environment.

The glass sheets, because of their weight and hardness, demand a more physical and Constructivist interplay and, therefore, are more arduously set into propped and architectural relationships. The neon elements are being placed into more tectonic—vertical, horizontal or parallel—associations, not that gestural neon has

been given up entirely. Several of the most recent pieces tend to contrast the transparent geometric glass shapes against rushes of gestural neon. Such contrasts inevitably take into account the glossy modulations of light reflected by the glass surfaces as well as the transparent shadows cast *onto* the studio wall *through* the glass planes themselves. We are still dealing with a highly elaborate coloristic sensibility but it appears that the inert rags and dusty flockings are slowly being moved away from.

Among the loveliest of these recent works is the one in which a gestural yellow diagonal of neon reflects on and through a glass square, or the one shown this June at the Whitney "Anti-Illusion" exhibition, in which a semicircle of fluorescent green neon is reflected into the lower half of a circular glass sheet flushing the clear glass green up to the central horizontal bar. This last work is particularly geometric in character—though all the recent neon pieces need not be. Another remarkable gestural piece is a kind of free "M" (Fig. 8), in which an orange neon light encircles five blue neon prongs. The front face of the orange stream has been silvered opaque forcing these passages to read as black strokes, while the orange light is deflected back against the wall.

The purpose of this essay has not been to create an argument on which one may make predictions regarding the future. Whether or not Sonnier retains his pre-eminence in a stream which itself is constantly threatened with evaporation because of its sheer delicacy, is simply beside the point. Instead the manifest excellence of Sonnier's work is the *donnée* which demanded a descriptive analysis.

EVA HESSE:

MORE LIGHT ON THE TRANSITION FROM
POST-MINIMALISM TO THE SUBLIME

Eva Hesse was born in Hamburg, Germany to a Jewish family on
January 11, 1936—in full *Hitlerzeit*. During her infancy, Eva Hesse
was separated from her family for a period of three months. In
1939, she went with her father, mother, and sister to New York
City where she was raised in Washington Heights, a neighborhood
which, since the large emigrations following the First World War,
had become largely a German-Jewish enclave in Manhattan's
Uptown. Bilinguality was to serve her well, for, shortly after her
graduation from the Yale University School of Fine Arts in 1959,
she and her husband Tom Doyle went to Germany and remained
there for nearly two years. Eva Hesse's first extensive exhibition
took place under the tutelage of the Kunstverein für die Rheinlande
und Westfalen in Düsseldorf in 1965.
This exhibition was the culmination of a deeper, more internalized
quest — the discovery of who she was, through the reconstruction
of the facts and fragments pertaining to her family lost during the
war. The return to Germany was "... a weird search, like a secretive
mission... a new generation seeking a past. I know nothing of my
family—my grandparents. Seeking out statistics, establishing losses
encountered by the H[esses]... never knowing their lives, their
never knowing me or mine... never having had grandma, grandpa
[Moritz and Erna Marcus], life at all the gatherings, house,
encouragements, proudnesses...." [1]

[1] From an undated pocket notebook /1964?/. This small notebook records stray hints,
addresses, names as well as immediate biographical material which Eva Hesse would need
to complete bureaucratic forms and the like, pertinent not only to her stay in Germany, but
to her husband's stay as well.

Eva Hesse's difficult childhood was further traumatized by the separation of her parents in this country, the remarriage of her father, and the death of her mother. Her diary notations indicate that she identified the intellectual and structural side of her mind with her father — sought, in fact, to conform to what she took to be those sources of pride which he took in her, perhaps as a guarantee that she would never again be abandoned.

A highpoint of her young career — and of paternal pride — occurred when, in the September 1954 issue of *Seventeen Magazine*, Eva Hesse's illustrations were feautured as part of the annual competition award, "It's All Yours." Her work had appeared in a nationally distributed magazine. She had earned $ 100. "We like to think that we discovered Eva Hesse," wrote Marie McPartland, the editor of the feature, "but actually she came up to *Seventeen* on her own in February of this year, fresh from Pratt Institute... We hired her on the spot to work part time on our staff. In the evening she attends the Art Students' League nearby. This month she begins a three-year course in painting, drawing, sculpture, and graphics at Cooper Union in New York City."[2]

In the fall of 1965 Eva Hesse returned from Germany to New York City where she was to die four years later on May 29, 1970. Her production, therefore, is strikingly compressed. In addition to the works themselves — paintings, sculptures, drawings, and the combined idiom that the artist preferred — Eva Hesse's estate also includes notebooks which range from ledger size to scratch pad in which she had, from adolescence on, recorded impressions, experiences, dreams, stray information, and artist's recipes. At times these were set down with fastidious control; at other times, they were hastily recorded, often in cryptic clues, especially when dealing with aspects of her private life. At the very end, when the intellectual equipment remained, but tortured by physical deterioration, many phrases are left unfinished. Even here there are type-size sheets of manuscript describing this experience.[3]

[2] "It's All Yours," *Seventeen Magazine*, September 1954, p. 140. Eva Hesse's illustrations appeared on pp. 140-141 and p. 161 of the issue.

[3] The manuscript is published in my "Eva Hesse: Last Words," *Artforum*, November 1972.

The history of artistic creation can never be said to be recorded in this way — the growth of a sculptural and pictorial oeuvre answers its own imperatives and not those of literature, even confessional or diaristic literature. Still, in Eva Hesse's case, it would be foolhardy to ignore these notebooks. Art history is richer for them, and they bring into sharp focus those personal and artistic events which shaped the production of a gifted art student, transforming it into one of remarkable power. The most painful notations record the central trauma of individuation provoked by the death of the artist's father in the summer of 1966 and the rupture with her husband which peaked at this time as well, events without which, I believe, Eva Hesse's art might have remained an effort of primarily local interest. These events are also mentioned as a means of introducing certain figures — Sol LeWitt, Mel Bochner, Lucy Lippard, Robert Smithson, and Helen Charash,[4] artists and critics largely, who were to reinforce the vision which these two traumas aided in triggering. The terror and isolation provoked by the death of the artist's father and the withdrawal of her husband from her — instead of forcing incipient madness — provoked the crystal lucidity of original creation. In the summer of 1966, during the complex events and family rituals surrounding the death of her father (in Switzerland, as it happened), Eva Hesse found herself in the unfamiliar serenity of her sister's household, surroundings which intensified a sense of guilt. She had not become the kind of artist which the "It's All Yours" suggested she might have become (neither did Sylvia Plath, who shares this curious coincidence with Eva Hesse). She wrote: "I feel more helpless, insufficient, stupid... I want to prove myself. My only weapon is art." In August of 1966 Eva Hesse's life as a mature artist begins.

Even at this short remove it grows difficult to ascertain the individuals who created the movement away from Minimalism and from formalist criticism. Certainly, Richard Serra, Carl Andre, Keith Sonnier, Robert Smithson, Robert Morris, Sol LeWitt, Mel Bochner and the critic Lucy Lippard must be recalled in this

[4] The sister of the artist who as possessor of these documents generously allowed me to study them free of any hampering stipulations.

connection; several of the artists listed here had also functioned in the capacity of theorists and critical essayists as well. Eva Hesse also contributed enormously to this shift of sensibility, and her journal notations after 1966 make constant mention of LeWitt, Lippard, Bochner, and Smithson, acknowledging their crucial assistance during a period when otherwise she might have felt herself alone in the making of a new art as well as of a new life. The death of Eva Hesse also makes it possible to regard her production in a way quite different from that of her Post-Minimalist colleagues. Their careers are still being elaborated. What can only be elaborated now, in Hesse's case, are our changing modes of perceiving what is important in her work.

During 1965 Hesse began to break with the explicit Expressionist and Surrealist clues of her art — those fine ambitions that an extensive art training and long European stay engendered. Biomorphic relief elements announced a fresh attitude toward pictorial-sculptural ambiguity. Some fifty items, drawings and combine paintings, comprise the checklist of the summer run of Eva Hesse's first exhibition, *Materialbilder und Zeichnungen* held at the Studio für Graphik in Düsseldorf from August to October 1965. The front page of the onefold checklist reproduces a photograph of the artist surrounded by five works. Although the reliefs are seemingly abstract, their organic inferences will, by the end of the following year, have been further attenuated so that what we now view as a kind of generative abstraction — breast and nipple forms, womblike configurations — will have evolved into a vestigial suggestiveness.

One is impressed by their vigorous biomorphism and sense of craft, as well as their often raucous color. This chromatic plangency is notable because it argues for a rejection of the systematic color theories of Josef Albers, one of the important teachers whose influence the artist underwent at first hand. Unlike her teacher's paintings, Hesse's works are expressionistic in terms of their harsh and obtuse color. Taking note of the generally monochromatic appearance of her work after 1965 — a monochromism largely traceable to an appreciation of Jasper Johns' work — I conclude

that Eva Hesse was a largely insecure colorist, never comfortable with this emotionally oriented world, despite her successes in Albers' classroom.

Once again in New York City and more self-aware of her ambitions, Eva Hesse found support among a small community of compatible artists. A disparate range of work came into being, resistant to the architectural and sculptural ambitions of Minimalism. These artists, in order to cut through Minimalism's solemn atmosphere, adopted a self-mocking stance. The general levity was viewed as "doing an Oldenburg number." The shifting sensibility was expressed in the growing use of highly colored, emotionally associative materials and through the rejection of the geometrical tradition of Constructivism. The limp, the pliable, the cheap were sought; the hard, the polished, the expensive became suspect. Unanticipated methods of seaming and joining were emphasized — sewing, lacing, grommeting. Rags, vinyls, street detritus came to be choice materials surpassing even welded stainless or Corten steel.

In the late spring of 1966 several artists of this stamp joined together for a group exhibition at the Graham Gallery, calling themselves *Abstract Inflationists and Stuffed Expressionists*. The exhibition was largely construed by the gallery-going public as a tardy Pop put-on, a joke, at worst jejune, at best harmless. This condescension was inescapable when regarded in the context of a larger situation in which Tony Smith, Kenneth Noland, and Frank Stella were taken to be the representative figures of modern art. The reviews of the exhibition were few and terse, equally understandable granting the youth of the participants and the unfamiliar idiom in which they were working. The most salient feature requiring mention went ignored — that such an option should have been adopted by a body of artists in the first place.

The announcement for the *Abstract Inflationists and Stuffed Expressionists* exhibition was a toy balloon, surprinted with the gallery particulars, emphasizing in this way an air of comedy. The good nature of the exhibition led me to write that Eva Hesse's contribution — ironically called *Long Life* (Fig. 9) — was a "slapstick ball and chain [that] might easily pass for an anarchist's bomb

designed by a color blind obsessive-compulsive."[5] I was struck by the process of manufacture — a core of papier-mâché painstakingly bound in gray-painted cord. The relationship of the piece to the early painting of Jasper Johns is notable especially in view of its subject matter — if that term is still a viable one. It can easily be allied with, say, the *Painting With Two Balls*, the gray version, which, like the gray work by Hesse is equally sexually inferential. Although Hesse's work also seems to bear reference to the early Johns-like production of Robert Morris, it seems doubtful to me that Morris' career ever had a decisive influence on Eva Hesse's work despite Morris' essay "Anti-Form" (*Artforum,* April 1968), a position paper to which Hesse's work is appended by virtue of her relationship to the movement Morris is describing.

From 1964 on, there appears in Hesse's work a conscious use of motival configurations. One such figure would be the "ball" and "chain" motif of *Long Life,* a large, round body from which a thin length depends or is extruded. Such a formal predicate remains constant through the remainder of Hesse's short career — perhaps abandoned in the plastic and rope skeinings and ladder-like structures of the last year of her life. Although in some German-period work such motifs are revealed, the "ball" and "chain" motif appears first to have been fully realized in a piece of 1966, *Total Zero* (Fig. 9) — now destroyed, somewhat inner-tube-like in shape from which a short swirl escapes. The motif is sexually connotative, possibly generative, carrying with it an abortive note inferring both uterine container and slashed umbilicus.

Such sexual metaphors are not introduced into Eva Hesse's work because of an active literary fantasy, but because they take their spur from closely lived experience. They are always a function of the actual events of a life painful from the first, even at its seemingly best moments. The "uterine" motif, for example, is given credence by the notations made in a notebook at the time that Eva Hesse was still a student at the Yale University School of Fine Arts. On November 2, 1960, Eva Hesse noted that "... her problems

[5] *Artforum,* May 1966, p. 54.

of mysterious pains have been detected and explained... A logical explanation and proper steps shall shortly be taken. I will have an operation and the opening at the ovary will be dilated." Later she noted, "Tomorrow I go to hospital. Tues., Operation."

While such innuendos in her art correspond to the troubled personal life of the artist, such a line of inquiry must remain speculative as it falls into the province of trained analysis, if even then. But that Hesse thought along such lines is substantiated throughout the notebooks. Her notations indicate that she was attracted to Freudian analytical patterns — as early as her studies at Yale — because they are so potently simple and seemingly true. In a notebook dated April 1966 (although it covers a broader period of time), the basic statement of the conflicts besetting her were recorded as the "Underlying Theme [of the] conflicting forces inside Eva" — in her notebooks she often refers to herself in the third person — viewed as an ongoing sadomasochistic multivalence within a Mother—Father polarity:

1. *Mother force: unstable, creative, sexual, threatening my stability, sadistic-aggressive.*

2. *Father, Stepmother force: good little girl, obedient, neat, clean, organized-masochistic.*

Later, through 1967-69, the motif of the trailing cord may be construed in the context of plasma bags and intravenous tubing, although by the period of her life when the surgical readings ought to be most evident, in the last year, this motif had, in fact, been displaced. Still, these motifs are not interesting because they may lend themselves to elaborate extrapolations of meaning but simply because their forms are interesting apart from any thematic obliquity. The forms infer, but they do not depict. Their essential ambiguity attests as well to a stylistic evolution out of Jasper Johns and through him to a still larger distillation of the Surrealist theory and a modern obsessive tradition, combined with, in Hesse's usage, ruggedness, pragmatic resourcefulness and an appreciation for the intrinsic physical properties of her materials.[6]

[6] These last qualities were those of Robert Rauschenberg's work of the period 1958-62, and

The compulsive coiling of these early pieces — a kind of pleasure-inducing craftswork — indicates a curious methodology. In this connection, the influence of Lucas Samaras (Fig. 23) is sensible in the tendency toward pictorializing sculpture which marks the later '60's and announces the Post-Minimalist phase. My intuitions are borne out by an important note: "I met Sol [LeWitt]," Hesse wrote, "at the Whitney [Museum of American Art]. Saw recent acquisitions (Held, Johns, Kelly) & Lipman Collection. Lot of mediocrity along with few fine pieces. One beautiful Samaras (2 inferior ones), a fine Morris & Judd. The Samaras I loved was a box covered with pins, cover slightly ajar, with bird's head forcing its way out from under cover. Old cords and rope dropping out from front."[7]

In addition to the dangling, stray appearance of the sculpture, Hesse also responded to the fact that the characteristic surface of a Samaras box is formed by a network of parallel strands of multicolored knitting yarn. The obsessive nature of Samaras' work — both in subject and method — must be emphasized as another means of altering the idiom of Post-Minimalism. The conjunction of this psychological strain with a less sensuously appealing art sustained by the lucid theoretical positions of her friends Sol LeWitt, Mel Bochner and Robert Smithson, may have accounted for the enormous psychological persuasiveness of Hesse's manipulation of the otherwise spare rigor of Minimalist and serial structures to which she equally was being drawn at this time. LeWitt and Bochner have contributed to our understanding of this evolution. Some of the essential reference works in the movement, say Mel Bochner's "The Serial Attitude" (*Artforum,* December 1967), include pictorial examples of Hesse's work without specifically illustrating

for a European-minded American artist, Rauschenberg, who carried off the first prize at the Venice *Biennale* in 1964, would certainly be a preoccupation. The doughnutlike apertures of some of Hesse's pieces of 1965-66 point to the automobile tires of Rauschenberg's "combine paintings," the very term which Hesse had used in German — *Materialbilder* — to describe her works on the cover of the brochure for her first one-woman show.

[7] The April 1966 notebook. In the same notebook, Eva Hesse once recorded as a compliment an observation made by the surrealizing and obsessive artist, Paul Thek: "He liked my work lots. Said, 'The best he's seen of eccentric fetishistic art compared to Lucas Samaras.'" These ideas are further developed in my "Rosenquist and Samaras: The Obsessive Image and Post-Minimalism."

the way in which her more psychologically focused art elucidated the theory.

Taking into account organic inference, mixture of media and the fact that Marisol is a well-known woman artist, one might imagine that Hesse's work was cued in some measure by Marisol's work. Yet, a visit to Marisol's studio is recorded in the April 1966 notebook and the entry makes it clear that while Hesse was struck by the openness of Marisol's attitude regarding the use of odd substances, she had strong reservations as well. "Marisol does all work herself. She will try anything, experiment with any medium, incorporating all things." Here the sense of community ends and Hesse sharply notes that "What she does do is leave too much on the surface — design, decoration. Mystery is lost."

The rejection of Marisol is important to note because of Hesse's strong consciousness of the problems of being a woman artist, sympathies which were at that moment beginning to be explored by the more alert members of the New York art community. As early as 1966, Hesse confessed that "...I have this awful trait in competing with male artists, which is to say almost everyone. Then, that's not bad enough, I compete as a 'woman' with women in 'female' areas. It's another major area to be thought about."

The biomorphic frame of reference in Post-Minimalism had, of course, been discussed since the emergence of Claes Oldenburg's soft sculptures, especially those of c. 1962-64, when Hesse herself was first being drawn to this metaphor in her German combine paintings. It is in this historical relationship that Hesse emerged in the *Eccentric Abstraction* exhibition organized for the Fischbach Gallery by one of Eva Hesse's friends, Lucy Lippard. It was at this time that Hesse came to know Donald Droll who was then the director of the gallery.[8]

The *Eccentric Abstraction* exhibition, held in September and October of 1966, is one of the most influential group exhibitions in recent history. Lippard viewed her exhibition as antithetical to

[8] The subsequent relations between the director and the artist were very close. It was at Droll's loft, in the spring of 1969, that Eva Hesse first collapsed. He saw her through her medical attentions. I am indebted to Donald Droll for facilitating my access to Hesse's private papers.

"...the solid formal basis demanded of the best current non-objective art." Importantly, she emphasized the "indirect affinities with the incongruity and often sexual content of Surrealism." Lippard noted of Hesse's work that "intricately controlled and tight-bound, paradoxically bulbous forms do not move but their effect is also both fixed and changeable. The finality of their black to gray gradation is countered by an unexpected unfixed space and the mood is both strong and vulnerable, tentative and expansive." Lippard presaged, that "The future of sculpture may well lie in such non-sculptural styles." What was a "non-sculptural" possibility in 1966 has clearly become a sculptural actuality, if not even a stylistic cliché, if one takes into account the number of artists at present working in an idiom immediately dependent upon Eva Hesse's achievements.

An underground was coalescing and emerging. The then unfashionable loft area south of Houston Street — hence SoHo, bordered on the East with the Bowery, where Eva Hesse had her studio — was discovered to be the new bohemia. Eva Hesse's life changed from that of agony and fear into one central to a vital movement. She was valued as never before by artists, colleagues and friends. She had found an important gallery to represent her work — the Fischbach Gallery — although she noted in her journal that she had hoped to be shown at the now defunct Dwan Gallery at which Sol LeWitt was represented, despite the fact that the astringent severity of the general character of the Dwan roster was foreign to the tendencies exploited by Hesse. Perhaps, too, Hesse still wanted to demonstrate to Tom Doyle, who had been shown at Dwan, that she could now stand independently of him, but on his own turf.

The works of this phase of Hesse's career emphasize loaded dangling forms, either presented singly or clustered in groups: the ball of *Long Life,* another, *Vertiginous Detour,* is a black ball caught in a net which hangs from ceiling to floor, a work composed of groups of nets stuffed with crumpled plastic sheeting, *Ingeminate,* the sausagelike elements of *Several* — the last two included in the *Eccentric Abstraction* exhibition (Fig. 9). These testiclelike clusters re-enact, in terms of their coloristic neutrality,

51

the lessons of Johns combined with the organic metaphor of Olden-
burg, fusing the former's conceptual presentations with the latter's
viscerally identifiable soft sculpture. They are unique however, in
that they foster an "intelligence" based on natural pressure, an
"intelligence" or "rightness" such as we experience in clusters of
onions, or sausage links. The tug of gravity, the action of the ground
sprawl, the steadying and the support of the wall is always felt, quite
unlike the autonomous works of Oldenburg. This remains constant,
even in Hesse's seemingly errant pieces, the networks of the last
year. These, too, have the natural "intelligence" and "order" that
can be found, for example, in the tangled silk snares of certain
nongeometric spider webs.

In this way, the visceral punning derived from Oldenburg was
displaced in favor of the pictorial/sculptural fundamentalism found
in the radical offerings of the day — say, in Richard Serra's lead
tossings, an important example of which is dedicated to Eva Hesse,
or in Carl Andre's metal "rugs." These presentations argue for the
baldest acceptance of the floor and wall and reject as bankrupt the
virtual monopoly the monolith isolated upon a plinth had enjoyed
for millennia. The frank acceptance of the rudimentary — as
directed against the base and therefore against the isolated "art
object" — was only one part of the Post-Minimalist bias apparent
in Hesse's work at this moment, since her work for two years
more at least, was to give equally strong evidence of Minimalist
structure, a style very much in evidence in New York art at that
time.

Eventually Hesse exactly understood her relationship to
Oldenburg. In her most artistically exclusive notebook — really
a collection of unbound looseleaf pages, undated, but largely after
1967 — Hesse observed of Oldenburg's work: "...as eroticism,
his work is abstract. The stimuli arise from pure sensation rather
than direct association with the objects depicted." These ideas
reiterate contentions made in Lucy Lippard's essay "Eros
Presumptive" (*The Hudson Review*, Spring 1967) in which the
critic attempted to isolate the sexual metaphor in abstract art, an
idea which doubtless had been mulled over between critic and artist
for some time before publication. In the article Hesse is mentioned,

but only in passing, and then, revealingly enough, when bracketed with the name of Lucas Samaras. Lippard observed that Hesse's "black, bound organs" offer an indication wherein "the opposition and eventual union of Eros and Thanatos is one more contradiction to be absorbed by form."[9]

During the emergence of an "Eccentric Abstraction" the abstract-sexual legacy of Oldenburg had been transmuted by the free acceptance of natural forces as well as by an idiosyncratic employment of a formalist bias. This is especially evident in the *Metronomic Irregularities,* one version of which was included in the *Eccentric Abstraction* exhibition. It is clear that from 1966 on Eva Hesse was at pains to answer to the total style of Minimalism. The notebooks begin to record exact mathematical notations, axioms, and definitions. Ultimately these notations will supply her with a repertoire of titles, just as earlier her notes filled with biological and genetic phraseology, had provided the names of many "eccentric" works. Transposing notions of graph, seriality, modularity, and checkerboard structure, Hesse, in the *Metronomic Irregularities,* for example, acted as if she were eviscerating a three-dimensional tic-tac-toe board placing diagrammatic figures one beside the other and

[9] The essay gained a broader audience when it was republished in *Minimal Art: A Critical Anthology*, New York, Dutton, 1968, ed. Gregory Battcock. Eventually to view Hesse's work as a fusion of contradictions became the standard way of handling it critically. In the exhibition catalogue, *Anti-Illusion: Procedure/Materials* written by Marcia Tucker and James Monte for the influential exhibition of the same name held at the Whitney Museum of American Art between May and July 1969 (at which Post-Minimalism was awarded museological and historical prestige after a studio and gallery existence), James Monte wrote of Hesse's work in dualistic terms concluding with the observation that "whether her works are diminutive and intended to be hand-held, or made on a grand scale, her finest sculpture has a unique animus which is anthropomorphic in quality if not in intent. Her work alludes to human characteristics such as the softness of skin, the swell of muscle or the indeterminate color of flesh fading under clothing after exposure to summer sun." Distressed by a facile dualistic argument, Lawrence Alloway observed in the exhibition catalogue *Tony Delap/Frank Gallo/Eve Hesse: Trio* (Owens-Corning Fiberglass Center, New York City, May-September 1970), that "one of our ingrained habits of thought is to arrange the world dualistically, in such pairs as right and wrong, us and them, North and South. In art, Classical and Romantic is one such pair; geometric and organic form is another. It is a sign of Hesse's originality, and to some people a cause of difficulty, that her sculptures do not conform to the latter pair. For example, the sculptures have a curious way of consisting of modular units, which, even as we recognize their repetition, become knotted and collapsed. John Perrault described her work as 'surreal serialism,' ["Art," *The Village Voice,* November 28, 1968] a phrase that catches very well the ceaseless play of systematic and organic elements in her work."

then, as if sewing or threading, determining rational junctures for hanging the boards together. This decision combines the firmness of Minimalist ontology with the erratic inconsistency of eccentric interconnection, an impression facilitated by the cotton-covered wires which act as the threading agent.

Hesse's serialist presentations were often string-wrapped semispheric reliefs, first realized in the important *Ishtar* of 1965 (Fig. 10), from which dangled at each mound's center, a length of line: the erotic abstraction of the earlier breastlike configurations treated in a protomodular sequence. Such reliefs were worked out in numerous geometrical drawings which emphasized circles deployed one beside the other in grid formation. This kind of delicate drawing continued throughout the remainder of her life, although in the last year the elements are much enlarged and handled more brusquely.[10]

Eva Hesse's drawing during 1966-68 emphasized modular and grid arrangements alluding, in this way, to the high regard in which Agnes Martin was held, although the delicacy of wash application in Hesse's serial composition — as well as the single motif in isolation — equally refers to the target figure in the Jasper Johns encaustic paintings of the mid-50's.

The controlled gradations of gray in this moment correspond in the artist's mind to an absurdist view of the world — an absurdness of the kind she admitted to experiencing in the work of, among others, Duchamp, Johns, and Andre, an absurdness which had been corroborated by the events of her life. It is tragically ironic, for example, that as a child, Hesse had been destined for German extermination camps, and in 1965 had found her first public there. This kind of world view is expressed throughout an exchange in a taped interview made during a three-day remission in the artist's last days, when Hesse was both aware of her rank as an artist and that her

[10] In April of 1970, while reviewing an exhibition of drawings held at the Fischbach Gallery, Hilton Kramer gathered that the works were "drawn from the structure of windows ... all soft-focus and atmospheric, at times Whistlerian." (*The New York Times*, April 18, 1970). This return to a broader drawing style may be regarded as a reemergence of the Expressionism of her drawings seen as early as 1961 when, shortly after graduation from the Yale University School of Fine Arts, Hesse joined a three-artists' show with Donald Berry and Harold Jacobs (The John Heller Gallery, New York City, April-May 1961) at which she was represented by a set of gesturally based drawings.

54

life was draining from her, perhaps the most tragic irony of all. "If something is absurd," she said, "it is much more exaggerated, much more absurd if it's repeated." [11]

The "Eccentric Abstraction" phase is a fertile period, dominated by such masterpieces as *Ennead* (Fig. 9) and *Hang-Up* (Fig. 11), the two works which gained in prestige for having been reproduced and exhibited widely. The meandering lengths of string in the *Ennead* refer to a numerical system, an ennead, a term derived from Greek to indicate groups of nine elements, although it also has a subordinate meaning relating to the mythology of the ancients. Moreover, the name carries with it an aural association with the name of Aeneas, Virgil's hero. The confused skeining of gravity-tugged lines suggests his wanderings. But, of course, the primary experience is mathematically based on a grid structure of dark, nipplelike, buttons.

Such mythologizing inferences are not gratuitous. Several works carry classical overtones. The great *Vinculum I* of the last year specifically refers to unifying bonds or links and to the bracketing symbol of compound qualities in a mathematical expression. But it also carries with it the forceful name of Vulcan smashing at his forge and the idea of the vincible (or the invincible) as well. *Laocoön* of 1966 takes the name of the Trojan priest whose warnings against the wooden horse of the Greeks went unheeded, and who was strangled with his sons by the avenging serpents of Athena and Apollo. *Ishtar* of 1965, with its ten double rows of hemispheres ranging from light to dark gray with each dome dangling a length of cord from its center, takes its name from a multibreasted mother goddess of Babylonian worship, the Aphrodite of the Ephesians.

Hesse's journals intersperse mathematical and mythological information, recorded because it corresponded to real working problems. She is an artist for whom the title of the work is deeply considered and exactly to the point.

Ennead was a central achievement for the artist.

[11] Cindy Nemser, "An Interview with Eva Hesse," *Artforum*, May 1970, p. 62.

It started out perfectly symmetrical at the top and everything was perfectly planned. The strings were gradated in color as well as the board from which they came. Yet it ended up in a jumble of string... The strings were very soft and each came from one of the circles. Although I wove the strings equally in the back (in the back of the piece you can see how equal they are) and it could be "arranged" to be perfect, since they are all the same length, as soon as they started falling down they went different ways and as they got further to the ground the more chaotic they got...[12]

But the chaos came to be valued as it determined the style of much of the last year's work with its sense of arrested clotting and insect-flight webwork such as we find in *Right After*.

Dearer to Hesse than the *Ennead* was *Hang-Up*. The artist identified it as "the most important early statement I made. It was the first time my idea of absurdity of extreme feeling came through."

It was a huge piece, six feet by seven feet. The construction is really very naive, it is a frame, ostensibly, and it sits on the wall with a very thin, strong but easily bent, rod that comes out of it. The frame is all cord and rope. It's all tied up like a hospital bandage — as if someone broke an arm. The whole thing is absolutely rigid, neat cord around the entire thing... It is extreme and that is why I like it and don't like it. It's so absurd to have that long thin metal rod coming out of that structure. And it comes out a lot, about ten or eleven feet out, and what is it coming out of? It is coming out of this frame, something and yet nothing and — oh, more absurdity!! — it's very, very finely done. The colors on the frame were carefully gradated from light to dark — the whole thing is ludicrous. It is the most ridiculous structure I have ever made and that is why it is really good. It has a kind of depth or soul or absurdity or life or meaning or feeling or intellect that I want to get... I know there is nothing unconnected in this world, but if art can stand by itself,

[12] *Ibid.*

56

these were really alone and there was no one doing anything like that at the time.[13]

The work was, as well, the focus of a long description in a New York Letter in which Lucy Lippard further commented on the issues of the *Eccentric Abstraction* exhibition:

Eva Hesse's gray sculptures depart from a... fanaticism that has absorbed rather than been conquered by a strong formal sense... Her most impressive work is Hang-Up, *an empty six-foot "frame" on the wall, from which emerges a huge narrow loop. Both elements are tightly wrapped, or bandaged, in cloth or cord, and graded, not obviously, from a very light gray at the upper left corner of the frame and a near black toward the right or the loop. Free and confined, regular and irregular, rectangular and unmanageable, the components exist in a peculiar idiosyncratic space. There is a yearning quality of suppression and release as well as pathos and humor to this strange relief that should reach a broad audience.*[14]

Despite the biomorphic inferences in Hesse's work she did come to grips with the Minimalist issue — but in a highly peculiar way. Facing up to Minimalism meant that Hesse had to formulate a special view of the cube in sculpture and the square in painting. These elements, while providing a compositional type which employed modular sequences and seriality, nonetheless allowed Hesse to fashion her own vision of counter-Cubist structure. They permitted a composition in which no element functioned preferentially to any other — taste and sensibility being, in Hesse's case, always imbued with biomorphic inferences and the mark of straight natural force.[15] The solution was easy for Hesse. In the *Accession* series of

[13] *Ibid.*
[14] Lucy Lippard, "An Impure Situation; New York and Philadelphia Letter," *Art International,* May 1966, p. 64. The issues dealt with in footnote 9 apply here.
[15] These ideas, except for the elements of biomorphic inference and the natural force, were worked out in the modular structures of Sol LeWitt whose influence on the Minimalist movement was enormous. When given a retrospective exhibition at the Haags Gemeente Museum, July-August 1970, he honored the memory of his friend Eva Hesse by dedicating the catalogue and exhibition to her.

1967 (Fig. 12) — "Accession, increased by something added," she once noted in the "art-notes" — Hesse turned to the conventional cube of Minimalism (cf. Le Witt's modular frames, Smith's hollow *Die,* Andre's daislike paltforms or Serra's one ton lead squares). In the first *Accession,* Hesse built a galvanized steel frame — this solution is closest to Le Witt (Fig. 13) — and laced the five faces up from the base with plastic tubing leaving the uppermost face open. The interior loops were then slashed on the inside in a manner similar to the way that woolen loops are clipped in the manufacture of hooked rugs producing a tactile cube, bumpy yet smooth on the exterior, but brushy within where the cut tubing still projected (Fig. 14). The tactile discovery was important and the artist repeated it three times, employing a casing of fiberglass from which the plastic tubing extruded in the subsequent versions. "That huge box I did in 1967, I called it *Accession.* I did it first in metal, then in fiberglass. Outside it takes the form of a square, a perfect square and the outside is very clear. The inside, however, looks amazingly chaotic, although it is the same piece of hose going through... It's too beautiful, like a gem, and too right."[16]

Even in Hesse's most serialized conceptions it was the sense of the hand, of making and doing, which took precedence. Compared to more purely theoretical Minimalists ("Solipsists" Mel Bochner called them[17]) — LeWitt, Judd, Morris — Hesse's version of seriality and modularity appears more playful, even "incorrect." The smaller floor pieces often seem little more than primitive checkerboards, games, childlike counting exercises quite unlike the metal and plexiglas monuments which we take to be the shining examples of Minimalism during its sway. In Hesse's work structural continuity is often disguised, rendered insensible despite the serialization. A key work is *Expanded Expansion* of 1969, in which fiberglass and rubberized cheesecloth — industrial materials which allow for the mark of the hand — permit a variation even though each of the elements or screens which compose it is fixed to the

[16] Nemser, *op. cit.,* p. 62.
[17] Mel Bochner, "Serial Art Systems: Solipsism," first published in *Arts Magazine,* Summer 1967, republished in Battcock, *op. cit.*

other. "I think what confuses people in a piece like this is that it's so silly and yet it is made fairly well. Its ridiculous quality is contradicted by its definite concern about its presentation."[18]

Such spatial concerns, curtainlike possibilities and serial hints remain as well in the rubberized fiberglass work called *Contingent* (Fig. 15), shown at the Finch College assembly *Art in Process IV*, held in the winter of 1969 and reproduced on the cover of *Artforum* in May 1970. Writing about the effect that this work had on him, Philip Leider, then the editor of the magazine, observed that it was "probably the only piece in the exhibit that had nothing to scream about, no manifesto to adhere to and no theory to back it. It is Abstract Expressionist sculpture of a higher order than I would have thought possible, an inspiration that I would not have thought available to a younger artist. Her work struck me as being as stumbling and as deeply felt, as expressive and as inchoate as, say, a work like Pollock's *She Wolf*." [19]

"Sickness" broke the hold of Minimalism and opened Hesse to a more sublime vision, one freed of local theory. It induced the most extreme reaches of Eva Hesse's work. Masterpieces dominate the last year. With the exception of the two versions of *Vinculum*, I think Leider was right in noting that the last phase of Hesse was one which was essentially Abstract Expressionist in its larger premises. Whereas *Vinculum I*, in which unified stretcherlike supports of fiberglass rectangles continue Minimalist seriality, the most expressive work of Hesse at this time deals with a skeining and interwining of forms, that in some measure recalls the Abstract Expressionist sculpture of wire and metal tubing made by Claire Falkenstein of the mid-1950's through the early '60's.[20]

The prototype of *Contingent* and its eight-part mock-up were included at the Finch College exhibition. Between the execution of the work and its viewing in the winter, Eva Hesse had succumbed

[18] Nemser, *op. cit.*, p. 62.
[19] *Artforum*, February 1970, p. 70.
[20] I also think that Lucio Fontana's savagely rent earthen and metal spheres of the early '60's were an important influence on Eva Hesse. Since she spent so much time in Europe she could not have failed to be aware of his work. The fiberglass variations of *Repetition 19, III*, with its grouped and clustered scatterings, and the more chaotically organized *Tori* of 1969, made of nine bucketlike units torn on the sides seem to indicate a knowledge of Fontana.

to the effects of a tumor discovered to be growing in her brain. A suite of operations began. She was able, however, to attend the opening festivities of the exhibition in December of 1969. "Anyway, did go to Finch — and it was an opening and I was told how great my piece was. I enjoyed myself despite feeling lousy," she noted in the manuscript describing the course of her disease and hospitalization. She also read the ambitious statement she had contributed to the catalogue concerning the *Contingent* series. In it she describes the experience of going beyond Post-Minimalism, beyond the local style, beyond art. Her words are only paralleled by the vision of art that was experienced by the first generation of Abstract Expressionists. Anyone who has studied Newman's "The Sublime is Now," Clyfford Still's confession in which he describes the discovery of an art devoid of any distorting premise of Western culture or Ad Reinhardt's statements regarding an iconic art of total placelessness, must be struck by the similarity of voice in Eva Hesse's statement.

> *... not painting, not sculpture...*
> *I remember I wanted to get to non art, non connotive,*
> *non anthropomorphic, non geometric, non nothing,*
> *everything, but of another kind, vision, sort.*
> *from a total other reference point. is*
> *it possible?*
> *I have learned anything is possible. I know that.*
> *that vision or concept will come through*
> *total risk,*
> *freedom, discipline.*
> *I will do it.*
> *...it's not the new. it is what is yet not known,*
> *thought, seen, touched but really what is not.*
> *and that is.*[21]

[21] Eva Hesse, a catalogue statement for *Art in Process IV*, Finch College Museum of Art, Contemporary Wing, New York City, December 1969-January 1970, n. p. Hesse's catalogue entry was transcribed from a tape recording.

Two options were left to Eva Hesse; one a purely physical art, the other an intellectual-mystical art. The latter conjunction is startling, but it is meant in the way that Still's is a mystical-intellectual art, or more clearly, Reinhardt's.

The first option is affecting but, however astonishing the last works are, they still may fall within the purview of the organic evolution of Hesse's career. Mel Bochner is probably correct in thinking, when on seeing *Connection* in progress in Hesse's studio, the fiberglass over polyethelene was being worked as a kind of physical exercise, squashing, or hand-over-hand manipulation, executed largely as the physical expression still open to the artist at this time. But certainly, as he equally realizes, this is not the central issue. Much of Hesse's work of the final year was accomplished through the direction of student assistants selected from her classes at the School of Visual Arts in New York City. She was a highly admired teacher and was instrumental in formulating what might be called a "School of Visual Arts style." It first received expression in the studios of that institution and, spurred by burgeoning interest in Eva Hesse's work, was quickly absorbed into mainstream vanguardism.

Similarly the untitled work, familiarly called *7 Poles,* was not executed as an act of physical therapy. Its familiar name is revealing: Pollock's *Blue Poles* is the source. In the same way that Pollock was at last able to get past history and culture to a kind of prehistory, the ultimate stylelessness which both Pollock and Newman regarded as the equal, if not the superior of the art of "culture", so too does Hesse's *7 Poles* have the bedrock fundamentalism of paleolithic sources.

The second option projects Abstract Expressionist "all-over" into actual space, a cosmos so to speak, an attitude realized in the *Right After* works (Fig. 16). During the creation of the *Contingent* series Hesse had undergone three surgical interventions. After these she returned to a piece that had hung fire in her studio for more than a year, suddenly recognizing in it a number of possibilities that had eluded her before (Fig. 17), a work resumed immediately upon her release from the hospital. "The idea totalled before I was sick. The piece was strung in my studio for a whole

61

year... I wanted to totally throw myself into a vision that I would have to adjust to and learn to understand." [22]

It was while working on the rope piece that Eva Hesse gained her widest, if unaware, public as she was photographed through this work for *Life* magazine in connection with an article on Post-Minimalism that was called "Drip Art," acknowledging in this way the resurgence of Abstract Expressionist qualities in much of the newer painting and sculpture of 1968-1970.[23]

Eva Hesse was no longer making easy or ingratiating Abstract Expressionist statements — she had moved beyond considerations of style. "The decorative is the only art sin" she once said. *Life* magazine had described the rope version of *Right After* as an unfinished work. Yet in the article Eva Hesse is quoted as saying that "this piece is very ordered... Chaos can be as structured as non-chaos. That we know from Jackson Pollock."

"...I remember I wanted to get to non art, non connotive, non anthropomorphic, non geometric, non nothing, everything, but another kind of vision, sort..." The voice no longer speaks to us, but beyond us. In her last year Eva Hesse discovered the sublime, another place and time at which the critic only guesses and where the historian maps only these superficial paths. She had left her Post-Minimalist colleagues and friends, and joined Newman, Still, Pollock, and Reinhardt.

[22] Nemser, *op. cit.*, p. 63.
[23] "Drip Art," *Life*, February 27, 1970, pp. 62-66. Lynda Benglis, Richard Van Buren and Richard Serra were also included in this photo essay.

THE ART OF RICHARD TUTTLE

In 1967 Richard Tuttle dyed a group of irregularly shaped and hemmed canvas octagons in various pots of Tintex. Shortly thereafter, when they had dried and had been hand smoothed, they were limply pinned to the wall or laid upon the floor (Fig. 18). It did not matter much in which way they were hung or where on the floor they were spread. (Exhibition photographs taken of the works are inscribed on the back "to be held any way.") The issue at hand was not primarily about figure/ground relationships (an extenuation of Jean Arp's collages "arranged according to the laws of chance"), nor were Tuttle's octagons simply still more artifacts in a long line of Dada-inspired work, although their roots in Dada, and in Arp particularly, cannot be denied.

Serious criticism attempted to locate Tuttle among those artists interested in confounding divisions between sculpture and painting. He was thought of as fusing painting and sculpture into a new polymorph in which sheer tangibility and blunt materiality alluded to sculpture while the character of soaked-in-paint bespoke painting. Some writers assumed that Tuttle derived from an aspect of field painting as it was then known in the work of Frankenthaler, Louis, Noland and Olitski.

One critic, Emily Wasserman, attempted more. In addition to recognizing Tuttle's relationship to field painting, she also referred to an evolution out of the artist's earlier wooden reliefs and indicated in which way Tuttle's peculiar hermetism—"withdrawn" she said—differed from other equally oblique and factual artists, in particular Brice Marden, David Novros, Don Judd and Carl Andre. In Tuttle's work she observed "...a concern for the sensuous and for a kind of chromatic fantasy... which are levelly denied by the work and thinking of his colleagues."[1]

[1] Emily Wasserman, "Richard Tuttle," *Artforum*, March 1968, pp. 56-7. Several important catalogs credit me with this perspicacious review. The catalogs *Live In Your Head, When Attitudes Become Form*, Kunsthalle; Bern, March-April 1969, and *Anti-Illusion: Procedures/Materials*, Whitney Museum, 1969, are in error in this respect.

For my part, I prefer to regard Tuttle's work in terms of its own organic evolution and the artist's personal experiences. Tuttle was born in Rahway, New Jersey, in 1941. His paternal line traces American roots to the early 17th century. The Tuttles had come here to be small land-owners and originally cultivated farms near where Trinity Church now stands. Some Tuttles prospered. Others, like the artist's branch, did not. Richard Tuttle grew up in Roselle, New Jersey, "a rather poor town," the second son of four children. He went to Roselle High, part of a class that was unusual only because it was "brighter than most." The family was conservative. His grandmother, on his father's side, set a family tone of fundamentalist Presbyterianism. The artist's grandfather was "something of a dilettante who wrote, drew and experimented." He would make gifts of his drawings to his grandchildren on the condition that they would continue a square-to-square grid enlargement with which the drawing would be accompanied and which had already been begun. At length, Tuttle got to college, Trinity College, Hartford, an Episcopalian school in which the artist found "little outlet for doing any creative work." During Tuttle's student days an exhibition at the Wadsworth Atheneum in Hartford, called "Black, White, and Grey," made a deep impression on the student, as did Agnes Martin, who had gone up to the museum to speak in connection with the exhibition. Shortly thereafter, Tuttle contacted Agnes Martin in New York to ask whether he might purchase one of her drawings. This inquiry marked the beginning of an important friendship. The highly ascetic, Minimalist persuasion of Martin's work is curious to admit in Tuttle at the time, although there may be the dim memory of grandfather's grids in all of this.

Very little remains from Tuttle's student days. He designed sets for student productions of *End Game, Zoo Story* and *American Dream*. (The emphasis on Edward Albee is partly explained by the fact that the author is an alumnus of Trinity.) Tuttle also designed two senior yearbooks. In examining *The Trinity Ivy* of 1963, the year Tuttle graduated and enlisted in the Air Force, one is struck by the nervous and delicate wood-block illustrations, several are full page. They deal in landscape ideas—vortices of solar energy and softer views of streams and border shrubbery. The wood-block illustrations have an

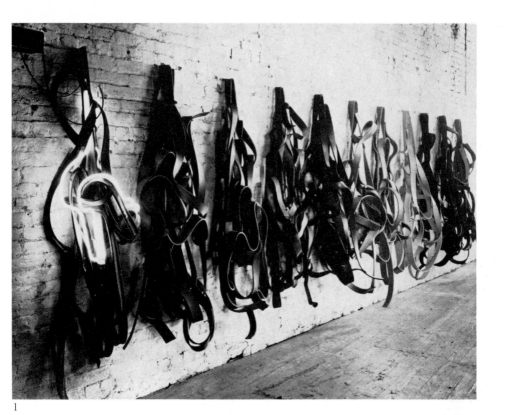

1

2

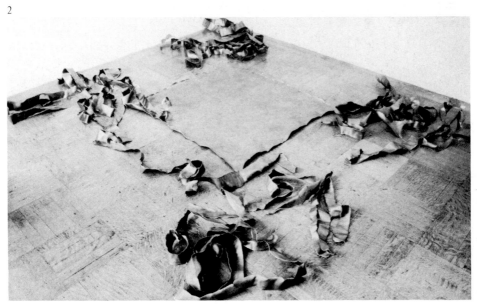

1. Richard Serra, Untitled, 1967.
2. Richard Serra, Tearing Lead, 1968.

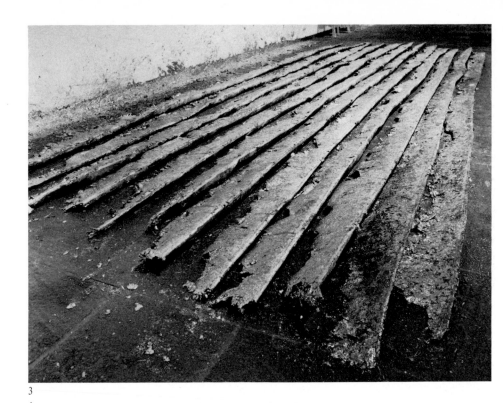

3

4

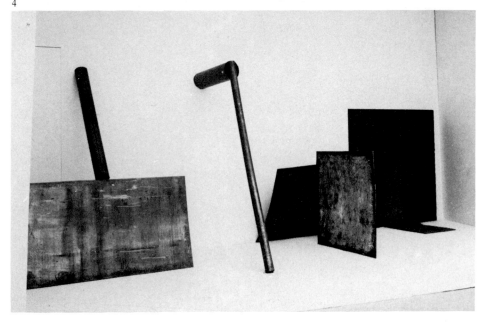

3. Richard Serra, Casting, 1969.
4. Richard Serra, Prop Pieces, 1969.

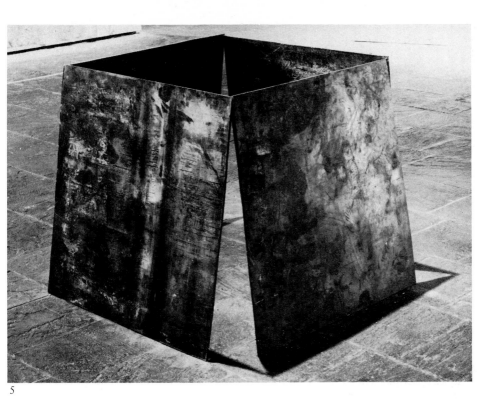

5

6

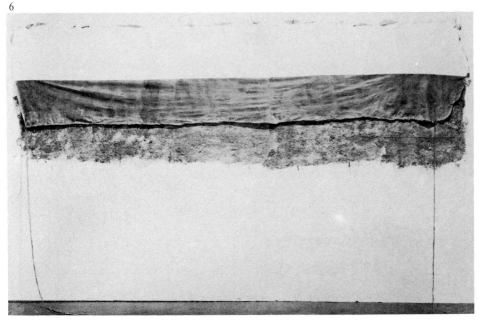

5. Richard Serra, One Ton Prop, House of Cards, 1969.
6. Keith Sonnier, Mustee #2, 1968.

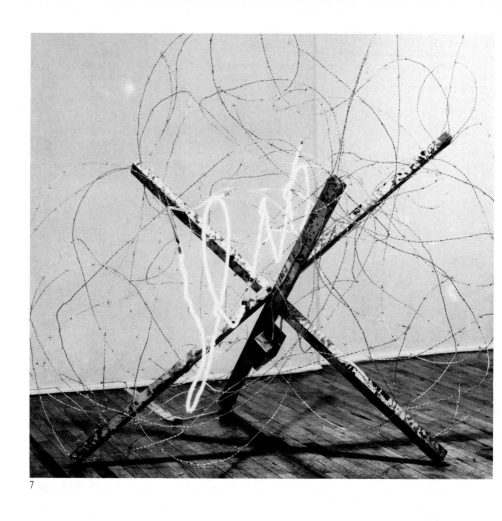

7

7. James Rosenquist, Untitled, called "Tumbleweed", 1963.

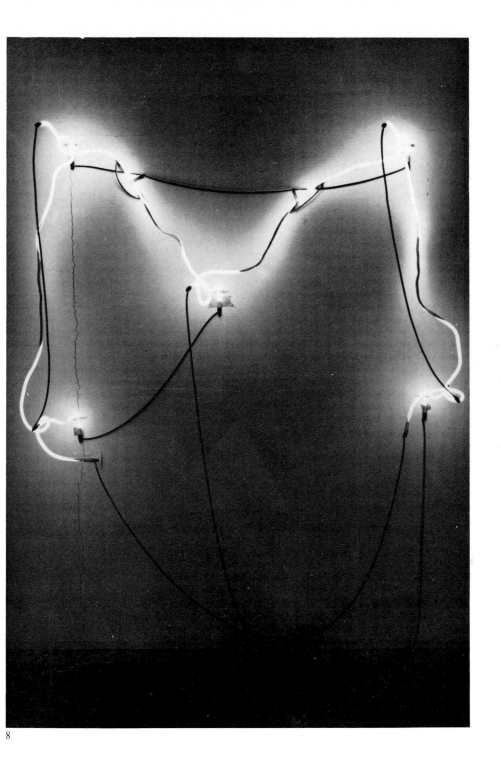

8

8. Keith Sonnier, Untitled, 1969.

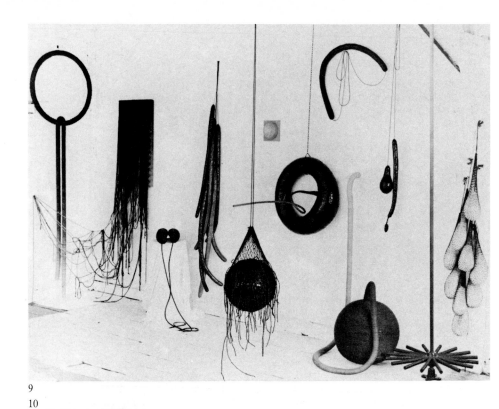

9
10

9. Eva Hesse, Studio view, works 1965-66.
10. Eva Hesse, Ishtar, 1965.

11

11. Eva Hesse, Hang Up, 1966.

12

12. Eva Hesse, Accession, 1967.

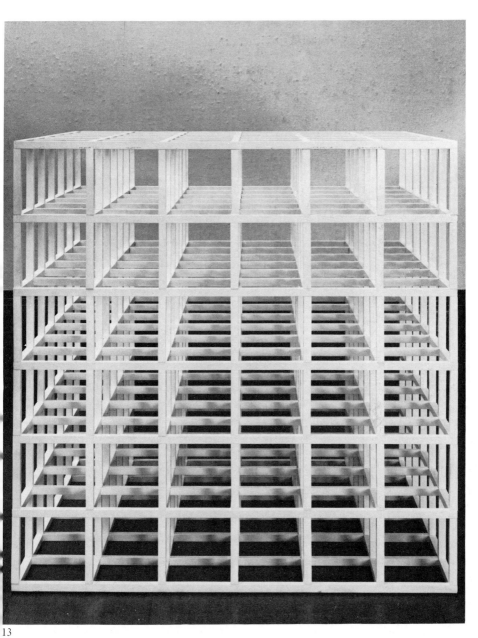

13. Sol LeWitt, Open Modular Cube, 1966.

14

14. Eva Hesse, Accession II, 1967, detail of interior corner.

15

15. Eva Hesse, Contingent, 1969, detail.

16

16. Eva Hesse, Right After, 1969.

17

17. Eva Hesse, Untitled, 1969-70.

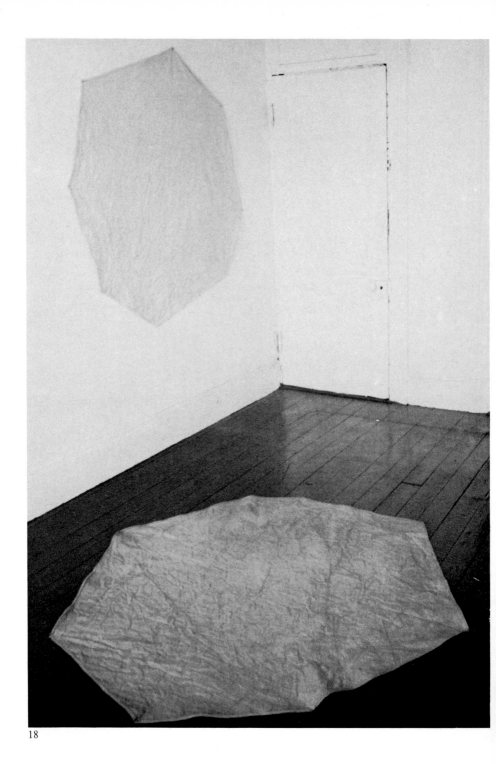

18

18. Richard Tuttle, Cloth Octagons, 1967.

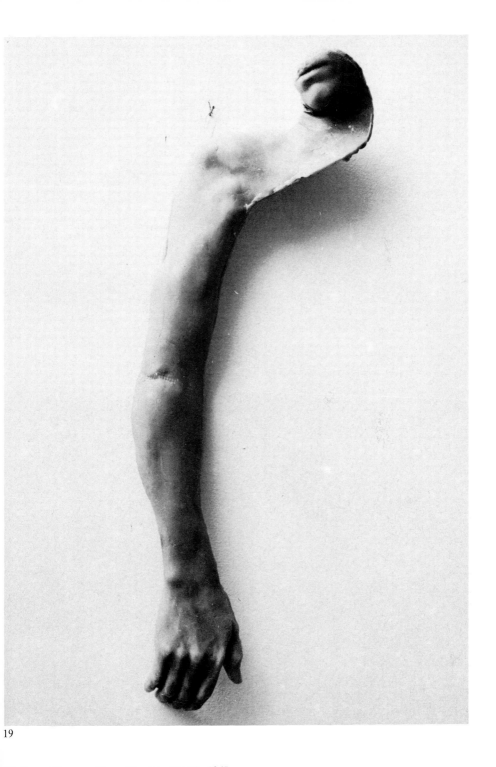

19

19. Bruce Nauman, From Hand to Mouth, 1967.

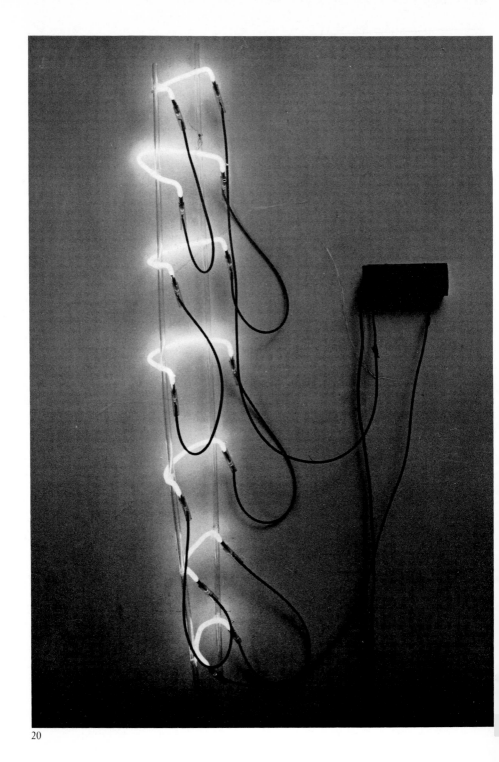

20

20. Bruce Nauman, Neon Templates of the Left Half of My Body Taken at 10 Inch Intervals, 1966.

expressionizing nostalgia to them that is widespread in semi-abstraction, a nostalgia that is perhaps at odds with the detachment of the cloth octagons—except, perhaps, for the latter's depressed, washed-out range of color.

Tuttle's experience with the Air Force exteriorized a break with the past and the mature person suddenly emerges from this episode. Tuttle describes a training that lasted six weeks. Three were spent as an underclassman, three as an upperclassman. The latter's duties included assisting in the "indoctrination" of the underclassmen. Training was completed by undergoing a machine-scored examination, the answers to which, in Tuttle's view, were "perfect median responses."

After "indoctrination" it was unimaginable to score below 80 although a person of military aptitude might score as high as 83. "I blew the machine. I did it on purpose. I got 2. I was everything for the authorities. Catatonic. They said I never could enter military or civilian employment for the rest of my life." At the end of six weeks of training Tuttle was honorably discharged. He was 22. He returned to New York and found modest employment as an assistant at the Betty Parsons Gallery, where he earned enough on which to subsist and still provide sufficient time to work on his painting.

Between 1963 and 1965 Tuttle began to construct things, "often little things, such as 3-inch paper cubes that fit neatly into the palm of your hand." The paper cubes stressed issues of incision, slotting, folding and cutting—of constructing—but with an oddly infant-like thrust to them quite different from the small, colored celluloid cubes of Lucas Samaras, which were shown during the same period at the now defunct Green Gallery. The 1965 wooden reliefs continued to explore these issues but exaggerated their consciously infantile quotient. The constructions were hollow, perhaps two inches thick. The reliefs were essentially ideograms of landscape or nature, treated in slightly amorphous contours and painted in single colors. They were supported by a nail which entered the work through a small hole in the back. The natural shorthand of the shapes—*Hill, Torso, Water, Fire*—were painted the blunt coloristic equivalent of the sense of the piece. *Water* was blue, *Fire* red, *Hill* grey and so on. In addition to their Arp-like qualities, the pieces also

resembled the elements of a child's fitted jigsaw puzzle—large, squat, simplified shapes. The pieces were exhibited at the Betty Parsons Gallery in September, 1965 and several of the works were laid directly on the floor, the most extreme option open to contemporary sculpture working against the tradition of the vertical monolith.

Of the motifs, perhaps *Hill* is the most important. It describes a single, rainbow-like arc on the wall. A drawing of 1963, *Elephant,* nervously depicts the arc of a vast and possibly protective elephantine mound or hump. This work is still drawn in terms of the delicate Trinity wood blocks, although its ritualizing "feel" is quite new in Tuttle's work.

The relationship of the 1965 ideogrammatic reliefs to the immensely important sculptural attitudes that were emerging in the 1960s is, of course, of greater moment. Constructivist practice—the attitude whereby the method of affixing element to element takes precedence over all other considerations in the execution of a work—first arose in Picasso's Synthetic Cubist assemblages of still-life material in 1913-1914. The intellectual artists of the Russian Revolution elevated this attitude into a style that came itself to be known as Constructivism. However remarkable the accruings possible to carving and modeling, Constructivist practice made evident the unmodernity of these earlier sculptural attitudes. It was not until the late '50s and early '60s that a viable alternative to Constructivism came into being, without, it is evident, supplanting it. It is a practice which receives its predicates from pictorial issues, from painting. There are numerous aspects of this radical option. There are, for example, sculptures which take on the color, texture and even the evanescence of painting and collage—Keith Sonnier's for example. Even more important than this, for Tuttle's work, is the kind of pictorializing sculpture which results when the depicted contour and the real contour of an image are congruent. This may take a representational form—a Flag by Johns—or a non-representational one—a lacquered plank by John McCracken. Such a pictorializing sculptural option—in part the result of Pop, in part the result of Minimalism—corresponds to the ideogrammatic reliefs of Tuttle. Of course there had been antecedents. One of the reasons

that Arp is once more so highly esteemed is that his painted wooden reliefs, particularly those made through the 1920s, articulate a similar attitude.[2] The substantive alignment of Tuttle's reliefs of 1965 with the critical sculptural issues of the early 1960s are striking and important. But, in themselves, I find the reliefs facile and disappointing. History, however, inaugurates a kind of *force majeure* and after the experience of the cloth octagons, and now the paper ones, the ideogrammatic reliefs, wall hung, unitary, displaceable at the possessor's discretion, theoretically appear more interesting. Hindsight has added much, particularly with regard to the issues which are still being argued in the cloth and paper pieces. As Tuttle told me, "I started out making thick wood pieces and they got thinner and thinner. They turned into cloth. And now I am doing paper."

I recently visited the artist in his midtown West Side studio, an anonymous neighborhood for New York, nowhere. The studio occupies the top floor of a tenement. It is painted a dingy white and is largely empty except for essentials, a table, a chair. Books and food are stored in the same cupboard.

The cloth and the (newer) paper octagons may be affixed limply to the wall, like garments, and they share formal concerns with the work of Sonnier and Robert Morris. They have less in common with Robert Ryman, with whose work one might be tempted at first to compare them. Ryman's papers emphasize surface; their white brushed surfaces reiterate the nature of the wall and the two-dimensionality of the whole undertaking. In the newer Rymans the

[2] Tuttle acknowledges his debt to Arp although he notes that he became aware of Arp only after the reliefs had been made. This cannot deny the derivation, however, since Arp's attitudes have long been subsumed into wide artistic consciousness. Tuttle, therefore, could have assimilated Arp's thinking from thousands of sources, not one of them being Arp himself. Moreover, the Arps at the Museum of Modern Art were known to Tuttle even if he had not thought about them especially.
There is still another art of the early 1960s to which Tuttle's bears striking resemblance, although in this case it is highly probable that Tuttle was unaware of it. I refer to the singularly important and neglected *Concetti Spaziali* of Lucio Fontana, particularly those reliefs whose surface is but little scored, or lacerated. Fontana was shown at the Martha Jackson Gallery in 1961 although he had been widely exhibited in Europe, with a long career played out in Italy, although he had been born in Argentina. And the similarity of Tuttle's work to that of Ellsworth Kelly is beyond dispute, a connection perhaps emphasized by Agnes Martin's historical association with Kelly when they and several other artists shared an old loft building at Coentes Slip in the late 1950s.

urge toward seriality has been replaced by other methods which still conform to emphasizing the nature of the wall-like surface, such as brushing around the square module so that the square shape is negatively expressed by the removal of the square template. There may be some affiliation, however, in the use of masking tape. These support the recent Rymans and they are the necessary, though hidden, support of Tuttle's paper octagons.

The octagons had been cut one after the other. Tuttle considered each new one an improvement over the last. He remembered the sequence. The earlier ones tended to have a more pronounced symmetry and axiality, a familiarness. One could easily suppose which part of the octagon was the bottom. It tended to have longer sides. It was heavier. The later octagons were more eccentric, employing greater numbers of variegated lengths to the sides and more unanticipated interior angles.

"The later ones are better," said Tuttle.

"I don't know if I agree with you, although I admit that they are less familiar."

"I would like to make all six octagons the same. But I'll never do that."

On the mantelpiece of a closed fireplace of what is now the kitchen lay a thin piece of wood through which many nails had carefully been driven, their exposed points spelling TUTTLE.

"Are you going to perforate your signature?"

"I was thinking about it."

"Do you sign the pieces?"

"Signing is equal to destroying the piece. It is no longer a piece of paper. It violates its purity. Here, I'll show you." Tuttle wrote his name with a felt-tip pen large across the face of one of the paper octagons.

"Purity" seems, in large measure, to be a function of the viewer rather than of the work: "They (the papers) set the limits of a person's appreciation. They are disposable and not disposable. Even Rembrandts are disposable. It all depends on the limits of a person's appreciation."

In the end, even the purity of the white paper is questionable. "I

have a hatred for this white thing. I can't stand the kind of purity that white implies in our environment. But the kind of purity that comes out of the complete electrical functioning of the whole human being—that's the kind of purity I aspire to. To be free of senses and the intellect. I would really like to be ignorant." The Zen overtones in these sentiments are not incidental. After the success of his cloth exhibition, Tuttle went to Japan for a year, visiting the villages rather than the major cities. He plans to return this year; the two books on his mantelpiece were a Japanese-English dictionary and a Japanese grammar. He does not encourage, however, a description of his own artistic ambitions in terms of his involvement in Oriental attitudes. "Any conceptions that Americans can have about Oriental ideas are really still about their own ideas..."

I had copied some inscriptions that Tuttle had made on working drawings for the cloth octagons. One read, "This is a working drawing of a more or less isometric house which made an empty house... only seven sides." Another read, "This is a drawing which ended the drawing of the work; the idea came out later in an eight side dull red piece."

"That was a joke," said Tuttle. "They were drawn after the pieces were made. The drawings showed me what I didn't want to know."

BRUCE NAUMAN:
ANOTHER KIND OF REASONING

Generally, they were pieces of rubber shower caps, which I cut up and glued together and which had no special shape. At the end of each piece there were strings that one attached to the four corners of the room. Then, when one came in the room, one couldn't walk around, because of the strings! The length of the strings could be varied; the form was ad libitum. That's what interested me. This game lasted three or four years, but the rubber rotted, and it disappeared.

... Marcel Duchamp (in conversation with Pierre Cabanne)

Bruce Nauman's career has been based almost exclusively in California. A lack of vigorous firsthand acquaintance with this ambience has made me acutely conscious of — though not necessarily sympathetic to — certain Californian qualities, which I often sense as outlandish. The central Californian characteristic seems to me to be a pervading narcissism expressed through mirroring and colorism predicated in a technically oriented automotive culture and a geographical metaphor. I think this originates and has been intensified by the comparative smallness of the scene, a feature which has tended to a stylistic inbreeding. This is a quality, not necessarily pejorative, historically noted in all regional art centers. It can be said as easily of London art today as of Dutch art at the height of the de Stijl movement.

The chief distinction separating the arts of the two seaboards, at least through the end of the '60s, appears to be between an art concerned with the *characterological* functionings of its *creators* (California) and the *morphological* processes of *creation* (New York.) Tersely, the distinction is between "being" and "doing." Despite the broadness of this distinction, it permits one to close in on Nauman who, if nothing else, stresses confession, autobiography,

70

and narcissism — certainly in the work after 1966, when Nauman's art seems or seemed primarily to be about the artist's ability to reconstruct himself before an audience. Such a theatrical intention is congruent in many respects with those episodes that have been variously named Process, Phenomenological (Marcia Tucker once punned "pheNAUMANology") or Conceptual art, and which I group under the umbrella term post-Minimalism. But in Nauman's case it is essentially a received art, stemming from Marcel Duchamp and given vitally important refurbishment in the work of Jasper Johns, in whose tradition Nauman continued to be nourished, at least through the end of 1969.

Fidel Danieli, a California critic who wrote the first intelligent article on Nauman, observed that Nauman's work "would appear at first exposure to be a vaguely repulsive caprice." [1] Danieli also affiliated Nauman to Marcel Duchamp (the *Green Box*) and to Jasper Johns (the *Skin Print* drawings). He recognized that Nauman was not above a certain duplicity, citing as an example of "cheating" the knees referred to in the *Wax Block with the Impressions of the Knees of Five Famous Artists,* 1966, which the critic knew to be impressions of the artist's own knees. Nor was Danieli deceived by the arch double-dealing of the title, a problem to which I will return. In a like manner, the romantic and mystical stance of the banners and neons (e.g., "The artist in an amazing luminous fountain"), were seen for what they were, namely "being poetical in a beautiful, self-flattering way."

Subsequent criticism seems to have consistently stressed the theme of Nauman's relation to Duchamp and Johns. In a statement by the artist published in the catalogue *American Sculpture of the Sixties* (Los Angeles County Museum, 1967), Nauman also recognized a derivation in Dadaism:

> I suppose some work has to do in part with some of the things that the Dadaists and the Surrealists did. I like to give the pieces elaborate titles the way they did, although I've only been titling them recently. That all came from not trying to figure out why I make those things. It got so I just couldn't do anything. So like making the impressions of knees in a wax block... was a way of having a

[1] Fidel A. Danieli, "The Art of Bruce Nauman," *Artforum,* December, 1967.

71

large rectangular solid with marks in it so *I had to make this other kind of reasoning. It also had to do with trying to make a less important thing to look at.* (Italics mine.)

After 1966 that "other kind of reasoning" accelerated toward the art object invested with extraformal meaning on the basis of the *title a pun,* for example, *Henry Moore Bound to Fail* (1967). As a literary formula the pun is a loaded area of intellectual experience for, as Duchamp knew, the circularity of the pun appears to provide information without getting you anywhere. Toby Mussman correctly observed in his study of Duchamp's film *Anemic Cinema* (made in conjunction with Man Ray) that "puns, unlike ordinary sentences, do not attempt to make a definite statement but rather they cast ironic doubt on the ability of any written sentence to make ultimate and absolutely conclusive sense." [2]

Reactions to Nauman's punning ranged from the positive ("...we all secretly enjoy that hideous sinking sensation engendered by a really bad pun")[3] to the negative ("... the most vexing portion of Mr. Nauman's work is related to his ingenuous literary punning").[4] A middle road is possible: "If one accepts the title on the level of poetic commentary, a debate arises as to whether the artist is pure and naive, or a witty and sophisticated literate. My experience favors an amalgam." [5] The works that led to these reactions were a set of color photographs in which the artist was seen performing such elementary activities as *Eating My Words.* In this instance the word "words" had been literally shaped out of bread and was being eaten. Similarly, *Waxing Hot* depicted the artist literally waxing the letters of the word "Hot." The photograph *Feet of Clay* depicts the artist's feet literally covered over with clay pellets. The images, therefore, have been given " meaning" and "recognizability" by fusing them to a cliché. The model for such an activity is obviously Marcel Duchamp. For example, *With My Tongue in My Cheek,* an assemblage relief of 1959 and a late self-portrait, combines a drawn

[2] Toby Mussman, "Marcel Duchamp's Anemic Cinema," 1966. Reprinted in *The New American Cinema,* ed. Gregory Battcock, New York, 1967, p. 151.
[3] John Perreault, writing on Nauman's first New York one-man show, *The Village Voice,* February 8, 1968.
[4] Robert Pincus-Witten, "New York Review," *Artforum,* April, 1967; as in fn. 3.
[5] Danieli, *op. cit.*

profile of the artist with a plaster cast of the artist's jaw. Similarly, Nauman's green wax piece, *From Hand to Mouth* (the color and substance deriving from John's early encaustic *Green Target*) is a cast of the right hand, arm, shoulder, throat, jaw, and lips of the artist's former wife (Fig. 19).

Another work of 1967 presents the artist's crossed arms cast in green wax, from whose severed biceps there emerges a heavy rope tied into a square knot. Although untitled, the verbal/visual interplay of the work turns on the following equation: as the arms are folded so is the rope knotted, or vice versa. In short, the rope and arms are permutations of the same knotted condition: they are tied in knots. In addition to the obvious relationship to Johns in terms of the cast elements of these works, they are also distinctly Johns-like in terms of the work's insistent proliferation of the *same* thing projected into a *different* state, diagrammatic or otherwise. Johns' celebrated *Ballantine Ale Cans,* 1962, one a cast and the other modeled by hand, is a well-known example of this kind of pairing. Nauman also stated in the catalogue quote from *American Sculpture of the Sixties* that part of his effort was directed toward making "a less important thing to look at." I take this to reflect an active indifference to the issues of reductivist abstraction as they were then being explored and a desire to make works which would *obviously* have no relevance to the solemn earnestness, for example, of Minimalist sculpture then at its apogee.

From 1965 on one sees a hyperbolic attempt on Nauman's part to create forms never before seen, made of substances and colored in ways equally unknown.[6] I do not quarrel with the aspiration; it is the very fiber of art. But the quest, though stated and perhaps even "felt" in these exalted terms, is equally arbitrary notwithstanding the fact that between 1965 and 1967, Nauman came close to realizing such an ambition. The forms which Nauman took to making at the time were spindly affairs, loaflike and split into arching rails. They were of two kinds, soft and hard; the soft group were made of colored rubber latex and the hard cast in fiberglass.

[6] David Whitney's picture folder of 44 works by Bruce Nauman, published by Leo Castelli Gallery, is helpful in dating the early shift in the direction of Nauman's work.

The works give off an aura of undernourishment and eccentricity. In many respects these "impoverished" works, supported directly by the wall and floor, anticipate many of the experiments associated with the rise of post-Minimalism — particularly the early rubber and neon work of Richard Serra — a history which I have attempted to write in my essays on Richard Serra, Keith Sonnier, and Eva Hesse. I would be hard put not to acknowledge the seminal role played by Nauman's untitled rubber, fiberglass, and neon works in redirecting the nature of artistic aspiration in the late '60s.

In November 1966, Nauman figured prominently in an exhibition held in New York's Fischbach Gallery called "Eccentric Abstraction," which represented the real surfacing of this counter-Minimalist taste in the gallery context. Works by Keith Sonnier and Eva Hesse were included among others. The exhibition was organized and introduced by the critic Lucy Lippard, who undertook to clarify "an aspect of visceral identification that is hard to escape, an identification that psychologists have called 'body ego'."[7] Lippard was referring to the capacity of the viewer to empathetically respond to unfamiliar forms in visceral terms. Yet the term "body ego" suggests another possibility — that a work may be the means whereby the artist employs his body or sections thereof, his lineaments, his personal possessions, or even his name, and in so doing transforms himself into a self-exploitable tool or the raw material of artistic presentation (Fig. 20). He becomes, in a certain sense, his own *object trouvé* — hence narcissistic. The term "body ego" certainly poses the possibility of this interpretation in Nauman's work after 1967, although Lippard's introduction was written on the basis of the earlier untitled fiberglass pieces, which she regarded as vehicles "unconcerned with conventional manipulation of forms in space and more involved with a perverse, sometimes bizarre expansion of the limits of art."

Such "expansions" obviously posit formlessness as a structural possibility, a condition recorded in Nauman's photographs of patted mounds of flour on the studio floor. Another counterpart would be

[7] Lucy Lippard, broadside to an exhibition called "Eccentric Abstraction," Fischbach Gallery, New York, September, 1966.

the *Composite Photo of Two Messes on the Studio Floor* (1967). The affiliation of these works with Marcel Duchamp's *Elevage de Poussière,* a photograph taken in 1920 by Man Ray of *The Large Glass,* which had been lying flat and gathering dust in Duchamp's New York studio, is inescapable. The works are alike in that they refer to insubstantial and amorphous substances. It is of larger critical interest, however, that they exist at several removes from the original, the "real" works having been replaced by *photographs,* which are, or have become by default, the central document of the experience, hence the central emotional repository of the works. It is obvious that with Nauman the "real" or "original" work had all along been an auxiliary effort. The shift away from an *original* by whatever means — photography, cinematography, tape recording, private journals, notations, memos, or ultimately merely the unexecuted idea or conception, allied to a valorization of the technological, cognitive, mental, or other processes — is the chief characteristic of Nauman's work. This most clearly identifies him as a founder of the Conceptualist movement, a post-Minimalist episode which is, in Nauman's expression of it, Dada in spirit.

The lateral spread of the *Composite Photo of Two Messes on the Studio Floor* is assembled in a manner similar to an aerial reconnaissance map. In this way it resembles a work called *Composite Photo of My Name as Though It Were Written on the Surface of the Moon,* which appears as if a repeatedly beamed electronic signal forming the letters of Nauman's first name had bounced off the moon and returned to earth at constant intervals. The work is predicated on dubbing, on christening, and though the similarity to Duchamp's "Readymades" may appear tenuous the connection is still discernible. Duchamp's investment of artistic identity in a neutral common object (a snow shovel or a bottle rack) was also in part based on a kind of baptism, on arrant say so. As the snow shovel and the bottle rack were Duchamp's "Readymades," so is Nauman's first name his "Readymade." Nauman's name, of course, is subjected to a complex alteration whereas Duchamp's "Readymades" were scarcely adjusted, if at all. Each individual letter of the name Bruce is arbitrarily repeated, similar to the repetitions of the *Six Inches of My Knee Extended To Six Feet,* or any of the

duplications of measurements and sections taken from the artist's body. Perhaps the most striking alterations occur in the neon work, which fudges the script of Nauman's *Last Name Exaggerated Fourteen Times Vertically* (Fig. 21).[8] In the latter work, the legibility is all but obliterated by the vertical scaling and one reads the name Nauman as a neon gesture. The title serves, in most of his neon pieces, to "explain" or to "justify." In short, it is at this moment, when Nauman comes more and more to rely on technological sources, that Duchamp begins to fade as a central preoccupation. Now, with the overwhelming dependence on technological recording devices, Nauman's art announces its entire reliance on behavioral theory.

No single work is more characteristic of Nauman's use of extraformal, verbal tactics than the two steel wedges of 1968 (Fig. 36); they are inscribed:

$$\frac{\text{LIKE}}{\text{KEIL}} \quad \text{and} \quad \frac{\text{WEDGE}}{\text{KEIL}}$$

The word play is facetious. The German word for wedge is *Keil*. A rearrangement of the letters of this word spell out the English word "like." Therefore the wedge *form* is equated with the German word "wedge," the anagram of the English word "like," or the same word as the first *Like:* punning or palindromic circularity. Moreover, the wedge shape is easily understood to be a phallic symbol into which a lentilshaped chamfer has been groved, a vaginal symbol. This additional sexual orchestration may derive from the sexual and poetic object of Duchamp's late work, *Coin de Chastété* (Fig. 35),[9] of 1951, in which a *wedge* has been pressed into dental plastic. The verbal fixation of such exercises are linked to Duchamp, from the quasi-pornographic caption of *LHOOQ* (*elle a chaud au cul*), or "Mona Lisa's Moustache" as it is popularly called, to the punning titles such as the *Anemic Cinema*. This kind of closed and perfect verbal/visual

[8] Neon appears in many of Nauman's constructions. Philip Glass, a musician and intimate of both Nauman and Richard Serra, contends that the neon spiral maxim, "The true artist helps the world by revealing mystic truths," is directly related to the optical spiral of Duchamp's *Rotative demi-sphere* of 1925. (Information supplied by Philip Leider.)
[9] *Wedge of chastity.*

76

decoction leads to a chain of equally absurd neutral elements. Such verbal/visual puns are curiously self-referential and hidebound. As experiences they tend toward introversion rather than extroversion. Even after one "gets" them, one is irked by the tightness of their boundaries because of their obviously axiomatic and tautological nature.

From all this one would imagine that Bruce Nauman was a mere Dadaistic *pasticheur* haunted by the specter of Duchamp. But, added to Nauman's verbal/visual juggling, there remains his equal commitment to sheer materiality and physicality which alone would mark him as foreign to Dadaism. Because of this latter aspect Nauman is a bedfellow of Andre, Hesse, Morris, Serra, Sonnier, Smithson, and any of half a dozen artists whose names readily come to mind. Nauman's uniquely private employment of neon would serve to rank him as an important figure.

Nauman's work exhibited at the Castelli Gallery in June of 1969 consisted of a set of holograms (photographs made with laser beams that manneristically exaggerate stereometry) which showed the artist viewed from below in multiple crouched and fetal positions (Fig. 22). These holograms alter one's spatial apperceptions in an odd way; they induce a sensation of looking into a stereopticon of a greenish coloration.

In May of 1969 a freestanding passageway that could be walked through was included at the Whitney Museum's "Anti-Illusionism: Procedures/Materials" exhibition. Its oddness was a function of its seeming neutrality, but as passageway it gained meaning on viewing a videotape shown at Nauman's subsequent one-man exhibition held shortly thereafter at the Leo Castelli Gallery. The videotape image revealed Nauman entering and exiting from this narrow corridor. It became evident that the width of the odd corridor was delimited to accommodate the deliberately exaggerated swing of the artist's hips. The passageway itself was virtually without meaning, which it subsequently and suddenly assumed only to the degree that it was revealed to be a visual boundary for the setting of the videotape.

Because of his use of cryptic self-reference, linguistic attachment, resistance to received notions of good taste (and therefore good sense and good behavior), and of experimentation as an end in itself,

Nauman *in the phase of his allegiance to Duchamp,* can be regarded as a significant artist whose work is important because — like much of Johns' later work — he continued to vitally extrapolate on the lessons of Duchamp.

The inferences then of these views are that Nauman's contribution as a critical artist is supported to the degree that he was able to expressively prevaricate on Duchamp. But, with the introduction of laser beam holograms and the greater reliance on technology and behavioral phenomenology, Nauman cut himself off from the experience which centrally formed his art.

It is apparent that two options were open to Nauman: he had either to continue to develop his attachments to Duchamp or he had to exposit purely epistemological information. But the very fact that his post-Minimal production was linked to Dadaism obviated an epistemological response and promoted an art of continuing self-exposure in the context of Conceptualism. However, the latter context is unable to support this kind of externalization since it cannot support objectification. And in being unable to support an art of things or of making objects, Nauman's post-Minimalism is betrayed by both his beginnings and his conclusions.

ROSENQUIST AND SAMARAS:
THE OBSESSIVE IMAGE AND POST-MINIMALISM

Recently I observed that "...an emerging official history... places post-Minimalism squarely at the conjunction of a meeting between Oldenburg's soft sculpture and the gestural tradition of Abstract Expressionism, discounting thereby the long continuity from late Surrealist theory."[1] I meant that the evolution from Minimalism to post-Minimalism had only taken into account a narrow view which regarded Oldenburg and the gestural tradition of Abstract Expressionism positively. Until this point, no connection to late Surrealist theory was drawn because such theory had been relegated to the dustbin by a critical apparatus which placed exclusive emphasis on "formal issues," issues implicit or central only to the executive act of art-making. With the emergence of an art that emphasized the pre-executive or conceptual phase of art-making, a mode of criticism anchored exclusively to art-making activity, as in formalist criticism, became recognizably inadequate. On these grounds some aspects which formalist criticism disqualified as unworthy of examination now elicit consideration.

The intention is not to revalue certain artists or styles across the board. However, the rejection of late Surrealism need not necessarily blind us to the development of a working syntax in this mode. In summation, post-Minimalism takes note of numerous options inherent to issues that long precede the mid-'60s, and which derive from the first successful style of the '60s, namely Pop art, as well as numerous late Surrealist antecedents.

An image notorious to the decade, Andy Warhol's *Marilyn* of 1962, is compulsively repeated in mechanistic terms, a repetition that in

[1] See "Eva Hesse: Post-Minimalism to Sublime."

part announces Minimalist seriality, but which, in fact, is largely related to the artist's obsession with cinematic glamour and media imagery. Marilyn Monroe's suicide in 1962 traumatized the popular consciousness in the period of the pre-Kennedy assassinations. The number of Marilyn-based images derived from this tragedy is in measure a function of ambiguities implicit in the suicide, an event in which a section of the public unconsciously took perverse pleasure. By contrast, James Rosenquist's *Marilyn Monroe* of 1962 in no way corresponds to Warhol's repetitive and serialized *Marilyns*. Nor is it especially important in this context to point to a different tradition in the heritage of Rosenquist's *Marilyn* which relates to Cubist collage and even more to Schwitters' *Merzbilder*. Noteworthy in the Rosenquist is a focus on the entirely professional smile of Marilyn, her capped, white teeth derived from cosmetic toothpaste advertisements, a tradition which Rosenquist knew from his apprenticeship as a sign painter.

Advertising smiles suggest interpretive means quite apart from the formal issues of any work implicit to this imagery. An elaborate interpretation of the advertising smile appears in the writing of Thomas B. Hess. On the basis of the Camel cigarette ad "T-Zone" of the '50s and '40s, Hess inferred the presence of a sexual archetype, the evil or destructive mother, in de Kooning's first *Women* series of the 1950s.[2] Certainly, the collaged smile of de Kooning's *Women,* instead of putting us at ease, can be viewed as ambiguous if not gruesome and threatening.[3]

In 1962, Rosenquist began to experiment with a loose and arbitrary sculptural arrangement in painting. These "combine" polymorphs relate to concrete biographical events in the artist's life, and enabled Rosenquist to advance aspects of post-Minimalism before any recognition of the peculiar pictorial and sculptural issues of the style was noted. One can point to *Nomad* of 1963 with its speckled plastic bag dripping paint on a disordered pile of wood, three versions of pictures caught in the branches of a tree, *Catwalk* of 1963 which "is merely an idea of walking across a place with lights

[2] Thomas B. Hess, *Willem de Kooning*, New York, 1968, pp. 76-79.
[3] No doubt the model for the smile is the Gorgon pediment of the 6th century B.C. at Corfu; or, if not so specific a model, then classical gorgon imagery generally.

shining through underneath and it's supposed to be at high altitude but of course, it's only like a little puddle or little thing."[4]
A striking example is *Toaster* of 1963. This Tide boxlike construction is filled with plastic grass, through which emerge two serrated circular saw blades. Rosenquist remarks that they are "like two pieces of toast... and trying to put your teeth on two sawblades."[5] The construction is loosely bound with barbed wire and *Tumbleweed* of 1964 (Fig. 7), like this image, continues to explore aggressive and lascerating possibly mortifying, tactile effects. An open work of enmeshed barbed wire, *Tumbleweed* is intertwined with a gestural neon passage supported by an armature of paint-splattered, crossed wood. The Surrealist implications of Rosenquist's work of this period are clearly recognizable as a function of unanticipated tactile effects, particularly the sharp and spiky. Rosenquist suggests that the introduction of barbed wire as a working material was induced, at least insofar as he can consciously identify, by memories of "animals and grasses hung up on barbed wire fences in North Dakota after floods in the spring."[6]
Remarkably, *Toaster* parallels Lucas Samaras' *Untitled (Face Box)* of 1963 (Fig. 23), one of the artist's first important series of pin and yarn boxes of the period through 1964. These self-portrait boxes are characteristically covered with prickly and threatening elements — razor blades, pins, nails of all sorts pierced or pricked through his own photographic image affixed to the surface of the box, or within the trays set in the boxes. Similarly, numerous recent nude photographic variations of the artist in his book, *Samaras Album,* continue to exploit these characteristics. Throughout his work, Samaras deals largely with polymorphic sexual inferences of a generally sadomasochistic ambiguousness. In the early '60s this kind of obsessional material is not only widely found throughout the work of Rosenquist and Samaras, but is also visible in the work of Lee Bontecou, Bruce Conner, and Paul Thek. Bontecou's metal frame constructions painstakingly wired with small canvas elements are typical. In several of the apertures formed by the metal frames,

[4] Jeanne Siegel, "An Interview with James Rosenquist," *Artforum*, June, 1972, p. 32.
[5] *Ibid.*
[6] *Ibid.*

81

7

the artist placed — serration to serration — toothed band saws similar to the rows of circular saws in Rosenquist's *Toaster* and the blades, screws, and pins of Samaras' *Boxes*. Bontecou's work occasioned frequent reference to a castration archetype, the *vagina dentata* (the vagina with teeth), though the artist denies so limited a reading.

It is important to emphasize the relationship of this highly varied body of work to the tactile effects of post-Minimalism. If we take Eva Hesse as a representative figure of post-Minimalism, the models afforded by Samaras and Bontecou cannot be underestimated, since both, unlike Rosenquist, elaborate their art through intricately crafted variations of set obsessional iconography. The prickly wiring of Bontecou's canvas patch to the iron frame is another example of obsessional, craft-based activity. Again, Samaras' affixing of spacedyed yarn in parallel, rhythmic rows undoubtedly influenced Eva Hesse's work, and other artists after 1968 whose work reveals clearly compulsive activity. It could well be conceived that this kind of straightforward and simple craft-based activity rendered dubious the traditional supremacy of easel painting, though some would designate this approach to handcraft as merely surrogate brushwork. Eva Hesse's consciousness of the problem imposed on women as artists would have made her aware of Bontecou's success in the early '60s, but I have not discovered reference to Bontecou in her journals; there is, however, reference to the problem of the woman as artist. To be sure, Hesse was strongly conscious of Lucas Samaras' work and early critics of post-Minimalism, such as Lucy Lippard, had bracketed their names.

If Hesse, and now her many followers, picked up on the repetitive, artisanal aspects of Bontecou and Samaras, the anticipatory aspects of Rosenquist's *Tumbleweed* were equally influential on several young Californians who were seeking a more open mode of expression. It should also be remembered that *Toaster* had been reproduced on the cover of the April 1964 issue of *Artforum,* at that time a West-Coast-based magazine, no doubt a contributing factor towards the shift in sensibility. Bruce Nauman used neon early in his spiral maxims and body templates, though his introduction of neon is demonstratively related to an exploration of

the thematic materials of Jasper Johns and Marcel Duchamp, rather than of Rosenquist. On the other hand, Richard Serra, associated early in his career with the West Coast and a friend of Nauman's, directly acknowledges his debt to Rosenquist's *Tumbleweed*. Serra's constructions incorporating neon elicited a strong response when exhibited in a group show at the Goldowsky Gallery in 1967. Several of Serra's pieces incorporated gestural neon counterpoints to an eccentric rubber structure pinned by twisted nails. An untitled eleven unit piece of 1967, the first element of which contains the neon meander, has often been discussed and is now well known.

Yet another untitled work of 1967, overlooked in the growing literature on the artist, is particularly applicable to the present discussion. Like the eleven-unit piece, it is made of neon and rubber belting fixed in place with nails. Despite the apparently elusive nature of its subject, this work seems to play upon a variation of the initials of the artist's name. In this sense it may be construed to be Nauman-like since Nauman, especially in this period, specifically dealt with neon constructions embodying thematic material derived from measurements of his person or aspects of his persona, such as the letters of his first name *Exaggerated Fourteen Times Vertically* or, *As If It Were Written On the Surface of the Moon*, both of 1967. Although there are earlier examples, Sonnier's *Triple Lip* of 1969, in which gestural neon loops about two electric light bulbs, can be shown to be partly inspired by this connection. What I am suggesting then is that eccentric and partially unclassified episodes in the art of the early '60s established and inspired a rejection of Minimalism.

Samaras, unlike Rosenquist, is more explicitly related to the Surrealist context. Like Joseph Cornell, who forms an actual American bridge with the French movement, Samaras continued to exploit the conventional vernacular of Surrealism. Surprisingly, this tradition relates to the work of Salvador Dali during the 1930s, when it would have been hard to dismiss this noted artist as captiously as one does today. Although the molten features of the oneiric elements of Dali's "hand-painted dream photographs" of the 1930s are of great importance, his sculpture, such as the *Tray of Objects* of 1936, is equally noteworthy. This work directly exposes

objects fetishistically intriguing to the artist and presented with little esthetic arrangement. Within the tray are small erotic sculpture, garments such as gloves and ballet slippers, chalices, puzzles and games — things which later would appeal to the theatrical fantasy of Joseph Cornell, not to mention the fetishistic aspects of Samaras' *Boxes*. Dali's *Tray of Objects* alludes to André Breton's own artistic efforts, the poem-objects, verbal/visual rebuses of significance to the Surrealist group in exile in the late '30s and early '40s.

Samaras continued in this vein through the '60s. As late as the *Chair Transformation* of 1970 Samaras remains affiliated with Surrealist thinking, which, above all else, strove to inaugurate psychic liberty through the exploitation of familiar objects in unfamiliar contexts, or in terms of disjunctive sensuous properties. The textbook example is Meret Oppenheim's *Poetical Object* of 1936, familiarly called the *Fur-Lined Tea Cup;* the inanimate ceramic object seems to behave as an animate entity, as if it were growing hair. The image violates our sense of function. We shrink from stirring the fur-covered spoon and hesitate to drink from the hair-rimmed cup. Such an elaborate and literary notion is occasional in Rosenquist's work, but in Samaras' work it is a formalized convention. Samaras' *Boxes* are seen as soft and metamorphic. The *Knife Transformations* are equally so. The *Chair Transformations* range from fragile accumulations of artificial flowers to stiff, plaster dripped drapery. The Surrealist myth of metamorphosis is the central issue animating Samaras' work and it may be because of his rigorous commitment to Surrealism that his work so often appears familiar, despite its recent date.

From the 1930s on, the Surrealists attempted to unify into simple presentations a multiplicity of structural possibilities. These metamorphoses commuted between animal, insect, avian, aquatic, and botanical life. Max Ernst's *Figure* of 1931 is a self-evident example.

The dislocation of tactile effect is still another example of late Surrealist activity which continued to find expression in post-Minimalism. Dali's melting watches in the *Persistence of Memory* of 1931 are striking because of the disparity between what we know to

be true of the molten state, namely, that its liquefaction is a function of extreme heat, and the cool crepuscular atmosphere in which the watches melt. Thus a sense of cool when there ought to be the experience of heat is similar to the unreasonable association of properties in Meret Oppenheim's work and to a quality of Samaras' work throughout the 1960s. That the metallic and inanimate watches are being eaten by an army of ants in Dali's painting indicates the inorganic become organic. The dislocation between substance and sensuous property is the key to the schizophrenic terror implicit in the work and marks it as a model for Samaras' variations.

On the basis of his work of the '30s, Dali has self-aggrandizingly noted that it was he and not Claes Oldenburg who invented soft sculpture although it is really the invention of the illusion of soft sculpture that states the case more exactly. "The ideas of Dada and Surrealism are currently in the process of being repeated monstruosly; soft watches have produced innumerable soft objects."[7] Dali's sculptures of this period, perhaps with the exception of *Rainy Taxi* of 1937 are in fact primarily hard-surfaced works. However, to develop the relationship between the soft sculpture of Oldenburg and Dali's work of the 1930s would open up an area which this essay need not cover because Oldenburg's work has certainly been acknowledged as establishing a key model for post-Minimalism. It is important to note that the retention of aspects of certain Surrealist activities throughout the '60s is responsible for the additional energy necessary to shift the Minimalist style off base. To this dislocating pressure must be added the conceptual nature of Minimalism. On the basis of this factor alone, the style would have evolved in unimaginable ways not evident in a rigidly formal examination of the Minimalist object in isolation.

[7] Preface to Pierre Cabanne, *Dialogues with Marcel Duchamp*, New York, 1971, p. 13.

EPISTEMOLOGY

BOCHNER AT MoMA:
THREE IDEAS AND SEVEN PROCEDURES

There was a time when art meant painting and sculpture and the acquisition of the techniques necessary to realize these ends required a set of "how-tos": how to mix colors, how to apply pigment to a surface, how to build an armature, etc. In the last three years, at least, it is clear that the techniques of art have been revised to become not so much studies in methodology as of research into what constitutes the elemental features of any particular situation. In my view the methodologies necessary to the artist are now art history and philosophy — the one to know where to begin, the other to know what to do. The methodologies then pose a set of questions, which in a certain sense, have never been raised before, at least not in the sense that the questions themselves constituted both answer and art.

The evolutions of Mel Bochner's work, these past three years particularly, indicate that the problem for him, at least in terms of the Conceptual movement (in which he occupies a seminal place), has become one in which he had to distinguish between ontological and epistemological activity. The first tends, if I understand him rightly, to emphasize the self-referential and the theatrical gesture. It tends to view conceptual activity as a fixed style, a way of doing, of being, of looking as an objective quality. If this is true, then the ontological Conceptualist is the artist who is most readily understood in terms of his art historical connectedness with Dadaism, with the theatrical side of Futurism and with Duchamp. His modern mediating episode became the Pop movement.

By contrast, the epistemological Conceptualist is engaged in the study of knowledge as its own end. He tends to make or do things for the kinds of information, knowledge or data which the things or

89

activities reveal. He tends to be a grammarian, a mathematician, a cartographer. His modern mediating movement is Minimalism. Bochner is, in the latter group, perhaps its best — that is, its clearest — exponent.

Whether or not the distinction is wholly viable between ontological and epistemological Conceptualism is, at this early critical moment, less important perhaps than the fact that its recognition allows one to claim for the Conceptualist movement the very thing it had apparently sought to deny, namely that its "quality" is a distinguishable feature. On the basis of Bochner's dualistic terms, although this was clearly not his intention, the critic now can point to the nominally "good" or "bad" in the movement, at least for the time being.

Bochner's present work is called *Three Ideas & Seven Procedures* (Fig. 24). It defines seven methods which give visibility — beginning, adding, repeating, exhausting, reversing, canceling and stopping — to the nonphysical, tripartite expression of number: zero, number, and ultimately line. The work is installed in the MoMA downstairs exhibition space: a room, a corridor, another room, and a vestibule in front of the cafeteria. Having painted these spaces white, Bochner has, at the entrance and at his own eye level mounted a left-to-right sequence of counting in black felt-tipped pen on masking tape all around the rooms. Conversely, the same action is made in red, on the same tape, starting from the right. The numbers are recorded in arabic figures, one series superimposed upon the other, at approximately inch intervals, some 2000 in all. Oddly, there are more black numbers than red ones.

Bochner finds that his eye level is demarcated at 71½ inches off the ground. However, differences of floors and ramps cause the tape at certain places to end up far above the head of the artist, although the level remains constant to the height established at the entranceway. This idea, as we see in several photographs accompanying the exhibition, was worked out in the white Renaissance rooms of Dr. and Mrs. Lorenzo Bonomo in Spoleto this past summer. (It cannot fail to have moved the artist to learn that these Italian chambers were those, according to legend, in which Michelangelo had once stayed.) Such an association was not

dissimilar to the ones I felt in front of Bochner's *Ten Aspects of the Theory of Measurement* installed this past spring in Greene Street (*Artforum,* May 1971) when I spoke of the fact that anyone moved by the experience of empty rooms could find a means of connecting *emotionally* with these bold examinations.

In the Bonomo rooms two pencil lines are marked, one designating true eye level, the other approximating it by hand (Fig. 25). The discrepant interstices between these levels is a prefiguration of what we now have at the museum. The museum problem seems that continuous levels can express discontinuous discrete pointing in terms of number. In short, the museum piece enlarges the Bonomo theory of discrepant interstices into one of scan and point. The immediate results of this conception are startling. Above all else a body of several chambers receives a continuous definition and unity. The effect is a kind of discounting of the separateness effected by the concentration imposed by the counter-counting episodes. The wholeness of the space a concomitant of the reversibility of the numerical system which, like a perverse chronometer, marks out a time and place of total arbitrariness.

By extension then, Bochner relocates the actions of conceptual activity away from reading and the mind, into one of perception and the body. In this way he expresses both a break with the Conceptualist movement as a whole and announces his own evolutionary character. This makes him sound like a phenomenologist — someone like Bruce Nauman. But the difference is in antecedent history. Nauman, working out from his own body, derives his information from the verbal and linguistic ativity of Duchamp, transforming his conceptual results into the ontologically quantifiable. Bochner, working from a bank of known and shared information, information which may in this light be regarded as established or objective data, derives his position from the reductivist tradition of the 20th century and therefore his conceptual activities appear epistemological in their effect. Both, however, produce situations which are actively at work upon the body and perceptions of the viewer. Certainly the most important difference between these positions is that the ontologist, by virtue of his history, is obliged to create objects, at their most ambitious

cognizant of special environments for which they may especially be created. The epistemologist extraordinarily enough — considering his history — creates systems free of local situations, the information applicable to any arena of activity.

The associations may even be enlarged. In Malevitch's *White on White* (1917) a white square was tipped upon a white ground, figure and ground distinguished not only by differences of white color but by a still evident pencil line. Malevitch's pencil line is now Bochner's masking tape; line as tape, figure as wall (or wainscoting) and ground as ceiling. Not only then are Malevitch's prophecies regarding the architectural potential of Suprematism realized anew, but another indice of the "inching out" of Minimalism into post-Minimalism, while retaining a base within Suprematism, is made evident. In this way Bochner assists us in understanding the work of other post-Minimalists, such as Robert Morris and Robert Smithson, while he indicates as well the richness of the problems posed by Minimalism.

SOL LEWITT:
WORD ⟨——⟩ OBJECT

Sol LeWitt epitomizes the lean intellectual orientation in current art. His moral and formal example is noteworthy and his influence can be seen in a range of work as diverse as the complex structural innuendos of Eva Hesse to the pared down verifications of Mel Bochner. The ubiquitousness and serviceability of LeWitt's achievement often make him difficult to categorize. There are rare instances of theatrical Conceptual production, for example, *The Buried Cube* of 1968 (a work documented in the catalogue of Sol LeWitt's retrospective held at the Haags Gemeentemuseum in the summer of 1970). That Sol LeWitt's work should seem to touch many bases is problematic — my problem, not his. I believe that there is a more sharply focused vision of LeWitt's contribution than perhaps the artist would be willing to admit.

One especially appreciates LeWitt's seminal position in the evolution of Conceptual activity. LeWitt's singular achievement is that his development of a theoretical posture nominally central to Minimalist structure freed Minimalism from its geometrically quantifiable condition, permitting it in this way to become the foundation of epistemological Conceptualism. In less stylistic jargon this means that LeWitt's attitude toward the simplified geometrical mode of the mid-'60s tended to further reduce such geometric forms to a residue of linguistic equivalence. The value of LeWitt's cube ultimately lay less in the form itself than in the possible and then unexplored use of a simple verbal description denoted by that form. Nor did LeWitt's use of seriality emphasize repeated modules as only a means of inducing visual interest and incident in an otherwise spare reductivism. Instead, the visual importance of seriality in LeWitt's work implied that composition could result from the use

of a homogeneous set of forms. These Conceptual sets were offered to the mind for intellectual gratification as earlier hierarchies of shape and color had been offered to the eye for visual delectation. LeWitt's work bracketed these two modes of apprehension and ordonnance. It had the double effect of validating more self-aware experimentation of an art of Conceptual sets (as the epistemological Conceptualists were begining to explore) while it continued to valorize in a fresh way certain implications of Jasper Johns' more conventionally composed art based on arrangements of heterogeneous Conceptual sets — e.g., the ale can rendered as drawing, painting, sculpture, lithograph, label, and "real thing," or, similarly, heterogeneous thematic accretions derived from flags, targets, and most importantly, numbers. The emergence of an autonomous epistemological Conceptualist group — whose members by now are working in highly disparate areas of research — at this point seems to underplay its once declared affiliation with LeWitt in favor of an ever more credible connection to Johns, one far greater than had at first been suspected.

LeWitt's recognition of a coequality between form and noun tended at the outset to isolate him from what was then considered to be mainstream Minimalism. It was not until the recent consciousness of a distinct Conceptual movement that LeWitt's contribution grew clearer. Precisely because his work is linked so closely to the current usage of language in art LeWitt now appears to be the most stringent Minimalist of all. By contrast, period stylists like Judd or Flavin appear to have explored imagistic, coloristic, or illusionistic issues which seem to have been, in hindsight, additional elaborations within their art. LeWitt's recent exhibition at the Kunsthalle, Bern, however, critically places him again into a paradoxical situation. Having led the transition of Minimal form into a Conceptual presentation, he appears to be reversing priorities in this exhibition.

The main reason for my concern is that — apart from the wall drawings which seem to be LeWitt's major achievement — LeWitt is still realizing older projects within the context of tangible, objectified sculpture. Currently, work is being fabricated along theoretical models worked out several years ago, an action which

the "nonexistent" or "insubstantial" conditions of the wall drawings, as well as the lessons inherent in the earlier work, ought to have vitiated as an esthetic, ultimately political, choice.

This objection raises an important question, one not only local to LeWitt, but to sculpture in general and to the major figures of Minimalism, painters included. Unlike sculpture of the past, the problem of replication, edition, and later production based on earlier prototype becomes — with contemporary figures — a crucial issue, one tied to the consciousness of the meaning and moral content brought about by a new esthetic.

The problem lends itself to two interpretations. The tendency toward geometrical form and industrial manufacture accounts and allows for replication at anytime. The tendency also explains the introduction of teams of assistants who can fabricate the work even in the absence of the artist, who may in turn become the foreman and the conceiver; but the artist's role as executant is phased out, often to virtual nonexistence. The point of art as language is that anybody can do it once the directives are in hand. In this way it is a seemingly democratizing process. By contrast, LeWitt's unique contribution to Minimalism raises the special issue of the verbal model that obviates tangible form itself, and in particular, the manufacture of forms based on earlier schemes, a production that adds nothing to the implications of the original achievement.

In LeWitt's special case, in fact, the manufacture of earlier projects seems a reactionary gesture in a production coexistent with the theoretical rejection of the possessable and the objectified. To wonder what a fresh, cubic configuration will look like, even if such a configuration had not been fabricated in the past, adds — it seems to me — little to LeWitt's art since the principles of such an action have been understood as a result of his work at least since 1967. It is the principle and not the object that is at stake. If it is the execution of an operation or its verbal equivalent that counts in LeWitt's work, then it would seem that my reservations concerning the newly fabricated cube series are well taken. The problem is that LeWitt now seems to reject the implications and the enormous changes in art occasioned by his earlier position. In continuing to produce objects as a function of Minimal sensibility he acts as if it

were the object that really mattered all along. If he is right and I am wrong, if it is the object that counts, then I am deprived of an argument. The situation would then be one of object as object distinct from object as idea, his taste versus my taste. My reservations would be trivial. If I am right, however, there has been a serious forfeiture of rank. I reject Sol LeWitt's new work (exclusive of the wall drawings) because I cannot theoretically justify it, not because I do not relate to his sense of human scale (being most put off by the proportions of the *Modular Series* — the 5½' cubic frames fabricated in interlocking, white baked-enamel steel elements). To me, what is vital in current art is not a function of object but a function of idea. It's never "inherent beauty" — whatever that means — that induces a sense of wonder but only the argument into which that object (and here I am regarding Conceptual art as a kind of object) can be fitted.

Further, to accept LeWitt's art as "object as object" means, as well, that one would be forced to view it as a stylistic affiliate of the '60s taste derived from the example of Frank Stella: a surprising bracketing since Stella's work is so thoroughly based in a sensibility which, taking its model from the historical evolution of Matisse's painting, is pitted against LeWitt's achievement as it is patently object-oriented. The apparent similarity is caused by the utilization of a generalized sphere of structure — geometry. In this sense LeWitt's straight lines countering curved arcs — the motifs though hardly the meaning of several wall drawings and graphic pieces — are similar in pattern to Stella's protractor variations. To insist on this similarity, however, denies the areas of discourse which I believe radically differentiate these two productions: color sensibility against theoretical didacticism, feeling and emotionalism against keen rationalism, sensibility against theory, object against concept.

Certain LeWitt's are nonetheless Stella-like in effect, particularly the hollow, metal boxes of 1968-72, ornamented in striped pattern sequences. These boxes, virtually unknown in the United States, are the ones which mark the most variant or eccentric application of LeWitt's taste. They divide laterally, vertically, triadically, a sectioning differentiated by strong herringbonelike patterns. Such

striped applications suggest that LeWitt can respond to spontaneous impulse, a response that in his case leads to pattern-making. Too many visual properties are at work here for these boxes to read as constituents functioning within a lucid set structure. An ungenerous reading of these boxes would be as a hangover, period ornamentation in the manner of Stella. What has been reopened to question by these boxes is LeWitt's all-important focus, namely that a Conceptual set is a viable organizational factor, equivalent, if not even superior to, visual or pictorial composition. They represent a serious recidivism in LeWitt's career, one perhaps more disquieting than any other.

Not only then does LeWitt himself occasionally veer in the direction of Stella, but so do those who follow LeWitt's operatives as well. It is intriguing that in the presentation of geometric form in terms of verbal correlatives, LeWitt is attracted by the imperative case. His simple language is direct command. There is something about this location in language (as differentiated, say, from Richard Serra's, whose work may be related to the infinitive of the verb, or from Bochner whose work at times parallels sentence structure) which gives LeWitt's achievement an often totalitarian or autocratic intonation.

In "following orders" it is curious to see how many period-taste solutions have already answered LeWitt's verbal postulates. A telling example would be the lithograph executed by the students of the Nova Scotia College of Art and Design in 1972. Surprisingly an expanding meander pattern — as is found in numerous compositions by Stella in the early '60s — resulted from the following instruction: "Using a black, hard crayon draw a straight line of any length. From any point" — the executant conceived "any point" as always the point at the end of a line, an extreme but still correct assumption — "on that line draw another line perpendicular to the line. Repeat this procedure." A figure resembling, say, an International Style floor plan could easily if not inevitably result from this directive, rather than the Stella-like fret which in fact evolved.

Perhaps the tautest realization of form as language is *Arcs, From Corners & Sides, Circles & Grids and All Their Combinations,* the working drawings which were prominently displayed in Bern.

8

One hundred ninety-five illustrations — some of them incidentally and misleadingly optical — correspond to such simple postulates as the first, *Arcs from one corner,* to the 195th theorem, *Circles, grids and arcs from four corners and four sides.* LeWitt's attitude means that no indecision exists as to when the art work is complete. The completion of the work is realized in the solution of the number of imperatives.

What is so striking in all of this is the deflation of the actions of art — there is nothing implicitly or explicitly "artistic" in art-making other than making the work of art or doing art itself. Paradoxically, art is execution but it is not in "the touch." So detached from the issue of facture has LeWitt's art become that his work theoretically may be executed by anyone following the artist's set of imperatives. In principle this is acceptable. In actual practice, however, there is a noticeable difference in those works executed by assistants and those executed by the artist himself, a difference both psychological and physical. An unresolved problem. LeWitt appears to have opted for the both extreme and obvious position: the artist is the person who thinks up things to do. Art is over when this chore is done. The art is the thinking.

A loss of confidence in facture (a theoretical loss perhaps more than an actual loss) underscores the wide malaise of painting at this moment. Just as LeWitt's wall drawings dramatize the virtual unimportance of stretcher-borne-cloth as support for art, so too does the verbal directive further undermine the belief in personal facture as the cogent embodiment of art.

Not incidentally, the discovery of the wall drawing was an achievement dispersed throughout the post-Minimalist phase, one that responded to a variety of dissatisfactions. Several examples come to mind from that moment at which the introduction of seemingly "eccentric" or "signature" substances began to be exploited as a color surrogate for the lost expressionism typical of Minimalism. In the winter of 1969, for example, Bill Bollinger filled the Bykert Gallery with green sweeping compound and powdered graphite, smudging a large disk of the latter substance on the gallery wall. More immediately similar in effect to LeWitt's position were the monochromatic wall drawings of Peter Gourfain shortly thereafter

executed in pastel stick on the same gallery's wall. I noted in the fall of 1969 that what Gourfain retained from his past was "registration, enumeration, and rigorous clarity of intention. What has been lost is the intermediary support (and the paint if not the pigment.)" Mel Bochner had been working in masking tape applied directly to the wall surface in LeWitt-like grid formations since 1967. These ideological tentatives were corroborated as well by aspects of the work of Robert Ryman. And so on.

It is of importance that the present occasion is not the earliest large overview of LeWitt's work, the first having been organized by the Haags Gemeentemuseum in 1970, for which a more sumptuous catalogue than the present Bern booklet was issued. It remains the basic reference on the artist. Tellingly then, two retrospective exhibitions have been organized in Europe, while none have been arranged in the United States, although of course, the frequency of the artist's exhibitions, first at the Dwan and now at the Weber Gallery, have kept us informed of his evolution.

LeWitt seems to be reaching or arriving at master status in Europe in a way unusual to careers in New York City. If the artist is opting for a European reputation it may be because of the rawness, the exposed nerve of working in New York City. Still, work by an American artist that is not going to fall into its own mannerism must, I believe, be executed in an atmosphere aware of the implications of any artistic position. It could be said that there is built into the European appreciation of an artist, as distinct from New York City, the idea that felicity is the touchstone of the artist's mastery. What appears to be happening to LeWitt might be described as a kind of pleasure-principle Conceptualism which occasions a certain hasty or casual execution. The wall drawings at the Kunsthalle, for example, are so diffidently executed (even the one done by LeWitt himself, rather than the group-executed work at the entrance) that they disparage the integrity of this vital contribution.

Divested of an acute sense of the scene means that LeWitt may not have given sufficient heed to the fact that certain pieces, had they been shown in New York City, would have elicited an instantaneous and abrasive result. I think particularly that the recent

folded and torn paper exercises should have been edited to include in the Bern exhibition the earliest examples of gridbased, folded and torn paper exercises which, it is claimed, have been part of LeWitt's production for some three years. The artist in this way would have indicated another area of his interest and scotched as well any misgivings as to date and/or directional flow of influence, as so much work of this type has been seen in New York during this past year.

Doubtless there are many persons who regard such an assumption as pointless. One does not quibble about dates when dealing, say, with the color red in conventional easel painting; why then take issue with who first folded and tore paper in the context of an art of idea? The answer to this question is a function of the nature of the Conceptual movement. Since the lesson taught by LeWitt is that the embodiment of an art may grow lean to the point of virtual nonexistence, the only thing then that is left inviolate or identifiable as art in such work is, in fact, the integrity of the idea. The reason that the Conceptual artist is so concerned with dating, *curricula vitae,* bibliographic niceties, and the appreciation of scholarly and art historical methodology is that through such attentions an exact delimitation of boundaries protects a unique achievement. Unlike conventional painting or sculpture, who had what idea first is a real issue, since the only thing that can be appreciated and evaluated as a personal achievement in Conceptual art is the vitality and validity of its idea.

This is not meant to be construed that LeWitt has been influenced by the very community of artist to which he plays so exemplary a role. I only state this reservation to stave off the possibility of misapprehension. As it stands, the Bern retrospective raises as many speculations as it answers. The sheer open-endedness of the result reveals anew the singularity and the importance of LeWitt's catalytic achievement, if only in the degree that it continues to inform and announce its solidarity of purpose with the dry and "deprived" actions of the epistemological Conceptualists.

MEL BOCHNER:

THE CONSTANT AS VARIABLE

What has happened in America, and Europe as well, as evidenced in current studio and cooperative practice and in public and private galleries, is that a conventionalized post-Minimalism has appeared, a style that damages the post-Minimalist achievement simply because it is synthetically spurred. What has been an analytical achievement for post-Minimalism has rapidly become for some younger artists an occupation of absorption and synthesis rather than analysis and activism. The nature of the art and the media network has led to a tendentious adoption and dispersal of a novel situation. Obviously, vital new styles promote a high degree of ancillary activity.

A few backward glances are necessary. The central preoccupation of post-Minimalism was the rejection of an art embodied in holistic objects — paintings read at a glance, sculptures of unitary presence, or forms that bracket these conditions. The preferred look was geometrical. Structure was simplistic — monadic, binary, tripartite. Color was monochromatic or aerated to sheer luminescence. Complexity was generated through the use of grid or serial structure. But, even as the sacred conventions of base and frame were rejected in Minimalism (sculpture *was* the base and pictures *were* the frame), other conventions were retained: paintings remained functions of canvas borne upon stretcher supports and sculptures were still monolithic, though often hollow. The use of "noble materials" or modern equivalents (steel, glass, acrylics, sheet metals, and plastics) was unquestioned in Minimalism. Paintings, for example, were "made of" paint carried onto canvas surfaces, although an anonymity of touch or other techniques (spray, staining, etc.) may have questioned the role of the brush. So dependent was Minimalism on the convention of colored canvas supported upon stretchers that an entire style was said to find its paradigm in Frank

Stella's permutation of this interrelationship, those paintings of his generated by the shape of the support. The principal effect of the stretcher-supported-generated image was the collapse of the figure-ground relationship into a single entity, into a class of object that functioned both as picture and sculpture. This encapsulation at length resulted in an early post-Minimalism which I termed "pictorial," in that it stressed uncommon substances and colorism (molten lead, neon, rubber, cheesecloth, and latex). Such materials tended to become "signature" substances, particularly identified with single artists: Serra/lead; Nauman/neon; Hesse/latex, cheesecloth; Benglis/polyurethane foam, etc. This "pictorialism," a refreshed use of eccentric substance and unstudied color, led to a counter-Minimalist pictorial-sculptural style.

Post-Minimalism then began as a style that rejected the stretcher-support and opted for direct wall appendage and the straight hanging of colored substance, whatever its properties. In this choice, the works of Keith Sonnier, Eva Hesse, and Lynda Benglis were exemplary. But an internationally dispersed network of artists attracted by the expressionist premises of the new "pictorialism," often extrapolated into their pictorialism, isolated motifs and structures derived from Minimalism. One found the freely dangling stripe cut away from Noland or Stella; maculated cloth reminiscent of Olitski dangled from the wall. The so-called crisis of easel painting, instead of resulting in intellectual retrenchment and reformulation led to the palliative of technology, provoking the wide use of videotape and film strip. Certain coloristic intonations, easily traced to second generation field painting, began to effect this new technological focus as well.

One aspect of post-Minimalism, however, remained faithful to the exploratory nature of the style. The post-Minimalist group contains those figures broadly designated as Conceptualist. One part of this group took as its models the lessons of Duchamp who, in an extraordinary way, first saw that art need not only be a function of tangible or visible form but sought as well to make manifest its existence through linguistic premises. These figures may be designated "ontological Conceptualists," that is, Conceptualists whose art is recognizable as art because they make themselves recognizable

as artists. The source of their work comes from their *being*. This art is implicitly pitted against another sort of Conceptualism that may be designated "epistemological," that is, an art which demonstrates through preexecutive analysis a connectedness to the intellectual art of the Russian Revolution. These artists are animated not by their consciousness of *being*, but by their commitment to *doing*. What is already apparent is that those Conceptualists most affiliated with Duchamp have placed too high a burden on the public persona and on self-presentation. The art of the Conceptual theatre has emerged — Gilbert & George, Vito Acconci, etc.

Of interest is the Conceptual activity allied to Suprematism. The esthetics of this Soviet Russian style, which so fundamentally shaped Minimalism, continues to shape the post-Minimalism immediately committed to an art beyond the mere visual appurtenances of canvas, color, and material. Instead it seeks an externalization through the employment of principles of language, an expression in language's structure, and demonstrations of the nature of truth. Several artists have pursued such lines of inquiry but none have done so more acutely than Mel Bochner. Bochner is not animated by any notion of "vanguardism." The term itself is anathema to him — vulgar, meaningful only to a patented sector of the art community and to academic frames of discourse. Bochner does not regard his work as "far out," or "in touch." He simply "does art" from day to day, a doing that in the context of his life is neither disruptive nor extreme.

II

Mel Bochner ought not to have been an artist, unless the cultural neutrality of his Pittsburgh childhood and youth were, in fact, the very requirements for a kind of art seemingly divorced from conventional frames of cultural or pictorial reference. Still, there are hints. His father was a sign painter, who had thought to become an illustrator, an unrealizable ambition given his economic situation. He may have nurtured however unconsciously on his part, his son's ambition to become an artist, the first stages of which Bochner began

as a student at the Carnegie Institute of Technology from 1958-1962, after completion of his military service. In this period Carnegie Tech was an uninspiring training ground for illustrators, but word did circulate that one of its graduates, Andy Warhol, was beginning to make a stir in New York when he switched from successful shoe illustration to a harsher painting based on popular advertising imagery. "Warhol made us realize that it was possible to be an artist and to have gone to Carnegie Tech."

The release from Pittsburgh and the *wanderjahre* it inaugurated first drew Bochner to San Francisco where he supported himself by doing odd jobs in antique restoration. His paintings, he recalls — they have been destroyed — were distantly reminiscent (as befits the locale) of Clyfford Still. Several blunt kinds of pictorial experimentation led him to undertake monochromatic exercises, the most significant of which was a gray 12" x 12" panel covered in thick paint and marked with a smeared hand trail. The similarity of this work to Jasper Johns' encaustic number series of the mid-'50s was observed by a friend — a critical connection which drew Bochner to a serious assessment of Johns and one which released him from the onus of painting itself. "When I first came to know Jasper John's work I saw that I could stop painting." Bochner was so struck, in fact, by John's number series that he began to desultorily jot down a body of notes on the meanings and implications of Johns' work. "Jasper Johns' *0 through 9*," he noted, "defines the lateral boundaries of its surface by measure of the stencil typeface used for the successive laying on of numerals. Both the visual and conceptual parameters of what is there to be looked at are present by the procedures necessary for its realization..." This worn pocket notebook became the source of a book called *Excerpts and Speculations,* which Bochner produced in single Xerox copy in 1968.[1]

The primacy of Johns in Bochner's work is further testified to in an address that Bochner made at the Institute of Contemporary Art, London, in 1971. Viewing the present situation as one of "post-

[1] It was this material, excepting the observations on Johns, that became "Excerpts from Speculations," *Artforum,* May, 1970. The use of the word "speculations" in the essay's title indicates Bochner's great appreciation of T.E. Hulme's *Speculations,* the general title by which the latter's philosophy and aesthetics came to be known.

modernism," he queried his audience if "Anyone ten years ago could have imagined that 'modern art' would become a period style?" According to Bochner, the inception of the "post-modernist" phase began with Johns, who first rejected sense data and centristic personality as the basis for art, partly replacing these conventions with another more investigative approach. Bochner contended that Johns

> interrogated the phenomenological condition of painting but went further by injecting doubt into the deadening self-belief of art-thinking to that time. Most essentially he raised the question of the relation of language to art. His paintings demonstrated that neither was reducible to the other's terms. It is in vain that we attempt to show by the use of images, what we are saying. After Johns we can never again slide surreptitiously from the space of statements to the space of events... in other words, fold one over the other as if they were equivalents. This alone signified the demise of expressionist art.[2]

In 1963 Bochner traveled back east, registering as a philosophy major at Northwestern University on the outskirts of Chicago. At the time Northwestern University was one of the few American seats of learning in which a strong emphasis on Phenomenology and Structuralism was to be found. Bochner began to read Roland Barthes. A reference in Barthes led Bochner to the objectified novels of Alain Robbe-Grillet. Apart from an occasional oblique phenomenological inference in Bochner's larger and later works, the year's tutelage in philosophy was important in that it supported an anti-expressionist drift in Bochner's mode of experience — post-Sartrian, post-existential, resistant to the humanistic glorification of angst, emotion, and romantic idealization. The chief philosophical figure who came to dominate Bochner's thinking is Michel Foucault who stringently emphasizes preoccupations with exactness, measurability, and definability, issues which Bochner epitomizes for us in terms of his own work. Bochner's preferred reading remains Foucault's *The Order of Things* (*Les mots et les choses*).
At this point, in 1964, Bochner arrived in New York City and

[2] Unpublished manuscript, "Problematic Aspects of Critical/Mathematic Constructs in My Art," 1971.

found cheap quarters in the east 70s. He supported himself as a guard at the Jewish Museum, a job he held until 1965. The first deep friend he made in New York was Eva Hesse. In my essay on Hesse[3] I have indicated the crucial interchange between friends that was taking place in the period of 1966. Notable among the encounters made by Bochner was one with Jasper Johns, to whose number paintings Bochner had attributed a systematized structure foreign to John's own view of them, at least in so far as the artist then discussed them with Bochner.

By 1966 the circle of Bochner's friends was formed. The circle ranged from Robert Smithson to Eva Hesse, and included other figures such as Brice Marden, and later Dorothea Rockburne. The catalytic figure in all of this is Sol LeWitt who exerted a moral influence in terms of the model of his dedication to art and who gave encouragement to artists less well-known than he. Sol LeWitt's contribution to these disparate artists is best understood in terms of the emphasis he placed on preexecutive articulation of any given problem. The complexity of the Post-Minimalist situation is exemplified by the fact that the exhibition called "Ten," one of the important exposures of Minimalist sensibility then at its apogee, opened on the same day in September, 1966, and in the same building as "Eccentric Abstraction," which was one of the first surveys of counter-Minimalist sensibility. "Ten," with its dignified square catalogue designed by LeWitt, was held at the Dwan Gallery; "Eccentric Abstraction," with its vinyl encased critical broadside by Lucy Lippard, was held at the Fischbach Gallery.

It was in the context of Minimalism that Robert Smithson emerged as well. However, the idiosyncratic view within his work was different from the rational systems favored by LeWitt and Bochner. LeWitt worked from a premise which rejected nothing implicit in a system once the system had been determined. At this time LeWitt was working with examinations of grid structures and all the possible permutations which occur in the facets of triadic groups of cubes one placed atop the other. Smithson, by contrast, in adopting certain systems in his work always inflected this work with

[3] "Eva Hesse: Post-Minimalism into Sublime," *Artforum*, November, 1971.

elisions, rejections, and increments which were not necessarily schematically inherent, but which came about through a more spontaneous response to geographical environment.

Within this spectrum of shifting Minimalist and post-Minimalist possibilities Bochner's earliest consistent work was a set of drawings based on the permuted possibilities of open squares similar to LeWitt's examination of triadic structure (Figs. 26, 27). It is not surprising either that all three, LeWitt, Smithson, and Bochner, responding to the heightened consciousness provoked by their social intercourse, pursued brief careers as art critics, writing hardnosed reviews of exhibitions unsympathetic to the larger aspect of the scene, but also writing key articles in the history of Minimalism. A didactic mentor, Don Judd, had also been writing criticism since 1959 when he joined the masthead of *Art Magazine,* then edited by Hilton Kramer. Judd had sponsored in the context of gallery reviews and the use of sparse description an art of unitary, stripped-down objects. Judd was the only reviewer these artists read with any degree of regularity or approval.

Typical of the connectedness of the critical thinking between these artists was a review written by Bochner and Smithson in a short-lived magazine, *Art Voices.* Quixotically, they "covered" the opening of the still unfinished interior of the Hayden Planetarium annex and wrote an ironic, multi-leveled photo essay called "The Domain of the Great Bear" (Fall, 1966). These collaborations are especially interesting because they attempt to solve the problem of lack of gallery exposure through the gesture of a review which, before anything else, is its own art manifestation. The most arcane feature of the piece is that several of the authors cited in the work — Piaget and Poe among them — had statements falsely attributed to them or were attributed statements the artists felt such authors were likely to make. Such a conceit crops up again several times in Bochner's career. The grid structure organization of Bochner's review of "Alfaville, Godard's Apocalypse" (*Arts Magazine,* May, 1968), incorporated quotations from disparate sources — some of them again falsely attributed. More recently, in the *"Konzept"- Kunst* catalogue for the Kunstmuseum in Basel (March-April, 1972), Bochner's entry thrice reads "Language represents thought,

as thought represents itself," a citation attributed first to Hegel, then to Mallarmé, then to Husserl. The work shows that the constant invented by the artist is a variable, whose shifting meaning is affected by our notions of the work of each of the figures to whom the statement is attributed. The statement, if made by Hegel, reads as if it were an epigram of Dialectical Idealism; if made by Mallarmé, an expression of thought as a condition of soul; if made by Husserl, the impression that thought is a phenomenological element, as if something solid. The contribution reiterates a message central to Bochner's premise, namely, that "Language is not transparent," now almost a catchphrase associated with the artist since he chalked it upon a blackened wall of the Dwan Gallery for the "Language IV" exhibition in June, 1970.

By 1966, the essential preoccupation of Bochner had become his notebooks in which complete notions and structural premises were worked out in highly finished diagrams. The first of these notebooks dates from 1964 when Bochner was still working at the Jewish Museum. This leatherette journal begins with illusionistic drawings for constructions which, generally speaking, contrast biomorphic forms against assertive geometrical ones. Their relationship to so distant a forbear as the *Abstraction-Création* group is still evident. In the course of elaborating this notebook sketch by sketch, day by day, an important leap took place in 1965. This is evidenced on a page for projected drawings, the shelf pieces, sketches for a work made, but later destroyed.

The drawings' strict measurements and simple structure reveal an appreciation for Don Judd's position. "I saw my first Judd in 1965, after I made the piece, but I read Judd's writing in *Arts Magazine*, as everyone else did, and I was aware that it was an apology for a specific position that artists were already calling primary structures." The shelf drawings occasioned the first verbal descriptions, an attempt to create as sharp an analysis of this object as Bochner had found in Robbe-Grillet's precise descriptions of objects:

> The point of this piece is to concretize one section of 'space'. To objectify, solidify and realize it. The 'form' it takes is a line. A hard, brittle metallic blue core which is also the time that is required to

move from point left to point right. The supports take on the characteristics of wall brackets in order to stress their unimportance. They are painted whatever color the wall is.

Impressed by Dan Flavin's fluorescent show at the now defunct Green Gallery in Winter, 1965, Bochner began to project small structures contrasting fluorescent tubes with mirrors—materials similar at the time to Robert Smithson's layers of mirror. Bochner's sharing of ideas visible in Judd's and Flavin's work meant that by 1965 his tendencies were clearly articulated and related to the strongest manifestation then open to American art. This becomes self-evident if we study the 1965 drawings which deal with simple numerical systems of triangles and hemispheres. They signal the beginning of a stress on set theory which continues to the present. Equally noteworthy are his attempts to work out complex structures which adumbrate a regularizing system without recourse to the conventional western 90 degree grid.

Bochner supported himself through 1965 by doing assorted odd jobs and through writing reviews for *Arts Magazine*. An adept apologist for the structural options of Minimalism, seriality and primary structures, Bochner's seriousness of attack must be acknowledged. He wrote such essays as: "Primary Structures," a review of an art exhibition for the Jewish Museum (*Arts Magazine*, September-October, 1966), an analysis of the fourth annual exhibition chosen by Elayne Varian at Finch College; "Systemic" (*Arts Magazine*, October, 1966), a study of Lawrence Alloway's overview at the Guggenheim; and "Serial Art, Systems, Solipsism" (*Arts Magazine*, Summer, 1967), which was republished in *Minimal Art*, a collection of essays edited by Gregory Battcock.

Bochner championed the preexecutive in art, what we would today call the Conceptual. Throughout 1966 Bochner argued that the best work of the day was being done by Carl Andre, Dan Flavin, Sol LeWitt, Don Judd, Robert Morris and Robert Smithson; all other comers were dismissed out of hand as dilutants and mannerists. The ending of his essay "Primary Structures" has the intransigent stance of a T. E. Hulme arguing for the London Group in 1914:

The New Art... is unlifelike, not spontaneous, exclusive... It is not engineering. It is not appliances. It is not faceless and impersonal. It will not become academic. It offers no outline or formula. It denies everything it asserts. The implications are astounding. Art no longer need pretend to be about Life. Inhibitions, dogmas and anxieties of nineteenth-century romance disappear. Art is, after all, Nothing.

Bochner's most prescient single review expressed an early disaffection for Frank Stella's painting. Writing in May, 1966, of Stella's exhibition at Castelli, Bochner understood the painter's predicament at a moment coincidental with his ascendance as the most potent figure in American art. Bochner observed that

> The logic and stringency of Frank Stella's earlier work directly opposed growth. His *completeness* was his insistency. In his latest pictures, since the possibilities of sequential development were excluded, he had to choose to be 'somewhere else'. The choice appears unfortunate. He counters all his previous virtues: symmetry with awkwardness, refinement with raucousness, strictness with arbitrariness. By trying to do something with Stella, he appears to have joined his imitators and variationists (*Arts Magazine,* May, 1966).

In 1967 Bochner's drawings incorporated a changed medium. Turning to black masking tape, he worked out a number of grid projects which were photographed after the tape was adhered to the flat surface of table or wall. He at length abandoned photography since it was expensive, and, more negatively, the photograph itself became an object in the world. Certain photographs developed visual deformation conundrums, such as when a grid applied to the projecting corner of a wall was shown in a flat photograph.[4]
It was in 1967 as well that Bochner made his first language experiments such as "Orthogonal Routes for/of Duchamp Re — (Blossoming) ABC," which may be likened to Carl Andre's rebus poems set in grid formations, although Bochner's are more abstractly permutative. Broadly speaking Andre's poems alter actual "sense." There is no search for literary "sense" in Bochner's verbal

[4] These photographs may be associated with Jan Dibbets' "perspective corrections," one of which, *Forest Piece* 1969, Bochner used to illustrate "Excerpts from Speculations," *Artforum,* May, 1970.

reformulations, although there is constant structural meaning. In this they may be likened to the artist's interest in serial music, *musique concrète,* the work of Stockhausen and Pierre Boulez, which he first began to listen to when a student at Northwestern. Bochner cites J. S. Bach, Schoenberg, Stockhausen and Boulez as models for works of art "based on the application of rigorous governing logics rather than on personal decision-making," a methodology which Bochner called "solipsistic" in "Serial Art, Systems, Solipsism." "For the solipsist," he wrote, "reality is not enough. He denies the existence of anything outside the self-enclosed confines of his own mind." Among other examples Bochner cites Jasper Johns, Sol LeWitt, Don Judd, Robert Smithson, Dorothea Rockburne and Eva Hesse, that is, "...artists who carry out their work to its logical conclusion, which, without adjustments based on taste or chance, is the work." Importantly, he notes that "No stylistic or material qualities unite the artists using this approach because what form the work takes is unimportant (some of these artists had ceased to make 'things')."

As early as 1967 then, Bochner had recognized that art may be, but need no longer be embodied in some kind of here and now sensuous object, like those things conventionally called paintings or sculptures. The feature that made art of certain activities was the integrity of the thinking that the work entailed. This is not the central focus of Minimalism — though it is implicit in the style — since, whatever else it may be, Minimalism was primarily realized in the fabrication of autonomous objects. At this point Bochner had come to personify what by now is self-evident — that whatever else art may be, it is the best *thinking* of any given moment.

Measurements, Drawings and Projects of 1967 and 1968 freed the artist from making photographs and objects. The primary works of this looseleaf binder were prepared diagrams for work to be executed in brown paper, to be marked with numerical charcoal indications for wall situations. Originally these investigations began with the set of substructures imposed by 36" x 48" elements, a convenient sheet size of industrially cut paper. These working drawings were later edited into a finished leatherette journal,

111

consisting of 28 finished drawings, a one-copy book called *Catalog of Plans 1967-68*.[5]

The *Catalog of Plans 1967-68* may be related to the experiments with set theory and scale relationships that interest Dorothea Rockburne. Bochner and Rockburne were aware of one another's work as early as 1967. During the following two years their preferred choice of material is often the same, paper especially, or simple substances like charcoal. Direct appendage of the work to the wall or laid directly upon the floor, a predilection for mathematics and set theory, "solipsistic" working through of problems, the absence of coloristic interest, and, above all, the intense rigor or intellectual commitment are further aspects of a certain theoretical similarity. The vital difference is one of affect. In Rockburne's work the issues addressed locate themselves within a quite different — seemingly more subjective — sphere of visual argument, particularly in her use of materials.

Bochner's *Catalog of Plans 1967-68* contains numerous experiments of significance, such as the measurements of excised elements of fixed shapes, the cubic measurements of the absent content of empty forms, the comparative relationships of constant paper measurements (one crumpled, one pristine), essays in variable lengths of paper unified through the use of constant widths. Most important was the introduction of the cord compass, a measuring device perhaps traceable to Jasper Johns' use of rulers radially dragged through wet paint. Bochner found the compass to be "the best universal to work with as it does not depend on rectilinear organizations of wall to floor." This idea matured in the period 1968-1970 and led to the "Generic Drawings" show at the Galleria Sperone, Turin, 1970, in which the string compass was used to establish the dimensions of the walls through the use of broad charcoal arc-segments self-recording a fundamental circular set.

The use of string compasses — and the concomitant indication of

[5] Bochner is strongly attached to didactic ends. He has produced not only books made by hand but also extremely limited edition books — or booklets — dealing with either exhibition material or with working aphorisms. The most influential of the latter is the French/English edition of *11 Excerpts*, put out by the Sonnabend Press in Paris. Its tone and scale are marked by *The Little Red Book of Chairman Mao*.

quadrant directions — led to the configuration of the ACE Gallery show, Los Angeles, during the summer of 1969, in which only the circular quadrants remain, not demarcating the rectilinearity of the wall or the floor, but the polarities North, East, South, West, independent of the gallery's actual structure.

Despite the richness of his production in 1968, the artist destroyed a large body of work. A single looseleaf binder remains, *Measurements and Theories: Drawings and Projects, 1968-1970,* a major concern of which is the blunt measurement of space. In May, 1969, the German dealer, Heiner Friedrich, gave Bochner his first one-man show at his Munich gallery. Bochner's installation, *Measurements* (Fig. 28), regarded the space as a rigorous compendium of exact measurements such as one finds on the blueprints of architectural specifications. Bochner had originally offered to execute a work called *No Vantage Point,* by which he intended that the gallery be painted white and a line be drawn across the entire enclosure at the artist's eye-level. (This proposal was repeated, but it reappeared in the Museum of Modern Art, New York City, "Projects" exhibition of 1971.) *Measurements* led to further German gallery activity. Bochner exhibited at the Konrad Fischer Gallery in Düsseldorf an installation of a longitudinal measurement dividing the entire space vertically in half. This was the theoretical counterpart to *No Vantage Point.* By this time Bochner was considered a pivotal figure of the Conceptualist movement, especially after his inclusion in "When Attitudes Become Form," Kunsthalle, Bern, an influential exhibition held early in 1969. At this international congregation, Bochner was represented by a long row of sheets of graph paper, 8½ inches wide, stapled in horizontal alignment to the wall, one beside the other.

But to conveniently tag Bochner as a "Conceptualist" is too delimiting because it does not take into account the strong sculptural feel of much of his work. I regard Bochner as an artist conscious of the physical, a kind of sculptor more than just a draftsman, although the setting down of diagrams may more easily be associated with drawing. Diagrams concentrate potentially vast organizations of spatial and surface locations, either in exact terms or in terms of perverse ambiguity — such as when we deal with the compass-drawn circles, or with eye-level lines. The most easily readable

sculptural effort is *A Theory of Sculpture,* installed in an abandoned factory in Turin. This work, which tests the possibilities of numerous measuring devices, especially the compass, also incorporates tangible members such as rudimentary plumblines. Moreover, actual physical elements lean and balance, interconnecting wall and floor and recall Bochner's preoccupation with primary structures as well as the work of Richard Serra. But the issue at hand is not physicality or materiality, but rather the exposure of principles of structure which makes physicality or materiality *seem* tangible.

The preoccupation with *Measurements and Theories* led to the March, 1971, installation at the Greene Street Gallery, New York City. Since Bochner regarded it as the summation of measuring, the exhibition was called *Ten Aspects of the Theory of Measurement.* The computations which engaged Bochner's energies were "derived, compared, reversed, extended, halved, dispersed, partitioned, bent, deflected, non-referred," functions of a working module 11'10", the distance between the centers of two parallel structural columns. However, one "did not end up solely with the measurements, but with a transposition of feeling which, if felt at all, is usually experienced while moving through architecture, particularly of the Italian 15th century."[6]

The full permutation of an idea in the context of deobjectification was realized in the "Projects" installation at the Museum of Modern Art, New York City, November, 1971. The work, *Three Ideas & Seven Procedures* (Fig. 24), delineates seven methods — beginning, adding, repeating, exhausting, reversing, canceling, and stopping — employed to give visibility to the nonphysical, tripartite expression of number: zero, number and ultimately line. The exhibition was installed in a sequence of spaces, painted white and interconnected by a length of masking tape applied to the walls running from room to room at a constant height. Upon this tape was recorded a counting sequence left to right in black, and superimposed on this sequence in

[6] R. Pincus-Witten, *Artforum,* May, 1971. This observation was corroborated by several Italian projects located in architecture of the kind noted, the most recent, installed in the Chiesa San Nicolò, Spoleto, in which the artist laid down in cruciform pattern fragments of Roman moldings, a spare variation of the ACE Gallery polarities.

red, right to left, a countercounting sequence. This exhibition refers back to *No Vantage Point,* but more immediate to our considerations, it developed ideas thought out in Italy during the summer of 1971 when Bochner drew two pencil lines across the face of a Renaissance room, one marking true eye-level, the other approximating it by hand. These kinds of actions indicated that by this point there were indeed two types of conceptual activity — the ontological, and the epistomological. This distinction provides the basis for critical judgment with Conceptualism, a movement which seeks to defeat criticism and art history through the incorporation of the methods of these disciplines.

To some measure the fact that Bochner's work takes place within chambers or upon walls means that a phenomenological thrust, however inadvertent, must be taken into account. Still, whatever the physiological experience implicit in such a situation, such an effect is only an ancillary result rather than a primary ambition. In this way Bochner's work should not be confused with that done recently by Bruce Nauman, Michael Asher, or Keith Sonnier.

Throughout 1969 it was apparent to Bochner that the core of his ambitions had become the discovery of meta-theoretical bases of activity, as well as the exhaustion (diagrammatically or theoretically speaking) of all possibilities implicit in any given informational situation. From this time, he subsumed his work under the generic title of "the theory," or "a theory," such as *A Theory of Objects: Line, Plane, Volume.*

Perhaps the leanest, most perplexingly stripped-down exhibition was *The Seven Properties of Between* (Fig. 29), installed at the Sonnabend Gallery, New York City, February, 1972. Utilizing several small stones, Bochner demonstrated seven axiomatic statements of the kind "If X is between A and B, it is not identical with A or B," or "If nothing is between A and B, they are identical." Among the difficulties of the exhibition was that these statements, inscribed on typerwriter-size sheets of paper, were placed on the floor in a seemingly arbitrary fashion, some paralleling the walls, others oblique to them. In fact, these locations were not arbitrary at all, but were part of a system aimed at distinguishing those statements in terms of their verifiability.

With regard to this problem, it is meaningful to view aspects of Bochner's activity in reference to issues brought up by the syntactical structures of Noam Chomsky. One of Chomsky's leading interpreters, John Searle, recognized that

> purely formal constraints placed on the semantic theory are not much help in telling what the readings are. They tell us only that a sentence that is ambiguous in three ways must have three readings, a nonsense sentence no readings, two synonymous sentences must have the same readings, and so on. But so far as these requirements go, the reading need not be composed of words but could be composed of any formally specifiable set of objects. They could be numerals, piles of stone, old cars, strings of symbols, anything whatever. Suppose we decide to interpret the readings as piles of stones. Then for a threeways ambiguous sentence the theory will give us three piles of stones, for a nonsense sentence, no piles of stones, for an analytic sentence the arrangements of stones in the predicate pile will be duplicated in the subject pile, and so on.[7]

In terms of Bochner's work such an analogy indicates that physicality or materiality is not his work's core and indeed it may be only an ancillary consideration of the information projected. Therefore, the stones — and more recently the leaves, the hazelnuts, the architectural fragments, the pieces of chalk, etc. — which constitute the viable tangible elements of Bochner's recent work are not to the point. With Bochner, substance is neutral, its quiddity is beside the point, merely a necessary evil, not used as "signature" material.

The relative insignificance of the physical substance of Bochner's art means that his work is pared down to an almost lean "otherness." In works relating to the Conceptual theater say or any of the several examples of post-Minimal phenomenology, there is always the tacit assumption of communal exchange between art and viewer. Bochner's work makes the most marginal concessions to even highly attenuated notions of "communication." It remains "out there," beyond the pale of conventional taxonomy.

In a perspicuous review of *The Seven Properties of Between,* Lizzie Borden, taking her clue from a reading of Wittgenstein, understood

[7] John Searle, "Chomsky's Revolution in Linguistics," *The New York Review of Books,* June 29, 1972, p. 22.

that "Bochner's literal mapping of these propositions seems to exhibit the relation of abstract logical truths to the structure of reality," concluding that

> The rocks, signifying necessary truths, are abstracted from the contexts we generally use in considering statements. Bochner has attempted to prove that the limits of logical articulation can lead to puzzling and obscurantist statements. The problem lies in an erroneous search for meanings in the objects themselves. By showing what cannot be stated, Bochner demonstrates the importance of ostensive definition, or gesture, in the comprehension of meaning. (*Artforum,* April, 1972)

The artist himself was prompted to write several pages on the subject since the *Seven Properties of Between* represented a "quantum leap" for his thought, one which "led, perhaps hesitantly, to the formulation of a meta-critical art." Since this document, a personal letter, constitutes a key exposition of the artist's thought, in conclusion I must cite from it at length: "Beginning with the premise that art's basis is knowledge, we can rapidly deduce that there is no art imperative for the object," the proof of this being that "there are pre-language operations but no pre-language objects." Still, "The question basic to any endeavor which sets out to examine knowledge is 'How do I know this is true?'... the verification problem... Therefore, the *task* of epistemological research... is to raise the verification problem to the foreground of esthetic problems." Bochner saw that the verification problem could be reduced to at least four components. "The first is tautological; a principle for determining truth which requires nothing outside itself. This is the truth of mathematics..." to which the artist appends the caveat, that to understand the meaning of his art as mathematics is false, since it is not his intention "to replace antiques with textbooks... My aim is to apply the same stiff criteria to thought that exists in any other theoretical endeavor, to reclaim the knowledge in art by art... The second verification principle involves specificity, a statement which necessitated an appeal to the stones to validate it. If, for example, I said that my pen is black, you would have to see this pen to know if my statement were true. The third case is more difficult to explain. Here, I was demon-

strating propositions which corresponded to the fact of the arrangement, but not solely to that arrangement. The statement was true for this instance, but not for all instances...." This generalizing principle was active in several of the 7 *Properties,* especially the wall. "This all brings me to the fourth principle, namely, the act of faith. In the piece which 'stood alone' in the back room I made a statement which was not true [If nothing is between A and B, they are identical] and a demonstration of it. The demonstration *appeared* to verify the sentence, but upon reflection could not possibly. However, given the situation/circumstances it was completely acceptable because of the conditioning inspired by the other six [examples]... Finally, all of these remarks are useless if the experience is not congruent with the thought."

My view of Bochner's art is that the experience is congruent with the thought.

BARRY LE VA:
THE INVISIBILITY OF CONTENT

A central option of advanced art in the late 1960s was the exploration of a "dealt-out" expressionist pictorial/sculpture. Lynda Benglis' manifestation of the style—linked to ritual issues in Pollock and a cult of media personality derived from Warhol—is typical. In the work of the late Eva Hesse, a vision of the Sublime (endemic to the first Abstract-Expressionist group) was developed alongside of postulates derived from Minimalist seriality. The Abstract-Expressionist quotient of Richard Serra's lead tossings keyed into a concern for process and the quiddity of sheer material implicit in Minimalist sculpture such as that by Don Judd and Carl Andre. Yet perhaps the earliest serious investigations of the pictorial/sculptural phase of post-Minimalism—ones that had a wide effect owing to a reproduction on the cover of *Artforum* in November, 1968—were the "distribution pieces" made from felt by Barry Le Va.[1] Yet, despite the almost instantaneous (and perhaps transient) awareness of his work of the late 1960s—a celebrity by art school imitation, stylistic rip-offs that in no way acknowledged their source—Le Va's career, of all the figures with whom he can be associated (Serra, Benglis, Keith Sonnier, et al.), remains one neither crowned by financial success nor illuminated by critical discussion.

Like Serra, Le Va comes from California. Born in 1941, he grew up in the Los Angeles suburbs. Protestant ethos stuff; his father's family was originally Alsatian, his mother's Scotch-Irish. High school and the crucial adolescent years in Long Beach. "It's a car culture, so when you get a car, you start finding out things to do." Finding out things to do in the fifties meant two things to Le Va:

[1] For an article by Jane Livingston, "Barry Le Va: Distributional Sculpture."

hard drugs for sure and art school maybe. Although he had always been interested in art and architecture, there seemed no way in. Drugs were a great adventure, but when a number of friends OD'd, Le Va recognized the importance of his original life choice. Art school seemed more attractive.

But art school in Southern California at the time offered little to Le Va; first "the brainless commercial art" of the L.A. Art Center (1964) and then the proscriptive expressionist figuration of the Otis Art Institute (1964-67). Still, while at Otis, Le Va responded to the teaching of Dr. Ralph Cohen who taught philosophy of aesthetics and provided the artist with an intellectual model whose world was scholarly. "He drew me to metaphysical speculation."

Le Va determined to be a painter, an ambition vaguely informed by images of Pollock and Newman, but as they appeared in *Life* magazine reportages. The "official studio style" in L.A. at the time was that of Rico Lebrun, one derived from Picasso's *Guernica*. By the mid-1960s, fashionable East Coast styles began to inflect this expressionist figuration, namely, hard-edge abstraction and Pop. Le Va's student paintings began to take seemingly trivial scenes like cocktail parties as subjects. These were smartened with stripes in the background or bright Pop colors. These "parodies of actions that happened in comic books" led Le Va to think of such organizations as potentialy three-dimensional, as a kind of mixture of painting and cutouts. This "objectification of a cartoon action" occupied him until the spring of 1966. The soft and funky materials used in this work, as well as its Pop figurative elements, dissipated into a more generally abstract, albeit expressionist, arrangement of shapes situated within a room (Fig. 30). Since the studios at the school were too cramped for this development, Le Va got one of his own. At length, "it was the stuff lying around in the making that became interesting, the absence of specific forms. It was the scraps, the stages, the time factors, the stuff around the object that grew more important than the object itself." Oyvind Fahlström, as Le Va acknowledges, informed his work of this time. "By then I knew about L.A. cult figures, but I didn't know any artists. La Cienega [Los Angeles' "gallery row"] just seemed all wrong for good art, and L.A. was too social. When I graduated in 1967, I had plans of coming to New

York. By then I knew that all the work that interested me was coming out of New York—especially the artists' writings."

Between 1966 and 1967, Le Va executed ten plexiglass trays filled with felt, "not exactly to get my MFA, but to have something to show at the graduate exhibition as Otis refused to show a floor felt unless it was put on a base." The trays, first to tenth, range in complexity from the simplest to the most intricately folded. The last year of art school coincided with a period of great growth in the off campus studio work. The studio work, for the most part, met with abuse from his professors, fellow students, and the Los Angeles gallery world. "I wanted to reduce art to my terms, then rebuild it—my terms, with nobody else's influence." It was not art, his critics claimed; it was not permanent, it was impossible of ownership. Their unconscious position was that artmaking was determined by a successful art market sensibility; hence it was, in its way, politically conscious (if reactionary) since it was oriented towards gratifying ownership.

Two professional critics on the West Coast were drawn to Le Va's out-of-school work: Arthur Secunda (himself an artist of neo-Dada bent), who sent photographs of the work to Barbara Rose in response to her "The Value of Didactic Art" article, and Fidel Danieli, who wrote the first note on Le Va's distribution pieces.[2] A complicated evolution was taking place in New York at the time. High abstraction was embodied in the architectural/sculptural mode of Minimalism. By 1968, the reaction to this taciturn iconic style was being effected, partly by the very figures who had legitimized minimalism in the first place (notably Robert Smithson and Robert Morris). This reaction publicly addressed issues that Le Va had been working out since 1966 in his "distributed" studio work.

The first pictorial/sculptural phase of post-Minimalism was accomplished in New York in part by Serra (who had started in San Francisco) and Hesse through work that de-emphasized the rigorous solipsisms of Minimalism in favor of an eccentric and expressionistically linked procedure. But it was Morris who, in the public's

[2] Barbara Rose, "The Value of Didactic Art," *Artforum*, April, 1967; Fidel Danieli, "Some New Los Angeles Artists," *Artforum*, March, 1968. The other artists were James De France, Peter Alexander and Carl Cheng.

121

mind, most embodied this alteration in style. His celebrated essay "Anti Form" appeared in *Artforum* (April, 1968); and in a long analysis of "9 in a Warehouse," the influential exhibition of this new tendency, Max Kozloff stated that it was Morris who assembled the artists represented. Philip Leider's more general account of the exhibition was entitled by the *New York Times* features editor "The Properties of Materials: In the Shadow of Robert Morris," reinforcing the notion that these changes were attributable to the catalytic effect of Robert Morris.[3]

Although Le Va does not figure in Morris' warehouse overview nor in the "Anti Form" position paper, he was a natural for inclusion in the "Anti-Illusion: Procedures and and Materials" exhibition held at the Whitney Museum in May-July of 1969. The attitudes behind his California felt pieces parallel the East Coast developments, yet Le Va views the anti-formal phase of Morris' work as "still tied to an object aesthetic, an art still captured in a single glance." He placed this interdiction as well on the artists who participated in the "9 in a Warehouse" show, among them Bollinger, Hesse, Nauman, Saret, Serra, and Sonnier.

Be these connections to Morris as they may, the stronger critical issue to be argued is the relation of Le Va's distribution pieces to Serra's process works which appear at the same moment. At a superficial reading, they occupy a wide overlap. Yet important distinctions must be made between them, the chief being Serra's attachment to distinct axiality and clear directional points of reference. Le Va rejected axiality for wide unclear dispersal in which scale—at times up to eighty feet in one direction—de-emphasizes objecthood. Serra's work of 1967-68 dealt largely with object as weight and constancy, whereas Le Va is interested in the ephemeral. In short, Serra's process pieces reveal his internal psychic condition as a sculptor; Le Va's reveal his fundamental psychological commitment as a painter.

Serra (and Smithson) admitted of entropy—the return of matter through chaos to the state of inert homogeneity—only as it was

[3] Max Kozloff, "9 in a Warehouse," *Artforum*, February, 1969; Philip Leider, *New York Times*, December 22, 1968.

a function of an entire organic process; it grew and then it came apart. This is very different from Le Va's perpetual chaos. Romantic and expressionist to the core, his work was not entropic; it didn't reveal in a later stage of disintegration indices of earlier phases of integration since, in a certain sense, Le Va's work denied integration from the outset.

Still, definable issues were addressed, if even broadly, in the diffuse nature of the 1967-68 pieces. In highly general ways, tangents were alluded to, overlaps described, and sites, directions, scales, spaces, and memories were all brought into play. Such visual comparisons, as were consonant with the expressionist cast of this moment, were interesting to the artist only in the instant of their being done, but they were visually not to be gathered after their execution. (Today, all of this work is known only through photographs). The irony of this romantic and expressionist position is epitomized in Le Va's comparison between one felt piece arranged by chance through dropping and tossing and another made according to a studious taste-oriented placement. One could not tell one from the other nor say which piece was better for a simple paradox: "content is something that can't be seen."

Upon his graduation from Otis in 1967, New York was still two years in the offing. Le Va spent the interim teaching at the Minneapolis School of Art, putting aside money to come East. Perplexed during these years by the invisibility of content, Le Va at his Minneapolis remove reflected deeply on the means to render the elements of his environmental pieces more clear. His reading changed from, say, a cult book of the 1960s like Daniel Spoerri's *An Anecdoted Typography of Chance* [4] to adventures of Sherlock Holmes and Ellery Queen. The point of a mystery story is to render visible the invisible content through a manifest fact, the clue. The artist becomes the criminal, the spectator the detective. Thus, tangent, overlap, site, direction, scale, space, and memory—the concerns of the "distribution pieces"—need not remain in an

[4] In this *nouveau realiste* and Fluxus work, Spoerri set up a chance studio still life and then painstakingly, often esoterically, catalogued each element within it. The unfixed nature of chance studio still-life elements were transformed into specific mapping and data retrieval—a kind of research collation.

expressionist limbo of perfect chance if one adduces them as a set of clues which serve as designations that lead to specific contexts and contents. The latter in turn partially determine the original clue. The desire to discover the clue, one that was consistent with and true to the specific work although different from piece to piece, led Le Va to determine a visual syntax consonant with the givens of each new situation. Thus the sources of clues may derive from, say, the counterpoints of attributed circles, the physical obstructions of a specific site, the types of visual elements and their frequency, and most importantly, as it happened, the kinds of physical and mental actions the artist feels are necessary to the investigation of a basic situation.

Granting Le Va's expressionist grounding, the mature results of this quest did not suddenly emerge. One could not guess that the heady aggressivity of the 1968 phase would lead to the spare cleanness of the post-1972 work. This phase—say, 1968 through 1972—while shot through with new poles of attraction, particularly regarding the nature of clues, still retains the inflection of his earlier expressionism just as the spare character of the recent work can be seen with hindsight in the first California felts.

Not that this mid phase is indecisive or vacillating. Often it is very direct, especially when the work, activities, or procedures are conjoined to unequivocal written assertions (rare though these may be) affixed to photographs of the work. Much of this work may be misapprehended as conceptual documentation since, in the absence of a gallery audience, Le Va's works were executed in the studio and photographed. Thus the photograph has the character of a point of reference, an archival record of the work. The photograph itself is not the issue; it serves as attestation to work done.

Characteristic of the 1968-72 phase are the suite of efforts called *The Layered Pattern Acts* (Fig. 31), works, that examine explicit cause-and-effect activities. One type is atomized—executed in chalk powder; the other, made from glass sheets, is not. What happens when you toss so much weight of chalk powder over so much distance; or when a glass sheet on the floor is shattered with a hammer blow, and then another sheet is laid upon these fractured shards, and again the hammer blow is struck? This serial fracture is continued

through as many layers as the artist finds suitable, suitability, as always, being a function of site.[5] In addition to explicit structural information about physical action *The Layered Pattern Acts* incorporate psychological issues as well, although it is tricky to unravel them. Clearly the works are marked by an aggressive tone—the hammer blows, or the physicality of pitching—but this oblique quality of danger, I think, is still ultimately linked to Le Va's primary psychological painterliness.

By the end of 1972, a characteristic gravity and dignity is manifest in the work, a sober texture which can be accounted for by the artist's prevailing fascination with the role of the clue.

> "A clue in the detectival sense may be of an intangible as well as a tangible nature; it may be a state of mind as well as a state of fact; or it may derive from the absence of a relevant object as well as from the presence of an irrelevant one... But always, whatever its nature, the clue is the thread which guides the crime investigator through the labyrinth of nonessential data into the light of complete comprehension...." [6]

The exploration of a site in terms of clues is mapped out in working drawings that range from the sheerly improvisatory to the highly finished. In this sense, like so much drawing of today's abstract reductivism, Le Va's drawing serves little as a document of manual or visual sensibility (though once its intentions are admitted its "beauty" is manifest), and far more as a halfway house between architecture and sculpture. In this, its Minimalist gerund is maintained. Le Va's drawing is diagrammatic and demonstrative; it illustrates nothing, but instead works out the syntax for the kinds of problems to be solved in each site.

This distancing of drawing away from sensibility takes on larger ramifications in Le Va's work insofar as the problems addressed not only key into scale models, but models of bodily movement, and as such engage kinaesthetic notions. Yet the passing similarity

[5] The glass pieces received their most fulsome presentation at Documenta, 1972, where a negligent administration allowed the work to become damaged, first by hostile workmen who tossed beer bottles into the piece, and then by a public who walked upon the layers of glass, thus disordering every contextual reference of the fragments.

[6] William O. Green's introduction to *Ars Criminalis* by John Strang, quoted in Ellery Queen, *The French Powder Mystery* (Signet, New American Library, 1969), p. 82.

of Le Va's drawing to dance notation (or even to time-motion studies in urban planning), especially from 1973 to 1975, is a source the artist rejects if only because dance notation infers repeatability, mimicry of movement, whereas Le Va's systems of movement within a site, while repeatable, are, more importantly, permutable; one person's movement may be entirely different from another's, although the information constructed from these movements will be the same in the end.[7]

More recently, the artist's visual vocabulary, ascertainable from drawing and scaled up in the actual environment, led him to select lines that on the floor may be registered as lines or as lengths—long or short as the situation demands—of wood lathe. Frequently such lines are marked on the floor by short consistent lengths of wood, small rectangular markers. The organic associations of wood are incidental. Instead, wood is used because it is readily available and easy to work—like paper, chalk, or masking tape. Wood in this context presents no special sculptural problems, nor does it call attention to its gravity or the difficulty of its manipulation. In this sense, no eccentricity attaches to it, that is, none of the idiosyncracy typical of the use of, say, latex, foam, lead, or felt as these materials have been used as "signature substances" in the pictorial/sculptural phase of post-Minimalism.

Le Va's vocabulary of geometric elements, however, remains constant within each piece; and just as the artist's job is to determine a consistent vocabulary within the piece, so the viewer's job is to decipher, decode the vocabulary or syntax. Thus all information within a given piece is "factual"; it can be reconstructed as consistent information in the mind or the movements of the viewer, most probably both. As such it is not wholly based upon artistic

[7] "Visual structures are nothing but an aid to thinking and belong to the psychological apparatus which draws the conclusions, not the content of the thoughts themselves. Thinking does not aim at the pictures but the logical structures which they express." Hans Reichenback, *Space and Time* (Dover, New York, 1957), p. 97. It was this book, Le Va says, which led him to *The Walking Stick Pieces*, 1973. In general, *The Walking Stick Pieces* address two possibilities: "The stick can be moved end over end, repeating its own measurement while travelling, or it can be moved laterally across the floor. That's a variable; you can move it with a short or long swing in a zig-zag motion." Representative of the latter type—though in certain works these motions are mixed—is *Equal Wall Base Divisions Crossed: 4 Phases (Walked Zig-Zag; Ends Touch, Ends Cut)*, 1973.

taste; but, in the variety of permutations to which these reconstructions are liable, neither can the work be said to be wholly systemic. Artistic volition still plays its role. For example, the circle as an organizing principle, as a device so to speak, is a clue attractive to Le Va insofar as it tends to be "a more ambiguous constant than rectangles." Hence the circle's shape and size may be first determined by variables of choice, just as frequency of tangent and overlap is subject to volition as well. Variables that govern Le Va's decisions may be choice of circle size, original generative placement within the site (on the drawing or in the site itself), and perhaps most importantly, the decisions and movements that the spectator will adopt in apprehending the original organizing processes of the artist.

This description largely relates to the work of 1973-1975; insofar as the spectator's apprehension has become more subject to variability than before, it seems fair to assume that Le Va's period of detective mystery clues is drawing to a close. Greater ambiguity in his work may be anticipated, and in this his work is responding to the growing level of ambiguity—in this sense, greater aestheticism, sensible in the larger body of epistemic abstractionists, such as Mel Bochner, Dorothea Rockburne, and Bruce Boice.

Despite many points of agreement with these figures, Le Va is wary of facile couplings. In measure, he disassociates himself from the aspects of their exploration by pointing out their more readily visible "shape orientation." Moreover, "their interest is primarily with content itself. I'm still interested in work that has some content outside of itself; staying with the audience, but still not theater."

JACKIE FERRARA:
THE FEATHERY ELEVATOR

I. *The Formalist Dysfunction*

Italics. Interior monologue stuff. It's so pretentious. What's wrong? Perhaps what's right? Suddenly I can't write about art as if it existed in a sanitized vacuum. Now it's clear that my fascination with contemporary art has two approaches. One is a sense of excellence before certain experiences—that's it, that's clearly art— sensations which engage the obligation of formal analysis. Well, it's not really that way, since the awareness of excellence is primed by the Knowledge of how objects or activities key into history. It's the unanticipated relationship between art and its externals (history, society, what have you) that provokes the meaningful gut level response (the word "meaningful" is a sellout). My convictions seem so obvious that I speak of this or that artist, this or that work, without prefacing build. The public must surely see it, and yet I know it doesn't.

Until late in the sixties, solemn formalism was assumed to be the only way one talked about art. The mandarin tone obtained as the signal characteristic of distinguished critical and historical discussion. Disinterestedness. I don't get it anymore—well, not exclusivity. There's this other side of me, the other avenue—work perceived as significant must be invested with the value deriving from biography, the really lived, the idiosyncratic datum, the human. Biography as form; biography is form. Reluctance to acknowledge this stems from a puritanical abhorrence of gossip, and from a class and guiltridden snobbery against being "in commerce," of being "in trade." The open traffic in biography is seen as promotional, advertising. Perhaps. As always it remains a question of whose voice, who's talking. Another class-conscious exculpation.

I scorn the experiential sop, John Dewey's sentimental ploy as a sell-out—a balance (bargain?) struck between the analysis of form and the recounting of biography. If it is patently undemocratic (and it is) to draw to oneself the profession of stating that such activities are manifest art, then surely it is as elitist to stress whatever it is that one does stress, even if it is biography over formal discussion. It all winds down to the mouse's tail (tale?) in Alice—an infinite spiraling decrescendo.

II. *The Artist's Studio*

8 September 1976. To Jackie Ferrara's Prince Street studio: orderly, lovely insofar as Soho' retrieved industrial space can ever be lovely. Her carefully crafted mounds and sloped pyramids neatly rising from the floor, filling out the working space, just missing the heavy-duty buzz saws and electrical equipment needed to make them. The living area is simple and reasonable: books; the occasional trade, work for work, with peer artists; the hangover bizarrerie from a much earlier abandoned "figurative weirdo phase." On the shelf there is, for example, a so-called 17th-century merman for some Baroque *wunderkammer*—a South Sea gimcrack, part humanoid, part alluvial. Ferrara tells me that there are two other examples, one in the Musée de l'Homme, the other scarcely perceived in a snapshot of James Ensor's studio. (The merman was a trade with an art dealer who gave it up for a big blowfish, and was bested in the swap). A bedraggled stuffed loon peers down from the bookshelf; a leather lizard perches on the ledge. One more false start; too elliptical. I'm not getting near the problem of Ferrara's sculpture.

Talking to Ferrara is an enormous pleasure. She is not a perfect art star fixated permanently at a sleek and ambiguous Milanese thirty—somewhere between 18 and 43—but a woman fully in mid-life with a rich suite of existences, all whole and fascinating in themselves, and not yet expunged, board-erased so as to insure one story, one myth. Since Ferrara was born in 1929, there are several lives, the most important (to us) coincidental with her move into the Prince Street loft in 1971. Née Jacqueline Hirshhorn in

Detroit—"my name had three h's, a j and a q"—she has kept the name of her second husband, Don Ferrara, a jazz musician. Detroit was ordinary background stuff, capped at length by a year at Michigan State. There she met her first husband, Peter Weber, now a hypnotist-phrenologist, then "just a good-looking guy. I wanted to play house. Everybody thought I was wild. I wasn't the least bit wild." The first marriage was brief. Ferrara left with $ 29 borrowed from her brother Austin. "I always wanted to come to New York. I always looked at pictures of New York, Greenwich Village. I tacked them over my bed. I desperately wanted to come to New York. I worked in a bank, the accounting department."

About 1951—in conversation Ferrara, as everybody else, is a bit wooly about dates—she arrived in New York, at length finding an apartment on the cheap Lower East Side, making her way working for a life insurance company. It's dreadfully banal and very real, the conversation of a fine person (tugged black braids shot with gray) coming to terms with a nostalgia for the past and her sense of shifting interpersonal relationships and in the changing art scene.

The discovery of art and the sheer depth of her gift coincide with such ordinary happenstance that I am deeply affected. Certain details key in the most willy-nilly way into movements of my own adolescence; we both, for example, overlapped at the Henry Street Settlement, never meeting. The time is the early fifties. "I was trying to find myself. I was interested in art. I took a couple of classes at the New School." So far no fallout. "I wasn't allowed to go to art school in Michigan. I couldn't take art classes. I was terribly obedient until I was 18."

Into the early fifties there is little about art; surely a rich field, but scant seedlings. "Then I started to take ceramics. I lived near the Henry Street Settlement House. I started taking these pottery classes and I loved it. After a while I made my dishes. They're all chunky. I couldn't work on the wheel very well." By 1955 Ferrara signs her pottery, and for the next two years there is an intense commitment to crafts: the fifties—strong personalities attracted by strong primitive cultures. Ferrara's pottery, shown

130

to me with bantering reluctance—my snobbishness was to be anticipated—reveals deep bowed forms and animal biomorphism synthesized from a ranging ethnographic lexicon, be it African or Meso-American ritual and domestic utensils. There are additional inferences of a Gottlieb-like pictogram expressed as incised graffiti. It's easy to patronize this work, its folkloric aspirations and integrity, its earthen organicity—there's a lot of grog in Ferrara's ceramics—all that art-as-experience stuff that craftspeople believe in. Perhaps all of that is beginning to have a certain period allure, the campy stylishness of a fictitious folklore invoked by the arty craftswork of the fifties. Twenty years later it becomes "realart" in the way that it never was nor could have been when it was made, despite all of its striving aspiration. I'm not just talking about Ferrara's ceramics which in this context appears to be given undue stress, but of a broad range of handicrafted objects of which Ferrara's are given a sudden distinction because the mature sculpture, dating to 1972, retrospectively confers distinction upon all early effort. One even recognizes in Ferrara's present sculpture certain hangover enthusiasms traceable to her ceramics. There is, for example, the whole feeling for the Meso-American itself now inferred through pyramidal stacking. This goes back perhaps to the moment of an almost physical enthusiasm but of no structured theory of art, both facets by which the American fifties are characterized.

"While I was taking pottery there was an opening at the Henry Street Playhouse Theater." The Playhouse was then a center for burgeoning dance and theatrical consciousness. Alwin Nikolais, seconded by Murray Louis. Ferrara ran the office, scheduled the theater, classes, that kind of thing. This capacity for neatness and organization must never be forgotten, especially as it counters, as will be seen, so much in Ferrara's work seemingly anathematic to this rage for order, so to speak. "I was still working at the life insurance company. When a promotion came along I didn't get the pay that the man who had the job before me got. I was angry about it, but I didn't see it in sexist terms either. We still weren't thinking that way in the fifties."

Suddenly Ferrara is talking about living in Italy for fifteen months

in a village outside of Florence, driving a Topolino, a little Fiat, casting bronzes. I'm brought up short, a synapse takes place, out of synch. I have her go back over the terrain. How did we get to Italy? Another relationship is brought into the conversation; it may be maximized but it can't be minimized. From the late fifties through '67 or '68, say for a decade, Ferrara was living with Robert Beauchamp. "It was my longest relationship." I think for a moment of the artist in question whose work has been regularly shown at galleries of consequence, Graham, Dintenfass, Green. "He opened the Green Gallery. He showed there regularly for years." Two things are going on: a recollection about a man for whom Ferrara feels deep affection, and through whom she had easy access into the changing art climate of the later fifties; and second, another history is being invoked, that of the Green Gallery itself. We tend to think of the latter solely in its final manifestation when Richard Bellamy was showing works that defined Minimalist aspirations. Yet, when it opened, the unstructured and expressionist characteristics traceable to Abstract Expressionism were still sensible in the then underground figures to whom Bellamy was drawn—Beauchamp, Oldenburg, Samaras, Kaprow, Segal—kinds of art informed by the Happening and divergent environmental ambiences. I recall Beauchamp's emergence as a "brilliant comer." Ferrara and I experience the rueful poignancy of years past. I recall my indifference to Beauchamp's painterliness and oneiric sexualized imagery invented in its very painting—animals, women, flight, turbulence. I think of Ferrara's phrase "figurative weirdo" and her early destroyed fetishistic art. It closely keys into the Beauchamp take and makes me uneasy about my facile dismissal.

"I would go to openings, art parties. There was a lot of social activity. Beauchamp didn't like to go so I would take friends. Dorothea [Rockburne] and I were friends. I used to see her every day. We used to talk "girl talk," you know, sex. She was working for Robert Rauschenberg then. It was about people, it was never about theory. I used to see Carl Andre all the time. He was thin and cute. Down from the Cedar Street bar there was Dillon's. It had a kind of shuffleboard game. Andre was the best, but I was

the second best." Fragments of transient art life in the late fifties, early sixties, as if from another planet; Andre "cute," "thin"; it's hard to imagine him free of the Marxist overload that burdens his persona today. Still, much of Ferrara's work is consonant with the vital rehabilitations of contemporary sculpture brought about through Andre's doctrinaire assertions and embodiments. Think, for example, of the exhaustive spiralings, serializations, and layerings themselves. They are locatable to Andre and are germane not only to his work but to Ferrara's or any of a dozen sculptors concerned with the maintenance of the vitality of the abstract reductivist tradition.

I question Ferrara about exhaustive layering, seriality. "I don't see any clear patterns," she answers. "The last couple of years on Delancey Street I was doing rope works, very hairy, very bio-morphic. I was doing two kinds of work: stuff that hanged and stuff that rose up from the floor." I assimilate the former to the pictorial and eccentric revision of Minimalist sculpture (around 1967-69); the latter I bring into the Andre purview. But to do so perhaps is precipitate, wrongheaded as will be seen.

When the relationship with Beauchamp faltered in the late sixties and Ferrara entered another with collage-maker Martin Greenbaum, she withdrew from circulation. Only in the early seventies, at last divested of human entailments and domestic encumbrances and dedicated fully to sculpture in her own place, her own loft—it's the only way—and beginning to produce work congruent with the major sculptural options of the moment, Ferrara once more ran into the people she knew back then. It was surprising for her to learn, for example, that Rockburne had in the interim become a well-known figure, an artist whose work on some broad ideological level corresponded to issues of her own reductive intentionist constructivism. Similarly Andre. It's hard for me to fully accede to this sense of how styles filter into existence. It seems to me that a certain memory screening has taken place, one that makes complicated episodes seem too easy, but to press the issue would be rude. I revert to Italy.

In 1959, Ferrara and Beauchamp were there. She had been making

just awful, now charming, little sculptures, and she knows it. "I lined up bronze figures. The bodies would always be the same, female. The faces I would paint, very African, very primitive. I didn't know how to make hands or feet. I really didn't know how to make bodies. It was very cheap then. Each figure cost about eight dollars to cast. Sometimes they would be in a setting." I asked whether I could see them. You could see that, in a nice way, Ferrara is going to fib, that she doesn't want to, that in the end she won't. She says she sold them recently as bronze scrap to a Canal Street dealer for cost, to be melted down. Maybe they still exist. The dealer still may have them.

All the while we had been talking I assumed that Ferrara's distinguished first one person show took place in 1973 at the A.M. Sachs Gallery where I saw her work for the first time— serialized platforms and towering pyramids of welted papier-mâché-like cotton batting. Ferrara goes to a little cabinet sideboard and finds an envelope. You know, the memorabilia that remains despite repeated domestic upheaval and the concerted eliminations of the trivia we carry through our lives. She hands me a document about which she has a lot of sweet tension, the invitation (bearing an illustration) to her first "one man show" held in December of 1961, when people still said "one man show" no matter what the artist's sex. The Janet Nessler Gallery, 1718 Madison Avenue, the kind of gallery that comes and goes, but not a vanity gallery with which the fifties were rife. The invitation listed the works. Inviations don't anymore. An occasional striving literary title, *Alcestis and Admetus,* that kind of title, but mostly the works were plainly named, say *Watchers,* the work reproduced on the somewhat pinkish paper; gorgeous ephemera—for those of us anyway who love the little history of New York art. Were I to check out *Art News* or *Arts* I bet I would find a sentence, a phrase or two, a snatch of a review. *Watchers,* a small group of flat-faced Ernst-like little figures, funny and silly and still a little folkloric (I bet the scrap dealer still has them, didn't melt them down. Who is he?).

III. *Tales (Tails?) of the Lower East Side*

13 September 1976. The problem is, of course, the time overlap. Ferrara may be unsure as to dates, though not to the features of an event itself. Within a general profile she finds no difficulty in verbally detailing the process of making a work of art. Once this process is assimilated to theory, problems arise. Sentences begin, subjects without predicates, ending in frustrated incomplete ideas. Under duress: "I don't ponder problems. I don't ruminate. I don't ponder the past. I am very of the moment. I am unbelievably unassertive about art; yet I have all kinds of opinions on other subjects."

How often have I met this block before! Is it locatable to the sheer anxiety the artist feels about creativity? On one hand, artists know that whatever is coming comes from somewhere; on the other, there is the fear that to locate the source, historically, critically, intentionally, in terms of specific models, whatever —all this may bring down to the ordinary, the mundane, the near religious belief in the creative process and in creation itself; and perhaps it may staunch the flow. Then there is the final blow: to recognize the source is to somehow be open to disdain; the fear that art loses status upon recognition of stylistic contingencies. This is compounded by a constellation of feelings which when pressed will silence the speaker. No more will come for fear of saying too much or too little, of overpraising or badmouthing; feelings of angst, of paranoia.

A big truth blurts out: "My position is very embarrassing. To have begun to make work in 1972 that was more suitable to 1965. I don't feel embarassed about it now..." Not to feel embarassment is of course the correct tack. What is growing apparent is that the maintenance of abstract reductivism presents its own kind of vitality in the face of the continuing evolution of a highly theatricalized conceptualism. The validity of Ferrara's position is underscored not only by her own sense of rightness and well-being with a continuing examination of pyramid variations, but in the very fallout of that fascination—exquisite, shadowed, dark channeled, complexly stepped, and chambered rises.

True, the critical distinction here is being drawn between a Minimalist logic carried through an exhaustive permutation in the late sixties as compared to similar solipsistic processes executed in the late seventies; the former emerged in a sudden rush, as it were, predicated on an activity located in thinking; the latter derives from direct manual evolutionary practice. Of course I exaggerate the distinction. There can be no practice without ideation, as there can be no ideation without process or activity. But these experiences may allow for different emphases. It is this difference which accounts for a manual, slow-based process and logistics in the present moment. Here unquestionably evolution will be slower. But as much may be said not only of Jackie Ferrara, but of Winsor too, whose current cube stackings and variations share several points of reference with those of Ferrara. In this sense, both these artists of merit (and still others who must be drawn into the purview) are responding to aspects of a certain impulse even sensible in the more extenuated and manneristic reaches of conceptual performance qua painting and sculpture. Much in the way that the behavioral conceptualists reject epistemology for content without form, that is, for autobiography and autobiographical extrapolation, so too do the current breed of abstract reductionists eschew epistemology, for pure doing—information or knowledge be hanged. Yet their work is in its final manifestation worlds apart from that of the behavioral conceptualists, and this because they have never relinquished the primordial archetypes of modernist abstraction: circles, spheres, squares, cubes, triangles, pyramids.

If so much of this art stems from a pure evolutionary practice and if, as I appear to be hinting, biography keys into this process, and nourishes it far beyond ways heretofore sanctioned in formalist criticism, then the change in Ferrara's work from the late sixties to the seventies may be examined in terms of her own view of biography, biography recorded as descriptive process. One could say to Ferrara, yes, hanging hairy forms and organic parasexual metaphors adduce an opposing typology—recumbent inert forms free of all metaphorical content whatever (Figs. 32, 33). In that sense, one kind of dualistic argument—wholeness based on com-

plementary halves—is the paradigm for this change. One could say something like that but such a cryptic reduction cannot possibly correspond to Ferrara's—or anyone else's for that matter—sense of elaborately lived episode.

"Then I worked in rope too. I lived on the lower East Side. It was Succoth (the Jewish thanksgiving Feast of Tabernacles). To celebrate the holiday, people came downtown to buy lemons from Israel, I mean big ugly lemons. Some people examined them with a magnifying glass to make sure that they were unblemished. A perfect fruit sold for up to thirty dollars apiece. It was unbelievable. Bad ones, I mean where the point of contact with the tree had fallen off the fruit, were dumped for ten dollars. It's all about this Lower East Side lore. Anyway, they were packed in a packing material, hairy raw flax, laid out in skeins. I started using this hairy stuff, joining it to tiny heads of dripped wax. I ended up liking the material more than the heads and the chicken nails and the fur-covered boxes. The boxes got to be very small, and long flax tails hung down. I started making these "tails," I guess that's what you'd call them. The "tails" went into the rope pieces. At the end of 1969 I absolutely never made heads or figures anymore. At the same time I started to use birds."

The use of organic substances invokes a talismanic, even ritualized function. Organic substance as material is intriguing because it may receive magical status for its having been originally totemic in some sense. The use of blood, for example, and most particularly in women's art (which might use it reasonably to celebrate the blood mysteries) is a case in point. Add to such substance the poetical stress of minute human referents such as doll-like heads and the point will be clearer.

The sixties especially experienced a lock step synchronism between an abstract reductivist art and a formalist criticism. One of the salutary effects of Post-Minimalism was to rupture the symbiosis of art making and critical writing. This was effected in part by the creation of an art for which criticism, by which (at the time) was meant formalist criticism, had not developed a vocabulary. Keying into this widely felt therapeutic was the need to externalize an extremely personal statement, especially on the part of women

artists who, long disenfranchised (except for a few token individuals), were locked out of the success of abstract painting and sculpture at the time.

The advent of feminist activism (and I don't mean by this that Ferrara was an activist) gave a political value to the private history and mythology of women, a mythology capable of being exteriorized in a talismanic fetishistic art; surely never before in modern art had this kind of elaborately eccentric, magically-endowed, autobiographically transmuted, talismanic art appeared. The point of this was not only to endow the female status with a power nigglingly accorded it if not entirely denied, but also to circumvent history and criticism since talismanic arts generally fall outside the province of history and criticism. Such art, like naive art, like ritual/primitive art, answers not the sequence of styles built into the modernist European calendar, but of a magical chronometer the solstices of which, its months and days, cannot be measured. This occurs because, on the one hand, this kind of art is always out there somewhere, impervious to normative stylistic history (if such a flow can ever be said to have a normal context), answering only psychic inner necessity; and, on the other, because it is occasionally suddenly there—in this sense, art atavistically responding to sudden new pressures occasioned by the changing flow of social economic force of Western culture; the advent of the women's movement would be the most dramatic modern eruption of the latter type.

A last story. In 1969, ironically grown allergic to flax and rope, Ferrara abandoned the "tails," and more humanoid fetishistic character of the work. "At the same time I started to use birds. The first bird I got was a crow..."—remember the musty loon on the bookcase—"I found it in an antique shop near Tompkins Square. Then I went to this feather factory on East 4th and Avenue D, a terrible junkie street. I asked whether they had any crows. A guy remembered that somewhere upstairs there were boxes filled with pigeons. We took this old grimy elevator. Feathers had stuck to it everywhere. We were in a feathery elevator. We found box after box of pigeons, 440 in all. If I took the lot I could have them at ten cents apiece. I took them. It cost $44. I brought them

home, sorting them out by color. I used them in my work. Eventually I used up all the birds."

In a corner of the studio there is still one left. Pratically all of Ferrara's early work has been destroyed. I climb a ladder to examine a work high on a wall, covered with plastic sheeting to protect it from dust. The birds have been arranged in softly interlocking paths across the surface. Monkey fur surrounds the stretcher supports and an array of pigeons dangles on threads from the bottom.

The totemic magical characteristics are apparent. I wondered about so elaborate a switch between this talismanic art and the taciturn monumental abstraction by which Ferrara's reputation has gained ground. Had I failed to mention that needing a pencil, Ferrara fetched one for me from the sideboard, originally a dental technician's cabinet. Pencils, pens, nylon-tipped markers, art supplies within had been neatly arranged according to particular function and grade. "I took them home sorting them out by color." She was talking about the birds. Of nails (chicken nails?) used to construct the wooden pyramids: "I take them home and arrange them by grade, by scale, by color." Such an occasion is not the place to trace, were it even possible, the filigrained network connecting fetish and compulsivity. Surely though, both the lost early Ferraras and the present neat, complex, quasi-impersonal pyramids are functions of the same initial impulse to constructivist compulsivity.

ONTOLOGY

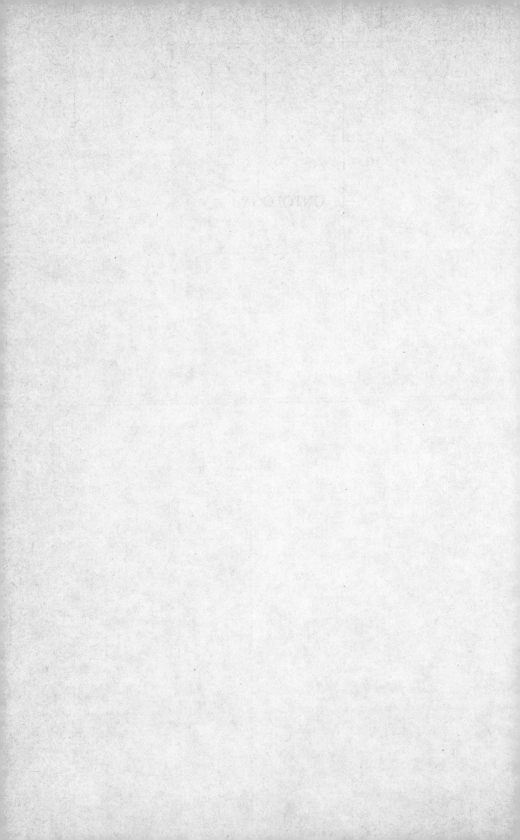

VITO ACCONCI
AND THE CONCEPTUAL PERFORMANCE

> *... there is mention of an Italian artist who*
> *painted with feces; during the French Revolution*
> *blood served as paint for someone...*
> —Guillaume Apollinaire, *The Cubist Painters*, 1913.

Vito Acconci, perhaps more than any other figure working in that
aspect of post-Minimalism associated with the Conceptual perfor-
mance, is the one who in a puzzling and constricted way allies
those open and anarchic stances with the abstract reductivist
enterprise known as Minimalism. In so doing he demonstrates a
point that I have been at pains to make—that it is possible to
recognize in Minimalism itself many of the clues which in fact
led to its own stylistic dissolution. In Acconci's work this was
achieved by conjoining Minimalist form with Duchamp-like thought
and behavior, a fusion which may only be short-lived because of
the virtually antithetical nature of these two positions. Instead
of forming autonomous objects this fusion has led, bizarrely
enough, to the Conceptual performance—one which heretofore
had been thought to derive exclusively from the Futurist and
Dadaist theaters of the First World War.

The general response these past two years to Acconci's "present-
ations," or "performances"—there seems to be no precise term
to cover what he does, although in the past it has often been
referred to as "body art"—has been, I suppose, to scoff ever
since Acconci's activities, in certain measure, have become familiar.
In this respect, as well as in others, one cannot fail to make
connections between Acconci's performances (if they are that) and
those earlier manifestations of behavioral phenomenology occasioned
by Bruce Nauman's absorption of technological apparatus into a
sensibility which had drawn upon a source in Duchamp. Instead

of continuing to work in a diffuse no-man's-land of Conceptual pretensions, Acconci now seems to concentrate his actions with such acuity that initial scepticism is replaced by the possibility that perhaps what he is doing may be akin to art, at least that side of art which has its affiliations in an obsessional focus. As Acconci himself has remarked:

> ... my work seems mainly concerned with what I guess could be called "attention" or "concentration"; like if I'm going to concentrate on my own body or a part of my own body, this intense focus on it, this intense channeling toward it is going to lead to a kind of turning in on myself which is a kind of masochism. But these elements are just sidelines, or by-products of this kind of attention or concentration. In the same way, if I'm concentrating on this other person or on my action with this other person, an exaggerated version of this is going to be what people can call sadism.[1]

In short, the earlier Acconci which was fashioned of a synthesis of Conceptual aspirations, has become more convincing as art because he is now able to manipulate and relocate inherited attitudes which need not *only* be understood as behavioral phenomenology.

"I used to think that art was not about therapy, I mean I learned to believe that art was not about therapy. But now I think that it is." Acconci was talking in a stuffy, makeshift booth, surrounded by the photographs of six persons close to him and about whom he had been meditating. The closet was airless and muggy as a result of the heat given off, I believe, from a tape recorder and amplifier. The light source was a hand-held flashlight. Acconci was speaking about *Seedbed,* a work which takes the form of a wedge-shaped ramp which slopes up from the floor to cover an entire gallery (Fig. 34). Within this wedge, Acconci passed two afternoons a week in a " private sexual activity," stated bluntly, in masturbation. Acconci's written and posted description of the piece touches on the following issues:

> 1. The room is activated by my presence underground, underfoot —by my movement from point to point under the ramp.

[1] Vito Acconci, from an unpublished interview with Barbara Fishman, November 23, 1971.

21. Bruce Nauman, My Last Name Exaggerated Fourteen Times Vertically, 1967.

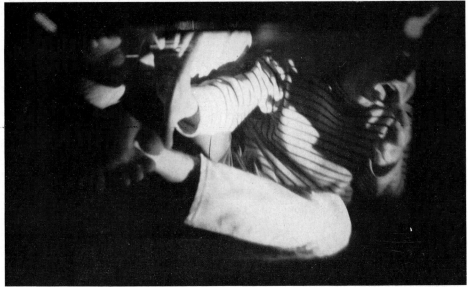

22
23

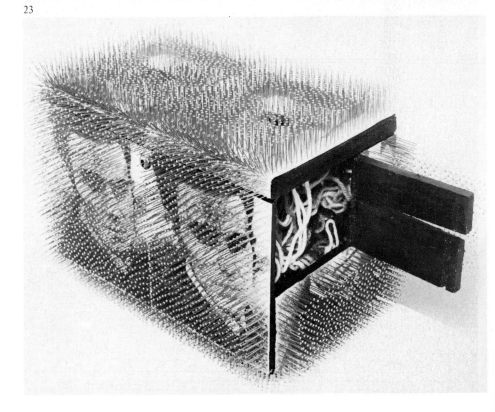

22. Bruce Nauman, Hologram, 1969.
23. Lucas Samaras, Untitled (Face Box) [Self Portrait], 1963.

24

24. Mel Bochner, Three Ideas & Seven Procedures [3 Ideas + 7 Procedures], 1971.

25

25. Mel Bochner, Room Series: Eyelevel Crossection, 1967-71.
26. Sol LeWitt, 47 Three-Part Variations on 3 Different Kinds of Cubes, 1968.
27. Sol LeWitt, 46 Three-Part Variations on 3 Different Kinds of Cubes, 1968.

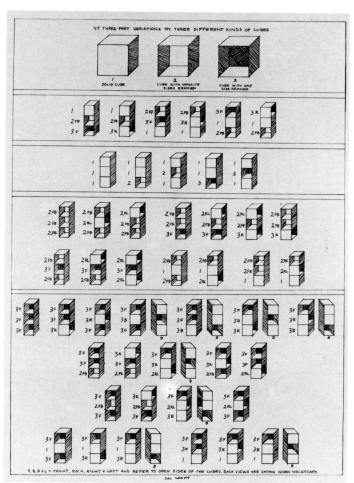

47 THREE-PART VARIATIONS ON THREE DIFFERENT KINDS OF CUBES

F. B. R & L = FRONT, BACK, RIGHT & LEFT AND REFER TO OPEN SIDES OF THE CUBES. BACK VIEWS ARE SHOWN WHEN NECESSARY.

SOL LEWITT

26
27

28. Mel Bochner, Measurement Series: Group "B" (1967).
29. Mel Bochner, Seven Properties of Between (1971).

30

31

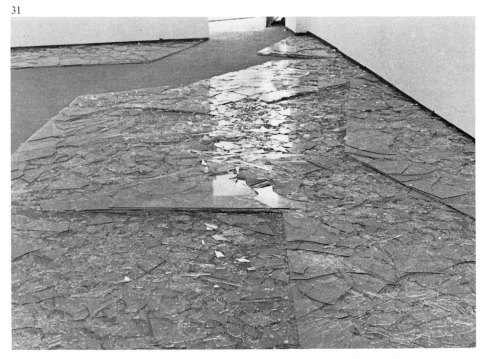

30. Barry Le Va, #10, April 1967.
31. Barry Le Va, Untitled (Layered Pattern Acts), detail, 1968-72.

32

32. Jackie Ferrara, Untitled, 1970.

33

34

33. Jackie Ferrara, A, ½A, A5, C, 1976.
34. Vito Acconci, Seedbed, 1971.

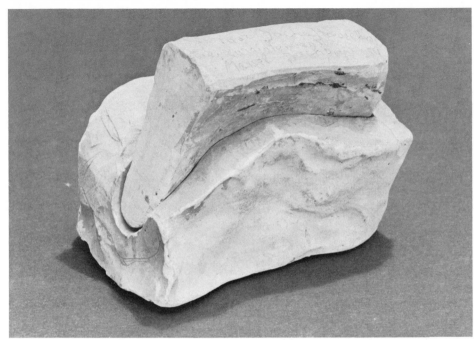

35

36

35. Marcel Duchamp, Wedge of Chastity, 1951.
36. Bruce Nauman, Wedge Piece, 1968.

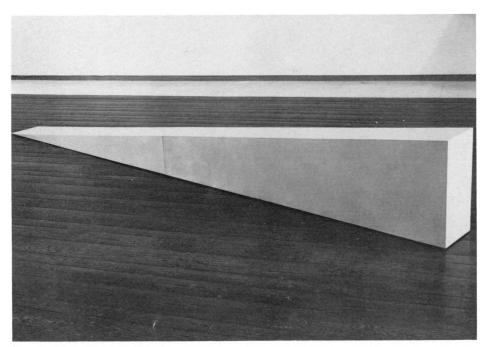

37. Robert Morris, Untitled sculpture, 1966.
38. Lynda Benglis, For Darkness: Situation and Circumstance, 1971.

39

39. Lynda Benglis, Exhibition Announcement, 1974.

40

40. Lynda Benglis, Now, 1972.

41

41. James Collins, Teaching Notes: Synectics-Line as the Articulation of Surface, 1967-69.

42
43

42. James Collins, Watching Leslie, 1975.
43. Robert Morris, Exhibition Announcement, 1974, detail.

44
45

44. Scott Burton, Pair Behavior Tableaux, 1975-76.
45. Scott Burton, Bronze Chair, 1975.

2. The goal of my activity is the production of seed—scattering the seed throughout the underground area. (My aim is to concentrate on my goal, to be totally enclosed within my goal).

3. The means to this goal is private sexual activity. (My attempt is to maintain the activity throughout the day, so that a maximum of seed is produced; my aim is to have constant contact with my body so that a maximum of seed is produced; my aim is to have constant contact with my body so that an effect from my body is carried outside).

4. My aids are the visitors to the gallery—in my seclusion, I can have private images of them, talk to myself about them: my fantasies about them can excite me, enthuse me to sustain—to resume—my private sexual activity. (The seed "planted" on the floor, then, is a joint result of my performance and theirs).

The poetical ellipses in points 2 and 4 play between the idea of Acconci's sperm spurted onto the floor but understood in its agricultural metaphor: as seed. Duchamp's parallel is *Elevage de Poussière,* or *Dust Breeding.* Not incidentally, Duchamp's subtitle for *The Bride Stripped Bare By Her Bachelors, Even* is "agricultural machine."

Superficially the piece might correspond to a sadomasochistic submission fantasy in which the spectator—unwittingly or wittingly—may literally walk over the prone figure of a masturbating "servant." Such an interpretation is too facile as it does not take into account what is finally interesting, namely that the Conceptual performance, at least in Vito Acconci's case, may be a fusion of the Minimalist position in sculpture with a refreshed comprehension of the erotic implications in Duchamp's late sexual works, most particularly *The Wedge of Chastity* (1951, Fig. 35). What is perhaps the least interesting aspect of the work is its seemingly outrageous or so-called shocking subject matter.

To adopt an extreme taboo in the context of a gallery situation in fact neutralizes its sexual emphasis, as it neutralizes the very notion of taboo. Since the spectator is a *voyeur* only in the sense that he is an auditor of the events [2]—Acconci's mumbled fantasies

[2] *Voyeur* and *auditor* probably correspond to the alter-egos of Jasper Johns' paintings of the mid-1960s, *Watchman* and *Spy*. See Jasper Johns, "Sketchbook Notes," *Art and Literature,* Spring, 1965, especially p. 192.

12

are amplified and broadcast into the gallery—the spectator may not comprehend the activity which is taking place literally beneath his feet. It seems more likely that the work does not attempt, as part of any programmatic intention, to neutralize sexual taboos, although this is its practical effect. Sufficient stylistic information suggests that Acconci, like Nauman—and I think the primary model was Nauman at his most Duchamp-like, ca. 1966-69—is dealing with an exaggerated, nonobjectified relationship to the erotic legacy of Duchamp.

An interpretation of Duchamp's evolution that is especially appealing at the present moment is that the elaboration of the adventures of the Nude to the Virgin to the Bride Stripped Bare By Her Bachelors is an extrapolation on the possibility of Duchamp's first name understood as a "Readymade": Marcel = MAR + CEL = *Mariée* + *Célibataire* = Bride + Bachelor = Female + Male = Androgyne = Rose Sélavy + Marcel Duchamp. In this context, Acconci's sexualization may be viewed as an extrapolation upon the androgyne of Duchamp. For example, the wedge-shaped floor seems apposite to the meaning of wedge as a fusion of male and female in Duchamp's third sexual object of 1951, *The Wedge of Chastity*. I have already attempted to demonstrate that the verbal-visual objectification of Nauman's two wedges (*Wedge Piece*) of 1968 (Fig. 36) are developments of the possibilities inherent in Duchamp's *Wedge*. In this connection Acconci's theatrical *Seedbed* and the Nauman might be regarded as cousinly efforts.

However, the ramp floor of the Acconci speaks for a source in Minimalist sculpture, Robert Morris' several untitled wedge-like works from 1965-68 particularly (Fig. 37). I do not think that Nauman derives in the slightest from Morris. Nor do I claim that Morris' Minimalist "wedges" even remotely correspond to Duchamp despite Morris' early production which seems so closely allied to Jasper Johns. One might have imagined that through the mediation of Johns, Morris' "wedges" might derive from Duchamp.

"Are you aware of Duchamp's three sexual objects," I asked Acconci, "and do you recognize the relationship of *Seedbed* to these objects?" "Yes."

In the film *Conversions* of 1971,[3] Acconci is seen tugging at his breasts, burning hair from his chest, and hiding his penis between his legs, that is, attempting to transform himself into a female, or, at least, into an androgyne. "Did this film record a process parallel to the sexual multivalence between Marcel Duchamp and Rose Sélavy?" "Yes."

Despite their fearful sexual obsessiveness, Acconci's activities raise a number of questions that are difficult to answer particularly as regards the cathartic relationship of the mental and physical dislocations of his work. Still, what is intriguing in Acconci's latest performance is not its increment of the "polymorphous perverse" or the virtual denial of taboo through exteriorization, but that Acconci is able to handle the Conceptual performance in a way which expresses a closeness to the processes of the mind as opposed to the experiences of the senses. By contrast, we have the puzzling performances of Gilbert and George. In comparison with Acconci the Britons have an "act," something which is as playable in a cabaret as it is in a studio or a gallery. In that sense their Conceptual performance refers back to the European Dadaistic experience, to the Cabaret Voltaire, to a Dadaism which mixed together sociological, political, and economic commentary realized in Futurist and Cubist modes. Their Conceptual performance, therefore, is social in its ramifications and implicitly sensory in its appeals. It is a presentation of deliberate theatricality and campiness. On the other hand, Acconci, beginning with the apparently sensual theme of externalized taboo and sexuality, conducts the Conceptual performance in a virtually autistic vacuum. In this sense he approaches social indifference—despite the enormity of the social implications of his work—and remains as elitist and infra-referential as Duchamp always was and as the general tenor of New York Dadaism in its heroic period was as well.

[3] Based on the photo-essay by Acconci/Shunk-Kender, "Conversions," *Avalanche*, Winter, 1971, pp. 90-95.

147

LYNDA BENGLIS:
THE FROZEN GESTURE

Lynda Benglis contributes to new options in American art—my reluctance to admit this is tied to her extravagance. Few talents today are so alert to the weights and balances of the actual moment and no artist seems more capricious, more casual. She appears to toss aside important realizations at the instant of their discovery. Rarely has the observation that art is about beginnings been more apt than in her case. In this sequence of feints and probes, Benglis stands in striking contrast to many of the major Minimalists of the '60s, who built their careers on one idea as an intense and committed demonstration of the continuing validity of a single option. In Benglis' apparent reluctance to remain with a problem taken to its most extenuated circumstances lies the notion that the artist evolves in disjunctive, not conjunctive, terms. Her formal volatility is her primary message and strength.[1]

Lynda Benglis left Louisiana in 1964 to continue her art studies at the Brooklyn Museum Art School. In 1969 she participated in a group exhibition at the Bykert Gallery with, among others, Richard Van Buren and Chuck Close. From May of that year to the present is hardly a long period. In terms of art, however, virtual generations have come and gone. The major shift of sensibility has been the emergence of a Post-Minimalist stance, first realized

[1] There are nevertheless traceable groups of work in Benglis' career — the wax lozenges, the knots, and the environments of tossed polyurethane foam, for example — these are types to which she will intermittently return. There is also the persistent Warholianism which lurks behind her formal choices. That too is a constant. The iconographic sets were examined at some length in Klaus Kertess, "Foam Structures," *Art and Artist*, May, 1972, pp. 32-37. This sensitive article addressed the link between formal choice and female consciousness in Benglis' work.

in the pictorial sculptures so well exemplified by Benglis' latex and foam works. Conceptual work and performances succeeded this pictorializing phase of sculpture, developments reflected in Benglis' use of video and her current mannered erotic art.

In the Bykert show, Benglis exhibited a latex floor piece called *Bounce*. As Emily Wasserman described it:

> Miss Benglis spilled stains of liquid rubber in a freely flowing, twining mass directly onto the floor of the exhibition space, mixing fluorescent oranges, chartreuses, day-glo pinks, greens, and blues, allowing the accidents and puddlings of the material to harden into a viscous mass. The outer contours trace the natural flow of the latex and define the amoeba-like but self-contained field of this strange and startingly *colored* spread. The method by which the piece was (non) formed is thus actually objectified while the events and timing of its process are congealed.[2]

Calling *Bounce* a "protoplasmic mat", Wasserman recognized that the work was "a kind of painting entirely freed from an auxiliary ground or armature"—a free gesture gelled in space.

By now, it is clear that Benglis was answering the fusion of painting and sculpture that had taken place in the mid-'60s. The pictorial sculpture I refer to generally, and Benglis' particularly, furthered this fusion by making a new object which is the result of an Expressionist episode enacted directly upon the floor. Choosing this option, Benglis, like Van Buren, Hesse, Saret, Serra, and Sonnier, transposed the easel tradition questioned in Abstract Expressionism into actual environmental enterprise.

Agreed: Pollock's career, from the 40s on, drifted in the direction of muralizing and wall-oriented ambitions. In addition to adumbrating the changed scale of American art, Pollock had keyed into an interest in eccentric process and substance as well. The most

[2] Emily Wasserman, "New York: Group Show, Bykert Gallery," *Artforum*, September, 1969, pp. 60-61. In an exhibition catalogue for "Materials and Methods: A New View," held at the Katonah Gallery in the Spring of 1971, I maintained that "the disintegration of Minimalism" was the central operation of the period circa 1967-70. This supplanting of a key '60s style was achieved through "a need for identifying sculpture in pictorial terms — particularly with regard to color and unusual substance." This exhibition included the work of Keith Sonnier, Eva Hesse, Richard Van Buren, Alan Saret, and Dorothea Rockburne, although it could have as easily included works by Benglis.

famous photograph of the artist, taken by Hans Namuth, shows him stepping into a canvas spread upon the floor. "Pollock pioneered the movement of dealing with materials used by the artist as the prime manifestation of imagery," said Benglis. "He drew with paint by dipping sticks into cans of liquid color and making an image on canvas placed on the floor, which was subsequently framed and hung. This was a new way of thinking."[3]

In Pollock's work, literary content was clued to ritual myth and Jungian archetype, the figure of constant human meaning revealed in psychoanalysis. By contrast, such content in Benglis' work is inherent to substance. As Pollock's paintings grew larger, ultimately to wall scale, he was able to step into them during their execution as he might have entered a great hall of prehistoric painting. I believe the register of handprints in the upper right corner of *Number One,* 1948 (The Museum of Modern Art), reenacts for the Jungian a major gesture of Paleolithic painting—the negative or positive handprints found, for example, throughout the caves of Pech-Merle, Altamira, Lascaux or Santander.[4] It was important for Benglis to be in her latex and foam "pours" of 1968 during their execution as it was for Pollock to step into the paintings of his 1945-51 Jungian phase. And, once Benglis' works are exhibited, the spectator enjoys a similar access.

Simultaneous with the pours, Benglis was producing eccentric and narrow wax paintings. Klaus Kertess observed of these capsule-shaped works that, "pigmented wax was put on layer over layer with a brush of the same width as the support, creating an image of two brushstrokes coming together and splitting apart at the center." *Tulip* (1968) "evokes the waxy beauty of tulips or of lips (two lips, my lips)." Benglis said to me,

> The wax paintings were like masturbating in my studio, nutshell paintings dealing with male/female symbols, the split and the coming

[3] Quoted in S. R. Dubrowin, "Latex — One Artist's Raw Material," *Rubber Developments,* Volume 24, No. 1, 1971, pp. 10-12. Post-Minimalism's connections to Jackson Pollock are widely acknowledged. A popular piece of reportage on Lynda Benglis, Van Buren, Serra, and Hesse, "Fling, Dribble and Drip," *Life,* February 27, 1970, stressed this affiliation.
[4] How access would be facilitated through Jungian psycho-analysis is explained by Judith Wolfe, "Jungian Aspects of Jackson Pollock's Imagery," *Artforum,* November, 1972.

together. They are both oral and genital. But I don't want to get Freudian: they're also Jungian, Ying-Yang.

Benglis produced these covert wax paintings for some time, although after 1970, the cracked and fractured wax encrustations move toward high relief.

Benglis' identification with Pollock in terms of substance, procedure, and secret imagery came during a period when the nongestural side of Abstract Expressionism—the Rothko rather than the Pollock—was viewed as the paramount issue of progressive painting. Benglis sought a painterly episode derived from Abstract Expressionism and informed by the "collapsed" objects of Minimalism. Both these sources are important for her since they tend, in divergent ways, to isolate or excise the autonomous gesture from the ground.

The free gesture is the central notion of Benglis' art. Since the early '70s, she has understood "the frozen gesture," as she calls it, to mean something both physical and psychological—psychological in the sense of a phrase like "it was a lovely gesture," or the term *beau geste*.

By 1970, Benglis was aware of new artistic models. After her latex throws, she turned to brightly colored polyurethane foam forms prefigured in Claes Oldenburg's more borborygmic soft sculptures of the early '60s. Benglis' floorbound puffy works only appear soft, however; actually they are hard crusted aerated bodies of plastic. "Oldenburg turned material and subject matter inside out", she said. "I don't like the recent Mickey Mouse stuff. Too Cubist. I like all his earlier work around '58 to '62." In addition, in 1970 Benglis became interested in day-glo pigment, pure color without black admixtures, and stabilized by ultraviolet resisters. Because of its high chromatic vibration and retinal irritation, day-glo sidesteps the usual issues of color, even though it is clearly hue. It tends to defy conventional color exploitation and the search for the subjective or personal palette of sensibility painting. Day-glo, tawdry and neonlike, tends to celebrate the commercial and the commonplace, and this seeming vulgarity fascinates Benglis. She wishes to "question what vulgarity is. Taste is context." Benglis,

151

then, worked out of Pop sensibility, but freed of that movement's specific imagery.

> I do not want my work to be iconographically Pop. I am still involved with abstraction. The first abstract paintings I ever thought about were some Klines shown at the Delgado Museum [in New Orleans]. Content grows out of form. Having an iconographic content can give me a form—say feminism, say Pop.

Day-glo offered the intensity most resistant to the floor—as Benglis remarked, the pigment "was down on the floor, but the color was up." Despite its low-class associations, day-glo has been used even in the rarified high art ranges of formalist abstraction. After his metallic series—itself reflective, therefore "uncolored"— Frank Stella, for example, undertook a day-glo series of works. The color in Morris Louis' *Unfurled* series (although of a different chemical structure than day-glo), also provided Benglis with a formalist model of high key color. Moreover, Louis' gestures in the *Unfurled* paintings are similar to the spectrumlike arrangements of lambent stripes in Benglis' latex and foam pours.

Do not be misled. All this connection to other work (and to formalist art which, after all, was "the enemy"), is outside the essential interest of Benglis' works themselves. As glamour is Warhol's message and the star his icon, and the square, circle and triangle are the existential characters in the dramas of Minimalism, so is the frozen gesture—the excised, congealed, colored stroke— Benglis' prime fascination and essential icon.

Instead of figure/ground Gestalts functioning within a conventional rectangular field, the environment becomes the ground for the figure. By 1970, Benglis' pictorial sculptures no longer ratify the horizontal of the earth, but begin to engage the entire environment. With the endless environment as the ground for the frozen gesture, she embraced the notion of theatricality and all that it implies— temporality, performance, personality, media exploitation. She transformed the place of exhibition into an evironment, a site awaiting a Happening. The excitement of these works is a function of the unconscious anticipation of such an event; they signaled a return to issues which had been carefully pruned from American art for a generation.

152

This anticipation of a temporal episode in her work, combined with her emerging conception of the frozen gesture as a free act, tipped Benglis to the use of video, though video was then being widely explored in terms of technological appeal. A kinetic result from a static impulse should not be surprising. Warhol, of course, preceded Benglis in this understanding when he moved from the seriality of, say, the Marilyns or the Brillo boxes to the sequential frame of filmstrip.

Benglis first used video equipment while teaching at the University of Rochester in 1970. She rejected the utopian ambitions of a generation of artists absorbed by the creation of the video synthesizers. Instead, she was drawn to the unselective recording of the actual as it happens, free of aesthetics or ideology, a kind of mindless one-to-one. Spatial superimpositions—piling image on image—interest her. These blurry overlaps deal with transposed seriality — not the lateral seriality or modularity of the Minimalist grid, though surely this is a source—but an in-depth seriality which takes time, blur, static, and transient environmental interferences into account—an imagery with memory built in. Benglis video piles up imagery in Expressionist terms similar to the way she throws paint or mounds foam. For Benglis, video is ubiquitous and expendable, like magnetic sound tape that, when it is recycled to record new information, effaces the old. Thus it renders expendable the very notion of the artwork.

"I got involved with video. I saw it was a big macho game, a big, heroic, Abstract Expressionist, macho sexist game. It's all about territory. How big?" Video offered Benglis a perfect medium of gesture freed from materiality; thus gesture could be as large as possible. This contradicts the prevailing view of the artist as singlemindedly devoted to eccentric substances and physical processes.

At the same time that Benglis grasped the implicit scalelessness of Post-Minimalism (and found in video a medium devoid of issues of scale since it was immaterial), she abandoned the comparatively small latex or foam work for the cavernlike environment. The environments (*For Darkness, Totem, Phantom, Pinto*), constructed at numerous galleries and museums, actualize the cave,

spilling grottolike forms well out into real space, often enclosing the visitor (Fig 38). Benglis poured and tossed polyurethane foam across inflated scaffolds which were subsequently removed. Since the foam sets quickly, the material needs no internal armatures; the works are supported by the real walls of the exhibition space. Some pieces employ a neutral color range. Others are hyped up with day-glo. Benglis sought theatrical special effects, adding phosphorescent salts to her pigments like those in rotting woods, lichens, and certain minerals. Under various lights or at special times, these grottolike formations glow "like relics from the natural history of some imaginary planet." [5] Again, the model for this rediscovery of the ritual site is Pollock. Nancy Graves, whose early work particularly is marked by a fascination with shamanism and the archeological site, made a similar rediscovery. Their position reintegrates the present with a precultural past.

Certain issues then stand clear in Benglis' work: she is fascinated with substance and eccentric materials as a function of Expressionist sensibility, and she takes pleasure in vulgarity, an attitude central to Pop. At Benglis' exhibition of metallized knots at the Clocktower last winter, for example, the artist, mindful of the holiday season, draped the balustrades with flashing Christmas lights. This colorism was specific to the occasion, but it also continues the eccentric coloration in Benglis' other work. The Christmas lights, the spangle and sparkle, the powdered metallic dusts, are a kind of infantile and magical coloration that violates "adult" notions of taste and artistic decorum.

Although Benglis is a southerner by birth, these tawdry cosmetic colors evidence the unapologetic, unrepentant range of California taste. She chooses glinting metallic flecks and plastic substances like the automotive sheens of art in Southern California, where she spends a good part of the year.

[5] Hilton Kramer, New York Times, May 30, 1971. Kramer was covering the opening of the Walker Art Center in Minneapolis, where he found "the most arresting [work] was Lynda Benglis' enormous and altogether macabre sculptural environment consisting of 10 bizarre black shapes that append from the wall ... this is the most impressive work of its kind I have seen since Louise Nevelson first exhibited her black walls in the nineteen-fifties. ..." A black-and-white videotape was made of the process of such an installation, "Totem (Lynda Benglis Paints with Foam)," by Annie McIntosh, taped at the Hayden Gallery, Massachusetts Institute of Technology, November, 1972.

The announcements for Benglis' exhibitions, like her choice of colors, function as infra-information. Rather than reproducing a work on the announcement of her 1974 exhibition of knots at Paula Cooper Gallery, she sent out a Hollywood style chromo of herself—a cheesecake shot from the rear, blue jeans dropped below her knee (Fig. 39). (An earlier exhibition invitation pictured the artist as a child dressed for a party in Greek *evzon* costume.) The cheesecake shot—in part homage to Betty Grable pinups—recalls for me a late version of Odilon Redon's *Birth of Venus*. Though this work can hardly have been in her mind, Benglis is strongly interested in Classical myth. Among her most recent works are pornographic polaroids rendered ambiguous by their cultural context—they are parodies of Mannerist and Hellenistic postures, il Rosso Fiorentino and ithyphallic kraters, a Leda without a swan. Robert Morris is her companion in several of these photographs, and in fact her cheesecake invitation is the pendant to his recent S-M fantasy poster announcement, which in turn references recent videotapes done conjointly. Morris exemplifies in stringent terms another intellectual artist attracted and repelled by instances of brute irrationality; something of Benglis' free-floating openness seems sympathetic to his conflicted outlook. In the work of both artists, overt sexuality points to a covert content—an ironic self-parody of sexuality, and not the exteriorization of a root eroticism. Benglis' sexual photographs are not to be confused with Vito Acconci's performances on erotic themes, although from the early '70s on, Acconci had provided a sensational model of this kind of disclosure. Superficially, Benglis' work reveals the tasteful, the glossy, and the narcissistic, while Acconci's secret sexual systems are more populist, and tend toward the squalid, the exorcistic, and the puritanical.

The distanced experience of instinct lends Benglis' and Morris' sexual work its Mannerist edge. Writing of Morris' S-M poster, Gilbert-Rolfe observed that it was "an ironic encapsulation" of the artist's position, and noted that the poster "concentrates on the artist's identity as a performer within an institution of a certain sort." The critic observes that this "implicitly heroic identity... can only be credibly maintained or it's capable of self-

parody. Without that capacity, one is left with a rhetoric that doesn't possess the ability to question itself." [6]

Both the explicit and disguised sexual orientation of Benglis' media exploitation remains a function of the frozen gesture. It has become the big risk. In Benglis' work, the new medium is now "the media." What is fascinating is the degree to which the artist, so sharply conscious of risk and stakes, perhaps remains unsure of the jackpot. I suspect she sees it as part of the mythical payoff that was Andy Warhol's by the end of the '60s. But to insist on this interpretation alone is to render base an equivocal activity which, though hardly neutral, is nonetheles disinterested in the way that all art is—however hard that may be to believe of the new erotic work. The problem with Benglis is not one of her creative blockage, but rather of the inadequacies of criticism to keep perspective without falling into mere reportage.

[6] "The Complication of Exhaustion," *Artforum*, September, 1974.

156

BENGLIS' VIDEO:
MEDIUM TO MEDIA

Although Lynda Benglis' work is difficult of access, certain of its elements stand clear: 1) an Expressionist bias; 2) a fascination with vulgarity as a willed act of style; 3) a mannerist distancing; 4) diffidently applied abstract structural systems; and 5) an elaborate crypto-autobiographical or infra-information system, referencing biographical detail as well as other primarily contemporaneous art. (This network of referrals stands in relation to Benglis' work as iconography stands in relation to earlier art.)

Post-Minimal art of the late 1960's is marked by a resurgence of Abstract Expressionist methodology transposed to a fully environmental scale. Benglis' work epitomizes the automatic gesture congealed into an object both painting and sculpture at the same time. Benglis grasped the idea that gesture may be understood as either manual activity or as linguistic metaphor, as, for example, when we say "beau geste." Similarly, she recognized that the notion of an artistic medium—a substance that the artist works with—is linked to the notion of media. In this sense, personal or private manipulation of substance is, at its most public expression, preempted by "mass media." Such an insight allowed Benglis to "manneristically" distance herself from subject matter. "Media," as the term is used today, denotes the movies, T.V., newspapers, magazines, popular organs of information dispersal. It connotes "issues," topical politics - for example, feminism or pornography. A conventional artist, man or woman, addressing such issues would see them wholly in terms of subject, as "subject matter." Benglis, playing the hunch, medium to media, sees in feminism or pornography not just their possibilities as illustrative content, but more,

157

their manipulative potential as form. Her work may be about these issues, but only insofar as feminism and pornography may be abstractly incarnated as form, as "frozen gesture."

A leap from tangible methodology to a freer play of language keyed Benglis into the use of video in 1970, while teaching at the University of Rochester. What Benglis had grasped, however intuitively, was video's implicit scalelessness. In some radical sense, what or where video is, is unknown; is it in the tape, on the monitor, in the electrical impulses, in ambient configurations of light or dark, in the audio? Is it in what we are looking at, or what the artist does or has done? Unlike earlier technologies, say oil painting or woodcarving, video engages intangible colored or black and white atmospheres. Benglis' video gestures further freed her from the impacted molecules of paint and brush methodologies. Earlier, her intense Expressionist urge had been gratified in luminously colored latex pours and aerated plastic foam moundings dating to the late '60s. (These vulgarly colored "pictorial" sculptures responded in part to developments within Claes Oldenburg's soft sculptures of the early '60s.) The strong loping gestures used to make the latex and foam works are often retained in Benglis' broad video camera movements.

The view that Benglis' art is merely another Expressionism— unsystematic, inexplicable crystallizations of perfect happenstance— ignores much of the "rational" aspect of her work. I prefer to point to certain "logical" systems employed in making these tapes rather than stress their Expressionism, which after all, is their most self-evident feature. (This "analytical" approach was cued by Lizzie Borden's exemplary entries for the Castelli-Sonnabend videotape catalogue, Volume 1, No. 1, 1974.)

Among the "rational" devices Benglis frequently employs is tape successiveness. Here, completed signatures of video are re-recorded while being played, so that the second tape reveals the artist newly relating to the earlier image. This sequential aspect, time and image cycled and recycled into third and fourth signatures, seems more common in tapes made before 1973.

Such "informal seriality" still demonstrates Benglis' commitment to an abstract structure that had been codified in Minimalism. The

Post-Minimalists retain as well as alter their abstract origins; often their temporal sequences parallel the checkerboard and grid structures central to the Minimal stlye which had reached its apogee in 1964-1966. Many of the audial and kinetic effects sought by contemporary "story artists" or "dancer artists," in terms of sound or movement—linguistic and theatrical means—reveal that these artists also seek to demonstrate a rootedness in the purely abstract concerns of Minimalism.

At the first public screening of Benglis' earlier tapes in the Spring of 1973, Bruce Boice, the painter and alert critic pointed to several abstract underpinnings in the larger matter of Benglis' Expressionist video work. These tapes particularly are marked by a heady recording, and a technical rudeness central to Expressionist immediacy and to Benglis' very delight in new technology. Finding Beglis' video simultaneously "boring, interesting, and funny," Boice noted that "the content of Benglis' videotapes is another monitor screen, which sometimes shows still another monitor screen... Usually the visual static is at one remove or more from the machine we're watching, it is on the monitor pictured in the tape."[1] Boice might have as easily pointed to the disparate relationships between what is said and what is seen on the tapes. These "synch/out-of-synch" relationships function often as not as an abstract holding pattern as well as an intuitive expressive device. In *Mumble,* particularly, the divergency between statement and image, between what one sees and what one is told one is seeing—a kind of reality testing—reaches elliptical heights. "The figure that is not on the screen right now is my brother. He plays football." Thus Magritte's famous legend "Ceci n'est pas une pipe" ("This is not a pipe") beneath the image of a pipe, has been transposed to our idiom.

Mumble was originally shown with *Home Tape Revised.* Both tapes are important for the number of autobiographical clues they reveal. *Home,* records a voyage backward to another time and place, from one kind of contemporary love to an earlier and, in

[1] *Artforum,* May, 1973, p. 83.

its way, more protective love of family. An aged grandmother repeatedly says, "I love you Lynda," during the shambling middle sequence that documents the artist's visit to her Mississippi-Louisiana homeland. The beginning and end of the tape reveals her friend Klaus Kertess, the art dealer and writer, typing in his New York studio. From *Home* one learns that Benglis is of Greek American and Southern Presbyterian descent. Her Greek origins provide a key to many Greek and "Hellenistic" clues throughout Benglis' work. This infra-information aids in transforming autobiography into formal and abstract issues. For example, several exhibition announcements reproduce a photograph of the artist as a little girl dressed in Greek *evzon* costume, the traditional Greek male garb. Such a man girl fusion is perhaps linked to ethnicity, one that may feed as well the current image of the artist as a contemporary California Venus, or as the object of extensive mannered erotic studies executed jointly with the artist Robert Morris.

Mumble is the earliest public disclosure of their key collaboration. I don't mean by this that together they made a single work, but rather that they fed each other's consciousness about the potential of video in a way that was mutually useful and interreactive. In a certain sense, Benglis' *Mumble* cannot be understood without reference to Robert Morris' tape *Exchange* and vice-versa. As *Home* reveals Benglis seeking solace in the bosom of the family, in deep America, in the present, *Exchange* reveals Morris seeking solace in art, in Europe, with its visual and verbal clues to past art—to Manet's *Olympia,* and Donatello's *Gattamelata,* among other examples. Both tapes deal with the frustration and confusion of physical desire with artistic creation. Morris' long text, which refers to "his" and "her" effects on one another (and therefore to earlier films and dances by Yvonne Rainer, with whom Morris has long been associated, that also focus on these archetypal male/female characters) is purportedly fictious.[2] Yet the text's autobiographical tone—a pendant to Benglis' *Home*—suggests that

[2] Some of the confessional tone of this text was struck in a nearly complete version that was published in *Avalanche,* Summer/Fall, 1973, pp. 22-25.

there's more truth to it than the artist perhaps cares to acknowledge. For example, he speaks of "a tape he made of a tape she made" as Benglis has included "his" image in "her" work. At one point Morris speaks of a seventh tape made together, and then later the accounting comes to 21 tapes in all although I doubt there were ever this many. In one particularly naked moment after all, this may only be literature he says, "the maniacal pursuit of art has led me to hurt women." This gets awfully tangled. At its simplest—yet most artistically complex—let's say that Morris is both grist and image for Benglis as she is for him. While the blurrings of truth are intentional one can't lay out all the relationships (so complex are they), not the least reason being a concern for propriety.

Erotic subjects figure largely in Benglis' internalized system of content as form. Like many other contemporary artists, notably Bruce Nauman and Vito Acconci, Benglis—cued by Duchamp as were the others—turns to her body as Readymade. "My video is personal to me, and I hope it might be personal to someone else. Video is one way in which I began to study an image, my image, and often those closest to me." [3]

The sequence of videotapes *On Screen, Document* (both of 1972), *Now* (1973), and finally *Female Sensibility* of 1973-74, demonstrate an increasing refinement of sexual or erotic Mannerism. In the first, the manual attack upon the body, say the drawing of the mouth apart in the manner of a Gorgon mask, while referring to Nauman's pioneering films such as *Pulling Mouth* (1969), indicates formal properties central to the early Post-Minimalist style around 1968. Benglis' Expressionist focus on regressive activities and sounds, long passages of visual static—an early tape is called *Noise*—as well as the more abstract content of screen seriality, alienates the viewer from conventional notions of female beauty. If this process does not exactly evoke "art" to the viewer, it is at least suggestive of "not nature."

In *Document,* while again acknowledging the paradoxical level

[3] *Art-Rite,* special issue on Video, Autumn, 1974, p. 12.

13

upon which seriality is structured into the work, Benglis alludes specifically to a source in Duchamp when, in a classic gesture of irony towards art, she concludes the tape by drawing a moustache across the image of her own face. The source is Duchamp's *L. H. O. O. Q.*, and like this celebrated work of 1919, *Document* infers the binary relationship between male and female, as do for that matter Gorgon-like grimaces. As Freud pointed out in a short but essential paper, "The Medusa's Head" (1922), Perseus, when beheading the Gorgon Medusa, enacted a culturally valuable surrogate castration. He points to the serpent locks of Medusa as a way of psychically overcoming castration anxiety—a fear central to the Oedipus Complex—through a multiplication of the analogue of the very organ which has been lost. The sight of a Gorgon induced petrification. This, Freud concluded, indicated that the vanquisher had totemically absorbed the central power of the vanquished and if decapitation here equalled castration, then petrification equalled phallic tumescence.[4]

Now, Benglis' first color video, engages a narcissistic dialogue with the artist's own image (Fig. 40). The videotape's most acute passages suggest a transformation of the image of the artist's tongue into that of a surrogate clitoris or penis. The autoerotic is perhaps the essential source of Mannerist sexual feeling. For the 20th century, this erotic myth was codified in the functioning of Duchamp's central work, *The Bride Stripped Bare by Her Bachelors, Even*. The relationship between Bride and Bachelors is auto-copulative, since both emerge (as does Benglis' sexual personality) from the same person—MAR (*mariée*, the Bride), and CEL (*célibataires*, the Bachelors)—that is, MARCEL (Duchamp).[5]

The notion of "infinite regression" that Borden points to in her

[4] First published in *Imago*, vol. 25, 1940. Reprinted in *The Collected Papers of Sigmund Freud*, ed. James Strachey, vol. V., Hogarth Press, London, 1950, pp. 105-106.
[5] I have pointed to this interpretation of the functioning of *The Large Glass* (as *The Bride Stripped Bare By Her Bachelors, Even* is more simply called) as a mythical model for the "Body-Art" of Vito Acconci, as well as for aspects of "Post-Conceptual Theatre." In terms of his autistic art Acconci has influenced not only Benglis, but a broad range of experimental artists attracted by theatrical-like alternatives to more conventional types of painting or sculpture.

catalogue essay for this videotape is further toned by the verbal directives of *Now,* since the query "Do you wish to direct me?" is always self-addressed. As Benglis' eroticism is metaphorically male and female at the same instant, so too is it slave and master. (This may be the source for Robert Morris' S&M exhibition announcement of April 1974, which, like much of his more recent activity has been spurred by, as it in turn inspires, Benglis' work. Benglis riposte to this announcement was a cheesecake, rear view shot, used as the exhibition flyer for a May 1974 exhibition of her work.)

The acuteness of sensibility revealed in *Now* culminates in Benglis' most startling and beautiful tape to date, *Female Sensibility.* This accomplished tape also exploits Benglis' most explicitly Mannerist color sense. The color of *Now* has a day-glo brilliance akin to the kinds of color Benglis used earlier in the execution of her latex and foam sculptures. *Collage* (1973) has a primary range of colors paralleling the rudimentary counting procedures and mechanistic Serra-related gestures (the mechanical chewing of the orange rind is like the repetitive catching gesture in Richard Serra's *Hand Catching Lead* of 1968). By contrast, *Female Sensibility* ópts for a Bronzino-like range of color: blue-green lips for one female participant (Benglis herself), and red-black lips for the other. This tape partly infers a mocking stance towards what certain commentators have viewed as the *de rigueur* lesbian phase of an emerging feminist politicization.

The slow, stylized caresses of *Female Sensibility* of course connote masturbation. In none of this however is there any gross fiber: nor is there any I believe in the now "infamous" advertisement published in the November 1974 issue *Artforum,* which certain critics took to be "an object of extreme vulgarity" that "represents a qualitative leap in that genre." [6]

This sanctimonious puritanism did not recognize that Benglis, in presenting herself as a nude-with-dildo, abrogates distinctions

[6] Letters to the editor, *Artforum,* December, 1974, p. 9. Its signataries: Lawrence Alloway, Max Kozloff, Rosalind Krauss, Joseph Mascheck, Annette Michelson.

between male and female—as does so much else in her work by subsuming these polarities within a single entity, echoing thereby the male-female subsumption in *The Bride Stripped Bare By Her Bachelors, Even*. In exploiting "the media" through pornography, and in so doing, transforming pornography into art, Benglis also pointed up the virtual loss of content—an absence fostered by academic repetition—into which female nude imagery had fallen in 20th century art.

JAMES COLLINS:

THE EROTIC AND THE DIDACTIC

Since Abstract Expressionism, it is clear the artist's most significant contribution is not made as a suite of objects aimed at delectation, but in the creation of a compositional premise that will rival if not supplant existing premises. The Abstract Expressionist postulated a compositional type—the Allover— rejecting the system of hierarchical comparisons built into the Cubist pictorial legacy. This achievement was followed by, among other examples, say, Minimalist holism and post-Minimalist atomization (itself a partial revival of Abstract-Expressionist principles).

The theoretical postulates of Minimalism adamantly questioned the adversary stance of the artist versus nature. By that time representationalism had been ratified in its approximation to the history of Modernism itself. What remained to Minimalism was a system of composition ratified in theory—as sensibility representationalism had been ratified earlier in its approximation of nature. Closer to our moment, it became clearer that both these ratifications by externals—nature or theory—equally were liable to sensibility variations—diversifications occasioned by the faltering power that nature and/or theory could still command. Thus the contemporary dilemma, occasioning an art of a resurgent pure sensibility, pure imagery or iconography, pure mechanical transcription of nature (recorded in technological media), or art of no physical embodiment whatever—pure ideation or conceptualism. Such manifestations were meant to suppress the artist's anxiety rooted in the lingering belief that he or she ought really to be making art that *was* critically ratifiable against a natural or theoretical model.

The most disconcerting circumvention of this refusal to jibe with

once-prevailing systems of external measurement is the internalization of the art-making process, withdrawing it into the self—body art, conceptual theater, what have you—and, in internalizing it, externalizing the conscious and unconscious autobiographies of the artists themselves. Vito Acconci and Lynda Benglis, for example, are artists who have enjoyed a certain notoriety, Acconci for the brute rawness of his early body performances and Benglis for an irony which allowed political issues—particularly feminism—to be incarnated as formal ones. Crudely put, most radical art today is all content, no form.[1]

James Collins also deals with an ironic range of themes, one which, like those of Acconci or Benglis, still reveals the artist's ability to externalize the secret, even forbidden paths in his nature in a way aesthetically recognizable through a binary structure linked to Minimalism.

Since Collins is an exotic, one is tempted to be preoccupied with his personality—after all, it plays a central role in his iconography. Moreover, his wit is so engaging as to oblige one often to record passages of his conversation verbatim.

Eldest of four brothers, Collins, now in his thirties, was born near London and grew up in Coulsdon—except for a South African sojourn during World War II where his father, a pilot, was sent to train. Returning to England after the war, Collins received a suburban grammar school education—"the usual kind of peaked cap bit." This was followed by four years at St. Martin's School, London (1959-63), "just when Caro came back from the States and decided to dump Paolozzi in favor of David Smith." Joe Tilson, Dick Smith, and Peter Blake were all teachers there,

[1] A rough index of this development can be found in a perusal of the list of artists included in the recent exhibition "Lives: Artists Who Deal With People's Lives (Including their Own) As the Subject and/or the Medium of their Work," The Fine Arts Building, 105 Hudson Street (November 29-December 20, 1975): Vito Acconci, Laurie Anderson, Eleanor Antin, John Jack Baylin, Lynda Benglis, Terry Berkowitz, Joseph Beuys, Christian Boltanski, Jonathan Borofsky, Chris Burden, Scott Burton, Colette, Chris D'Arcangelo, Agnes Denes, Howard Fried, Gilbert and George, Peter Gordon, Guerilla Art Action Group, Douglas Huebler, Ray Johnson, On Kawara, Nancy Kitchel, Bruce Kurtz, Les Levine, Anna Link, Mark Miller, Dennis Oppenheim, Adrian Piper, Marcia Resnick, Salvo, Joanne Selzer, Willoughby Sharp, Alan Sonfist, Eve Sonneman, Andy Warhol, William Wegman, Roger Welch, and Hannah Wilke.

attesting to an undercurrent of popular iconography amidst an otherwise generally provincial manifestation of Abstract Expressionism.

Painting at the school honored a strict separation between "the hairy chests and big boots of the sculptors and the painters, who by comparison seemed effete gentle creatures. The sculptors were the heavies. I dislike sculpture and sculptors. All that clay..." Particularly sensitive to matters of elegance, Collins recognized that his boyhood was marked by a profound "sexual/satorial awakening. Between seven and fourteen when I lost my virginity to Linda Leroy, I was infatuated with books, libraries, clothes. I visited every museum in London and every gallery. I've always detested physical paradigms, especially sports. I missed military service, thank God. In clothes I was able to recognize my manic compulsiveness. I was always a fanatic about clothes. When I was 22 I hitchhiked to St. Tropez with six pairs of Jack Buchanan shoes! [An allusion to the elegant ballroom dancer, England's Fred Astaire]. I externalized my identity through the structure of my appearance. When Richard Smith came back from America he was all accoutrements—chinos, tennis shoes, watchbands. I went through a very expressionistic sartorial phase—bowler hats and garden boots. I was pulled into Caro's office and reprimanded for wearing black leather gloves, bone jewelry, and pin stripes. It's not about flamboyance. What was important was social awareness. I don't really love myself, I can't always deal with the person I am, my social grace is a defense mechanism; I'm very conscious I'm in control—it's me mum on me back."

Collins' prejudice against sculptors and sculpture is a humorous pose. His painting from 1958-68 is also marked by the macho excesses of Abstract Expressionism and the English absorption of that style dating back to the big show held at the Tate in 1958. "Kline and Pollock opened up possibilities to us as to what painting could be, drawing us away from the moribund state of English modernism. The so-called avant-garde guys were doing Abstract Expressionism with a touch of social realism over an

Auerbach kind of surface."[2] As for the American conception of what constituted English modern art in the '50s—Keith Vaughn, Lucian Freud, and the St. Ives School, Moore, Nicholson, Hepworth—Collins cared not a jot. And in the English popular tradition—Hogarth through Victorian narrative genre—he thought himself equally disinterested, except as it at length came to be manifested in David Hockney's illustrations of manners. The Regency fop (of which Gilbert and George are the current music hall versions) was the only English popular tradition that caught his imagination, the fop dissembling in middle class terms.

On leaving St. Martin's, Collins painted, taught, and began to write. His best work at the time was sublimated into teaching. English art in the 1950s and 1960s was "rich in a teaching sense, but the results of the work of the teaching artists tended to be trivial." Collins' strongest statement of these views (a decade in the formulation) was expressed in his rejection of Richard Hamilton's work in a review of the latter's 1973 retrospective held at the Guggenheim Museum,[3] an article written nonetheless with a deep sense of misgiving, since Hamilton in many respects—certainly iconographically—prefigures interests of Collins'. Collins' rejection of Hamilton is not so much a rejection of imagery, especially Hamilton's sexual imagery—elegant young girls pissing, for example—as much as the neat dispassionnate Englishness which Hamilton brings to this taboo imagery. To kill the father is, of course, to acknowledge the paternity.

Collins' fascination with teaching led to the *Teaching Notes* of 1964, a collaborative effort with two other English artists, Ken Haw and John Sullivan.[4] Influenced by Roy Ascot's design courses

[2] A reference to Frank Auerbach, an expressionist painter whose canvases are loaded down with inch-thick scourings.

[3] "Richard Hamilton: The Two Culture Theory," *Artforum*, December 1973. Here Collins wrote that while "the level of English art literacy has been high, the level of art aspiration has been low. Gentle art and decorous criticism go hand in hand. The tradition of the English gentleman with art as but one of a number of civilized activities... has meant the maintenance of an amateur status... If the Richard Hamilton retrospective shows one thing, it is that a literate and intelligent approach to art doesn't necessarily generate interesting or important artworks."

[4] A loose-leaf typescript of these notes was completed by June of 1966; the illustrations of them were made while Collins taught courses at the Epsom School of Art and the London College of Printing.

at the Ealing School of Art which sought to locate the art-making procedure in social rather than aesthetic referents, Collins' design courses stressed an art-making founded in identity problems, language problems, sign systems, and the body itself. Among the "synectical" problems (i.e., problems that stress creative solutions), for example, were demonstrating how line articulates a surface—students lay foot to head upon a street (Fig. 41)—students fabricating objects from other students' written instructions, and students using objects alone to reveal a diary of their day. "Hybridizations" [5] also were conceived wherein visual forms of differing properties were "married" and each stage of their intermelding worked out in diagrams or drawings.

Such attraction towards theoretical structure in art largely accounts for Collins' development, from the unconscious formulation of derivative expressionist painting at the beginning of his career to the still unconscious formulation of his early American work in 1969—when the radical options of post-Minimalism were originally misconstrued as anti-formalist ploys—to a conscious rejection of all formulation, at length reaching the present state of an art of explicity wry sexual revelation.

A schematic breakdown of Collins' career thus may be structured: from 1964 to 1968, Collins the field painter and teacher; 1968-1969, a fascination with projects and process, the entry of photography into his work, the abandonment of painting, and his decision to come to New York. Between 1970 and 1972, he felt temporarily allied to the Art & Language group (particularly Ian Burn and Mel Ramsden), but in their pre-Maoist, pre-*Fox* phase. Collins at the time realized several conceptual proposals as mailing pieces; each work, translated into French and German, was mailed out internationally to a body of key recipients. In an early example, *Delegation Proposal* of August 1970, two strangers were introduced one to another (by two stand-ins for Collins) and either agreed to acknowledge the meeting or reject it. The

[5] "Hybridization" is revealingly discussed in Collins' searching article, "Pointing, Hybrids, and Romanticism: John Baldessari," *Artforum*, October 1973.

documentation consisted of a photograph of the encounter and a certification by the participants as to their willingness or disinclination towards the meeting. These mailers (begun in England) moved from such casually simplistic examinations of social systems through elaborate statements on semiotics, linguistic structure, also designed as international mailers throughout 1971, by which time Collins had already settled in New York.

In May of 1973, Collins' astute essay "Things and Theories" appeared in *Artforum,* marking his rupture with the Art & Language group, as he had come to sense the inability of intellectual or conceptual theory to function as a surrogate object. In certain respects, "Things and Theories" represents an adieu to pure linguistic conceptualism. This leave-taking was rooted in Collins' recognition of the truism that whatever the artist claims he does, his activities must remain in some inescapable sense visual. Visuality is the context wherein that class of creatures known as artists and that class of objects known as art is defined. Not to recognize this is, ostrich-like, to jam one's head into a sand bank of rationalizations justified on extra-visual, extra-aesthetic terms— namely linguistic and/or Marxist interpretation.

The Marxist content of Art & Language is governed by the correct perception that art and aesthetics is ultimately a bourgeois notion; since the bourgeoisie is indicted in the fine-grinding Marxist historical machine, so too must that class of objects recognized as art. But, like all who have practical experience with the merciless application of an historical dialectic, what Collins came to regret was not the loss of a broader conceptual range in his work (that clearly has remained), but the brutal exclusiveness and fascism that the mindless application of theory generates. And after all, painting and sculpture continue.

Beyond that, Collins recognized that Marxism was being applied by artists ultimately outside the real world of Marxist history—they, like any other member of the bourgeoisie, would quickly be up against the wall motherfucker come the real revolution. Thus the Marxist, ultimately neo-Maoist pose remained aesthetic, played out in the overalls of Marxist letters and proletarian manners. The fact that these writers were artists always got in the way despite a real

knowledge of linguistic and socialist theory.[6] (What remains unknown in the pure critiques of the Art-Language-into-*Fox* group is just what the art they would promote *does* look like. We now know what they don't like. Surely, they cannot be pressing for doctrinaire Socialist Realism?)

The introduction of photography into Collins' own work in late 1968 was accompanied by a need to be honest to the existence of highly idiosyncratic personality traits. To face them without guilt or remorse meant that the artist would have to draw upon them for the iconography of his work though they might conventionally be regarded as indelicate, not to say indecent. In this way their psychic power would be both channeled and neutralized. This range of subject matter, primarily sexual in character, already had been broached, for example, in the rambling monologues and physical actions of Vito Acconci's sexual performances that dealt with themes such as tantalization, fornication, and sex change. What Acconci, Benglis and Collins make clear is that anything can be made public—is publishable— and that that which is most personal and centrally private is also that part of artistic production most organic to the artist, even if it is most liable to elude critical discussion not to mention social censure from art critics who are hampered by optics defined in social criticism. So is this range of artistic production attacked by ideologists of the right or left.

From the end of 1973 on, Collins felt empowered to manifest aspects of a central voyeurism,[7] one that largely determines the style and methodology of his films and prints from filmstrip frames. These graphics are marked by a Warhol-derived stillness

[6] Art & Language group's caustic response to "Things and Theories" was published in *Artforum*, September 1973. The group's bourgeois gallery associations render their positions ambiguous, as does the partial underwriting of *The Fox, 2*, by the National Endowment for the Arts.

[7] By now it is easy to indicate that the voyeur has become a central figure in the iconography of modern art. He exists in numerous forms, particularly in the work of Jasper Johns (e. g., *Watchman*, 1964), and generatively in Marcel Duchamp—for example, the beholders of the ravishment of the Bride in *The Large Glass* are *the Oculist Witnesses* into whom we introject the spectator's role. They watch for us. And when at length *The Large Glass* was transformed into the real empirical space of the *Etant Donnés*, we, as spectators, viewed the ravished bride through peepholes bored into "the perfect door." [See, subsequently, Bruce Nauman's *Perfect Door* for a contemporary (and extenuated) relation to this theme.]

in which the female subject and the artist are filmed from the front or rear, flattish Manet-like confrontations of figure shot with a cold inaffective camera. Exploiting his social identity (as he did in the chance meeting documentations from the late 1960s), Collins introduced himself as an artist, explaining his project to unknown women. "The choice of a girl is what it is about. An adventure, socially authorized in the sense that I'm an artist."

On one hand, these frontal images of females reveal slowly scrutinized erogenous areas, erotic cues—the inner shadows of a blouse—a process which, in the duration of unflinching mechanistic gaze, de-eroticizes the subject. On the other hand, these images are linked to binary structure, a means of introducing an abstract formal content to the work. Thus, as is characteristic of Collins, the didatic and the erotic interlace in a mutually supportive system. This binary structure mirrors issues seen throughout contemporary epistemic abstraction such as Mel Bochner's "estimated and measured" elements, or Robert Morris' "left hand/right hand drawings in time." This abstract content structures such films as *Watching* — (fill in a woman's name, depending upon the sitter, Fig. 42), *Two Kinds of Watching,* or the *Portraits of* —.

In films of this kind the screen structure is of two or three abutted rectangles. On the left-hand screen, say, Collins is seen observing (gazing as active not passive) the sitter for the duration of the filmstrip; on the right, a still photo of the sitter may appear. In *Two Kinds of Watching,* for example, the image of the artist on the left may be seen scrutinizing the sitter in the background, while on the right the *metteur-en-scène* may be seen to flip through still photos of the same sitter.

In the *Portaits of* — series, Collins is fascinated by the "hybrid" of fragment versus whole. In these, the central rectangle shows the whole face of a sitter while on the left, one observes, say, the sitter's eyes, and on the right, her mouth. This tripartite structure is maintained in, say, the *Portrait of Rochelle* in which the center screen reveals the face of a young woman stripping, the left screen focuses below her waist as she removes her slip, and the right shows her removing her blouse to reveal her breasts.

172

In the *Watching and Imagining* films, the left-hand screen presents the image of the artist from the rear observing a young woman, while on the right, the artist is seen frontally and thus unable to see what the young woman in the rear is doing. In such works the erotic content is intensified because the artist denies himself knowledge of the sitter's activity. In *Adjusting Rochelle's Pants*, for example, Collins, in a somewhat subservient position, smoothes and adjusts the undergarment of the model as if in preparation for a perfect fashion photograph, unusual in that he is seen to actually touch the woman. The smoothing and tucking engages the pleasures of the voyeur and frotteur while still honoring a basic binary structure of current abstraction. The irony of the scene here is underscored by the artist's desire to perform two socially ambiguous acts, lifting the model's skirt and adjusting her slip. The edgy tension of this work builds towards a gratification that is never given vent, a sexuality that is all foreplay. This extreme erotic tension coexists with the implicit sexual defusing occurring when such acts are reprographically transformed through the film loop—three feet equals three-and-a-half minutes—a particular made universal.

Collins' sense of the female rejects "earth-woman" mythology or an Amazonian feminism, encompassing instead the glossy female types derived from high fashion. His former wife Anne Saunders, a fashion designer and collaborator on his early conceptual pieces, intensified his particular sensitivity to the nuances of cliché star gestures and brittle femininity characterizing the fashion vision of the female. Collins also embraces the fashion photograph for its urgent coloristic stress. Prints made directly from film frames maintain this exaggerated technicolor quality, and the fashion photograph, with its somewhat glacial predigested aura of sharp elegance, keys into his earliest, manic sense of style.

Obviously this art can be dealt with in terms of a post-Warhol media-orientation or a mindless Pop-derived imagery of gloss and fashionability. Yet Collins' imagery, partly conceived though it may be in Warholian terms, dilates upon a central erotic experience in the artist's life, one that owing to its psychic centrality eludes censure, full interpretation, or criticism. Like all the ploys to

173

circumvent criticism marking significant contemporary art, this disclosure is a means of obviating and denying an art that is exclusively locked into a suite of critical/formal strategies (though this rejection of strategies may itself be a strategy).

Traumatic autobiography is impervious to measurement. What can one correctly say of an exquisite agonized moment in an English train compartment in which a young man scrutinizes a pubescent girl also caught up in the muted tense energy of this instant as she slowly raises her school skirt above her panties in order to allow the young man to better contemplate her inner thighs?

It's not that we have nothing to say about the role of sexual narrative in conceptual photography; nor that a psychoanalyst would be unable to postulate a theory of sexual behavior stemming from this Nabokovian trauma; it's not that there isn't a technological orientation, a media fixation, or a high key representationalism in the moment to which this situation cannot easily be associated. But what the content of such an encounter does is to render shabby standardized modes of critical address. Formal interpretive mechanics grows grosser and more inappropriate as they are applied to psychological human situations of such fine tautness and privacy. Pure behaviorism is a kind of impermeable abstraction. One doesn't know what to make of the data. Whatever the interpretation, too much remains raw and naked.

Perhaps, for this reason, the extreme reaches of behaviorist conceptual activity will, as a broad stylistic movement, tend to dissipate. The fall-out of an art of private iconography, body art, conceptual theater, doubtless will fade—but disappearance is not the same as never having been. The voices of the status quo, factionalists of predetermined critical hypotheses, have already largely discouraged this mode of expression through an embarrassed neglect—a silence tantamount to erasure—and an equally fearful puritanism.

SCOTT BURTON:

CONCEPTUAL PERFORMANCE AS SCULPTURE

"A perfect cube looks stable in comparison with the flux of ap-
pearance, but one might be pardoned if one felt no particular interest
in the eternity of a cube."

—T. E. Hulme

With the relaxation of Minimalist principles in the late sixties,
the practice of sculpture was able to enter a highly pictorial and
coloristic phase in which many tangible embodiments were in-
carnated through an expressionist painterliness. This was succeeded
by a theoretical and absolutist intention, a systemic rigor of
thought still embodied, however, in objects conventionally conceived
of as paintings or sculpture—the squares and cubes of Minimalism.
Another strain of conceptual activity rejected the external embo-
diments of painting and sculpture for an internalizing, self-
referential urge that sought sculptural incarnation through the
artist's use of the body itself. This led to a resurgence of "theatri-
cal performance" and a concomitant reliance on documentation:
photographs, videotapes, films, etc.
Of all the figures in this by-now classic vanguard activity—e.g.,
Acconci, Benglis, Morris, Oppenheim—Scott Burton, by his mo-
desty, poverty, and ambient association with the more unstructured
and unpowerful elements of this tendency, managed to get lost.
Yet if one thinks of his valuable *Pair Behavior Tableaux* revealed
at the Guggenheim Museum early this year, or his freakishly per-
sonal and exquisite furniture pieces shown at the Whitney Museum
Annual (1975) and at Artists Space (1975), or his sociologically
manipulative erotics at the "Lives" show at the Fine Arts Building
in September 1975, one realizes with what a sharp aesthetic and
critical intelligence one is dealing.

Some background is necessary. Burton, born in June 1939 in Alabama—"that's not important; I don't feel like a Southener"—was raised within a genteel Presbyterian ethos, a boyhood salvaged by a mother who made him feel extraordinary. When his parents divorced, he was relocated to Washington D.C.

Power came from reading, through aesthetic commitments, through scrutiny of the National Gallery and the Phillips Collection, and through adolescent bohemianism. At public schools during the fifties he was sharply aware of distinctions of all kinds, not the least of them his dissembling vicarious life at the fringe of economically privileged Georgetown kids.

At fourteen Burton decided to become a *New Yorker* cartoonist: "Steinberg led me to Picasso." He began to attend the Saturday art classes at the Corcoran—went to one but never returned. Instead he chanced on the Washington Workshop for the Arts. The painting instructor was Morris Louis. Burton stayed only for a session because everybody around him was staining bed sheets: "I was only up to Picasso." At Western High his art teacher was Leon Berkowitz, through whom he met de Kooning. Across such happenstance he at length grew aware of the importance of the emerging Washington Color School, of Greenberg, and the mythology of who was introduced to whom by whom. Through these interchanges, he learned the pecking order of the heroic generation of New York painters and its suite into second and third schools. In 1957-59, Burton summered at Provincetown to study painting with Hans Hofmann; in 1959 he came to New York to study literature at Columbia University.

The Washington Workshop side of things made up his emergent public adolescent identity as artist. Its covert aspects are more compelling. Burton came to take an obsessive fascination in architecture and decoration, fixated by, among other things, the classic furniture advertisements of Wormley/Dunbar in the fifties which repeatedly locate pieces of furniture in landscapes, on beaches, and in forests. Burton now understands this fascination to be an evocation of his "longing for an ideal family life." He construed the reordering of the furniture in his room as "the re-living

of one's childhood in an ideal way." Even then he began to see how furniture transforms one: "A table is not anthropomorphic. It's just a vertical against a horizontal. But a chair is anthropomorphic." These ideas were then inchoate notions, just barely liminal art fodder. Day-to-day life was played out as "a teenaged Tenth Streeter."

Visiting Scott Burton in his Thompson Street tenement walkup, third-floor corner apartment: life is an accumulation of things crowded in the suite of kitchen-cum-studio, sleeping room-cum-studio, livingroom-cum-studio. Work is everywhere. The exquisitely finished furniture sculptures are protected from dust under sheets of plastic. Burton, a small tight man in small rooms, cocked and peppery, a bit like a caged animal. Bookshelves tower and piles of books lean crazily. The Mario Praz *Illustrated History of Furnishings* and his study of *European and American Conversation Pieces* accessible for fast reference. Picture postcards dot the cracking walls: images of furniture from Tut's tomb, Shaker chairs hung on pegs, Louis XVI fauteuils, American functionalist dinette furniture of the thirties and forties.

We talk of the first furniture pieces, the Iowa *Furniture Landscape* reproduced in *Triquarterly* 32 (Winter 1975): temporary installations of furniture in smallish clearings of forest. He had made an intense search for the right pieces all over town. Floor movements in the forest were determined by a house-scaled clearing that honored a rationalist ground plan. The intention was not a new picturesque; and it certainly was unintentionally surrealist though its poetical affiliations were inescapable. "The *Dream* of Rousseau, how could that not be an influence?" he replied to an obvious question.

If one could trace the role of furniture in Burton's thinking it might run something like this: the objects in the landscape of the Iowa piece yield up the notion of furniture as psyche; this in turn leads to furniture as surrogate people, which reverses itself into people-equal-furniture, a prefiguration of the *Behavioral Tableaux;* last, if this system is correct, it recreates an entire process of psychic reintegration. Burton will be "made well" (assuming for argument's sake that he is "unwell") at the moment when

the last equivalence is reached, when people equal people. I am describing a kind of therapeutic history, not a consecutive series, but one in which events happen all at once.

The furniture pieces splay into three sectors: first, performance; second, furniture (as tangible and objective sculpture); third, photography—not for photography's sake, but as an ancillary creation invoking a complex, private, frequently sexual iconography. Often of necessity these three threads meet and interlace. All of the elements of Burton's work—be they furniture piece or furniture as psyche—can be shown to have first emerged in the late sixties. Like most significant figures in post-Minimalism, consciousness came around 1968—"Something in it allowed me to orbit. After conceptual art I could see how to do work."

The performances are traceable to street works and activities animated by John Perreault, Vito Acconci, and Marjorie Strider, among others, in the late sixties, in which the events are so similar to daily street life or created seemingly with the stuff of street life as to be near indecipherable from the very fabric of street life itself. Among the activities: "Appears in public as a woman, drugs self to sleep at public art-opening, runs naked in street."[1] The intention of course was to create an art of little aesthetic profile, a raggedness given moral consequence through a conscious rejection of high abstract principles as they continued to be articulated by Greenberg and neo-formalist critics. For these critics "enemy art" was one that relinquished a vis-à-vis confrontation, an inert separateness from the viewer. To undermine this inhuman parity meant that this fringe group transformed painting and sculpture into a kind of psychological behaviorism and para-performance activity—inconceivable as art (then as now) to the formalists.

High formalist art was at the time inculpated by its assimilation to a corporate identity, its shimmering veneer aestheticizing the American adventure in Vietnam, and anesthetizing the odious

[1] From Burton's xerox catalogue piece ironically titled "Odd Years"—odd numerically, not even, bizarre. These activities date to 1969. See *Lives* (*Artists who deal with People's Lives* [*Including their Own*] *as the subject and/or the Meaning of their Work*), Fine Arts Building, November-December, 1975, n.p.

Nixon years. Gut level conceptual street performance at least had to its credit the fact that whatever kind of art it was, it was not formalist art. This transformation in urban aesthetics around 1969 often forced the artist to turn back upon himself as the primary raw material of his art. It was accorded a final prestige *à rebours* in that not only the formalists, but the whole art world tended to find its psychological and autobiographical content suspect, not quite respectable. Mind you, Burton rightly views the use of autobiography—content without form—as only a bridge, a transition out of conceptualism. His major concerns today, traceable to aspects of the earlier experience, engage the complex semiotics of behavior and the reintegration or reassimilation of decoration to art.

The early conceptual activities at length led Burton to characterize the artist as a prancing ithyphallic satyr—a "tragic priapic artist," [2] the classical *cothurnus* burlesquing the archetypal macho expressionist. Burton brilliantly costumed this startling sexual image in the manner of grotesque obscene buffoons in the classical theater by affixing a black dildo to specially maculated overalls. The costuming of this personage was worked on through 1973-74 to take into account the subtle changes in overall cut and heel size— say, the emergence of the platform heel (an imaginative metaphor for the satyr's cloven hoof)—that have taken place in men's apparel during these years. It may be that the finessing of such details grows out of Burton's frankly anti-technological conceptual bent— anti-"tech art," video, films. Instead of being composed of a lot of electronic equipment and hardware, Burton's art is built out of bits and pieces, clothing, second-hand furniture, aesthetic detritus and hand-me-downs of all kinds, and, as such, is close in spirit—however extenuated—to early collage tradition as maintained across the combines of Rauschenberg. I suspect that Burton's revulsion for high technology is sustained by an association of technology with "the Father" and/or other conventionalized notions of the male.

In a May 1973 lecture at Oberlin, the artist dissembled as a

[2] Ibid., 1973.

clean-cut American, wearing a short-haired wig and suit and tie, presenting a slide lecture on his own work in the third person, as if he were a young instructor talking about someone else's work. A blackout followed, and wig, jacket, shirt, and tie removed, the artist was suddenly revealed in overalls and white face, a conscious parody of the modern American male artist with the phallus sharing importance with the overalls. Oddly, such laborer's garb forms a sartorial continuum from Regionalist conservatives to urban modernists, from John Steuart Curry through de Kooning to Carl Andre. Despite the failings of this performance, Burton saw the power of work in terms of its photographic documentation, and the photograph then became something to be re-exploited in ways both intrinsically and extrinsically artistic. Its intrinsic value functions as a self-referential and autonomous art about which commentary is speculative; its extrinsic material is involved with an elaborate dialogue on certain evolutions in current art.

To understand a bit of this one has to go back to the Lynda Benglis ad published in the November 1974 issue of *Artforum*. In this advertisement, the artist appears with short-cropped hair, "shades," sporting a dildo. Here Benglis is, on a public level, commenting on issues of pornography and feminism. "Benglis, in presenting herself as a nude-with-dildo," I noted, "abrogates distinctions between male and female—as does so much else in her work—by subsuming these polarities within a single entity, echoing thereby the male-female subsumption in *The Bride Stripped Bare by Her Bachelors, Even*." [3]

Benglis is additionally engaging in a private interchange with Robert Morris, memorialized particularly in Benglis' videotape *Mumble* (1972) and Robert Morris' *Exchange*. "I don't mean by this that together they made a single work," I said of these videotapes, "but rather that they fed each other's consciousness about the potential of video in a way that was mutually useful and interreactive." [4]

[3] "Benglis' Video: Medium to Media" for "Physical and Psychological Moments in Time," a first retrospective of the video work of Lynda Benglis (Fine Arts Center, SUNY, Oneonta, January-February 1975), n.p.
[4] Ibid.

The shocking advertisement was part of still another retort to Robert Morris' advertisement for his exhibition of April 1974 at Leo Castelli and Sonnabend Galleries (Fig. 43).[5] In that S&M poster, the male-female ambiguities of the Benglis ad are expressed at the same instant in the artist's appearance as a master (the Nazi helmet) and a slave (the studded collar and manacled hands). On one hand there is the extroverted oiled beefcake shot of Morris contrasted against the dainty modesty of the barely visible elastic of his jockey briefs.[6] In turn this exhibition poster inspired Benglis' rear-view jeans dropped cheesecake announcement for her May 1974 exhibition (Fig. 39). There was also in this Benglis material a reply to Vito Acconci's performance *Conversions* (1971), the most startling moment of which is when Acconci tucks his penis between his legs to express himself as a female. Benglis with a dildo reverses this process, expressing herself as a male. Acconci, Benglis, Morris, and Burton maintain the preeminent status of the androgyne whose myth is codified throughout the oeuvre of Duchamp. Despite the inescapable sensationalism inherent to such imagery, its real interest reflects a maintenance of the Duchampian tradition.

What we are dealing with, of course, is the much higher visibility of erstwhile secret sexual life coincidental with the early seventies,

[5] Susan Sontag, "Fascinating Fascism," (a prime study debunking the post-War whitewashing of Leni Riefenstahl, prompted by the publication of Riefenstahl's *The Last of the Nuba* and Jack Pia's *S.S. Regalia*), *The New York Review of Books*, XXII, 1, February 6, 1975, pp. 23-30. "If the message of fascism has been neutralized by an aesthetic view of life, its trappings have been sexualized... The solemn eroticism of fascism must be distinguished from a sophisticated playing with cultural horror where there is an element of the put-on. The poster Robert Morris made for his recent show at the Castelli Gallery in April 1974 is a photograph of the artist, naked to the waist, wearing dark glasses, what appears to be a Nazi helmet, a spiked steel collar, attached to which is a large chain which he holds in his manacled, uplifted hands. Morris is said to have considered this to be the only image that still has any power to shock: a singular virtue to those who take for granted that art is a sequence of ever-fresh gestures of provocation. But the point of the poster is its own negation. Shocking people in this context means inuring them, as Nazi material enters the vast repertory of popular iconography usable for the ironic commentaries of Pop art." p. 28.
[6] In a startling apposite way S&M terminology is part of the jargon of video technology: "In dubbing, the machine that has the master tape on it is called, unsurprisingly, the *master machine*. The vtr's (video tape recorders) that record the information fed from the master machine are romantically known as *slave machines*." And so on in this vein. Peter Weiner, *Making the Media Revolution, A Handbook for Video-Tape Production* (New York, Macmillan, 1973), pp. 161-163, esp.

an awareness that owes much to the liberating forces generated by the women's movement and its attendant male consciousness including gay lib. For consumers this was reflected in the proliferation of sex shops, "toys" like dildos and vibrators, sex movies, etc. Susan Sontag could take the Nazi imagery of homosexual masochism to task in the *New York Review of Books* (February 6, 1975) while on a more public level, the *Village Voice* featured articles about S&M homosexuality (e.g., Richard Goldstein, "S&M: The Dark Side of Gay Liberation," *Village Voice,* July 7, 1975), elements of which had been circulating in gay pornographic movies such as *L.A. Plays Itself* (Fred Halstead, 1973).

The volatile issues of pornography, feminism, homosexualism, and manipulation of the media generated by Acconci, Benglis, Morris, and Burton are surely traceable to certain assumptions about what we consider the materials of art to be. One says that a sculptor uses wood or plastic or bronze; saying that means that sculptors employ various mediums in their work. The plural of medium is media. Only media doesn't mean mediums in American usage, but rather it means radio, television, magazines, movies and advertising. In short, it means Warholianism, the manipulation of advertising and promotion as a central message of one's art. As such, Warholianism—the introduction of media to the possibilities of artistic materials—is the most recent "ignoble material" admissible since the Cubist collage definitively established the parity between what academics had earlier viewed as a conflict between "noble" and "ignoble" substances. In this sense, Warholianism—the media as medium—admitted to the sculptor's range of investigation an intangible substance hitherto unrecognizable as even being open to manipulation. Such an idea ends in clarifying the distinctions inferred in the English language usage of the verb "to manipulate," a meaning which engages not only the physical working of a real material, but the psychological or ideological alteration of minds and bodies. A last word: Warhol as an artist of immediately contemporary interest is a dormant issue, while Warholianism exerts its emphatic interest.

Of course, I stress beyond Burton's own view of his activities his role in the Acconci-Benglis-Morris-Burton sequence because, of

the four, Burton has had the least mileage. Thus, it was with a certain feeling of having been overlooked that Burton read my associations with ithyphallic kraters to describe the manneristic and Hellenistic intentions of Benglis' shocking imagery. In his piece in the "Lives" show, Burton proclaimed his dominance over Morris and Benglis by a public recitation of a jealous sexual fantasy, a group of dream fragments. This is distilled in the catalogue to the laconic "1975: Relates Wet Dream." It is not the provocative sexual matter of the work which is impressive—that kind of material has already entered the middle-brow media—but an irony stimulated by and, in turn, entering the deeply covert interchanges of artists who are successfully "making it" in the larger sense of the art scene and market by an artist working at the margin. It's obvious that this fantasy exists only as a fantasy. Yet, within Burton's work, it is the most explicit and aggressive sexual content in an art that is otherwise marked by extreme reticence and allusiveness. In fact, according to Burton's reading on his work—insofar as any artist can dissociate—the "Lives" piece serves only as a modest footnote to the behavioral studies and furniture pieces. I attribute to it an importance that its very modest incarnation can barely sustain, an importance indicative of the often involuted, almost incestuous commentaries carried on in more recent antiformalist art.

By contrast, the most extreme contraction of experience, obsessive understatement, and exquisiteness of craft is realized in Burtons' *Pair Behavior Tableaux* (Fig. 44). Here the mise-en-scène is two ordinary wood chairs, set at either end of the stage, that are in every proportion either too high or too awkward or too uncomfortable, owing to the platforms on which they are placed. Between the chairs two lean men anomically interrelate. The viewers seated on folding chairs, are forced to view the stage from a distance of fifty feet across a closed auditorium pit. The actors—one can say "sculptures"—wear chinos, white t-shirts, and high platform shoes—a further derivation from the artist-as-satyr image. They go through a set of forty-seven fixed tableaux based on attraction/repulsion motions recalling, if you will, Léger's *Ballet*

Mécanique, or more immediately, the presentations of Gilbert and George. But, importantly, Burton does not appear—he is offstage—unlike the English sculptors who are their own sculptures. Burton makes no such confusion, one perhaps necessary to an early stage of body art, viz. Acconci, Bruce Nauman, et al. In Burton's case, the metteur-en-scène is the sculptor, his "actors," his "sculptures." The positions chosen in this suite of poses are static and tense, chilling, inhibited, tight. The movements are rudimentary: get up, sit down, step forward, step back, sidle, with a sharp attention to mannered glossy poses or positions. A close parallel is found in the ambiguous hieratic gestures of Ferdinand Hodler's Symbolist paintings. Thirty-five minutes into a long hour, a performer at last touches the other's shoulder. It is a kind of performance devoid of dramatic climax—a suite of archly mirrored interchanges. The mechanistic actions are those of the performers; the human, those of a dissociated and straining audience that fidgets, coughs, checks watches, and the like.[7]

This muteness in part stems from the seemingly inert forms of Minimalism, forms which an early generation of modernists might have thought incapable of eliciting empathetic responses. (T.E. Hulme's aphorism is a pithy example of this attitude.) Here characters are reduced to the inanimation of Minimalist sculpture. I have noted the stark formal character of Minimalist sculpture. While rejecting the isolated vertical monolith as the *sine qua non* of the species, it replaced it with a new metaphor—that of furniture—floorbound, horizontally sprawled, industrially prefabricated (rather than handicrafted)— the "rugs," so to speak, of Carl Andre, or Richard Artschwager's early still Pop formica boxes, one part Judd or Tony Smith, the other simplified images of table cloth, chair leg, or chair back. Thus sculpture became a kind of non-utilitarian furniture, the radical art quotient of which

[7] Linda Shearer, commenting on the *Behavior Tableaux,* notes in the Guggenheim flyer for them (February-April 1976) that "they're not like Happenings insofar as the spectator is not allowed to become a participant in the proceedings. He [Burton] also refuses us the theater's traditional distractions by imposing both physical and psychological distance. In so doing, he forces us to concentrate on specific gestures with an intensity parallel to the intensity of his manipulations of these gestures."

was expressed in a quirky absence of usefulness and in terms of its horizontality.[8]

If a modernist option in sculpture engages or incorporates an awareness of sculpture in terms of furniture-like affiliations, and if the artist is in fact not a mute generalist abstractionist but indeed a highly specific mannerist dealing with an ambiguous but still decipherable iconography, then sculpture may be expressed either as a conceptual performance or as painstaking reconstruction of pieces of furniture of specific stylistic character. Burton's case is exemplary. His sense of furniture moves from the found to an invented design based on an exact knowledge of period style. To date, several reconstitutions—the tables at the Whitney Biennial —for example, have been finished, though a dozen have been projected, some already in fabrication. Fascinated by rationalist design and vernacular art deco, Burton's taste leads him to variant forms of Bauhaus and de Stijl and the Arts and Crafts tradition. These pieces of furniture are counterparts to the human in his work: in a more extensive installation of chairs at Artists Space, chairs had been set up within a shallow stage-like space and exquisitely illuminated in the manner of Jean Rosenthal or Jo Mielziner, celebrated masters of stage lightning.

The most startling of the works is a huge bronze armchair cast from a kind of Grand Rapids revision of Queen Anne—a balusterback slat and muffin legs (Fig. 45). This real-life chair evokes less the shadow of Pompeiian bronze furniture than that of Johns' Paintbrushes cast in bronze in the Savarin coffee can, or the ale can pair, one of which was cast, one modeled. In Burton one witnesses the force of convictions embodied within a finessing, ironic parody.

[8] For example, "We have seen, in the past two years particularly, an almost concerted assault on the axiomatic verticality of sculpture in favor of horizontality. There is, of course, a kind of familiar horizontal form which, although not called by the name of sculpture, has always insisted on certain sculptural qualities—furniture. When Brancusi made horizontal sculpture, he justified himself by regarding the results not as 'sculpture' but as 'furniture,' calling such sculptural artifacts 'Bench,' or 'Table,' stressing in such appellation a functional rather than horizontal connotation.
"In this respect, that Carl Andre's floor-bound square modules should be called 'Rugs' seems less fortuitous than may appear at first hearing..." see "Richard Serra: Slow Information."

15

THEATER OF THE CONCEPTUAL:
AUTOBIOGRAPHY AND MYTH

The posthumous revelation of the diorama *Etant Donnés* gave lie to the canard that Marcel Duchamp abandoned art for chess in 1923, when.he left the *Large Glass* unfinished. For 20 years at least (c. 1946-66), Duchamp had been intensely engaged by the continued elaboration of the mythology that had occupied him between 1912 and 1923—the arcana of the *Large Glass*. Duchamp scholars now realize that the imagery of *Etant Donnés* represents a working toward nature from the mechanomorphic elements of the *Large Glass*—empirical representationalism deduced from diagrammatic terms instead of the reverse.

The title *Etant Donnés* as an expression indicates those syllogistic premises that are "given" or "granted" in a logical argument. When we say so and so is "granted," in French we say "etant donné." In *Etant Donnés,* the granted elements are identical to those of the *Large Glass*—the waterfall and the illuminating gas—physical and metaphorical sources of energy.

Significant to the development of *Etant Donnés* are three small erotic objects of 1951, the *Objet-Dard,* the *Female Fig Leaf,* and the *Wedge of Chastity*. All the titles of these familiar and curiously ambiguous talismans play with literary conceits and/or outright puns. The pun is the touchstone of Duchamp's thought —a circular process of reasoning that thriftily returns to the same place while releasing fresh insights.

These three sexual objects account for certain inferences that clarify the mode of Conceptual art that deals with autobiography and/or myth. The three objects respectively are male, female, and a binary image—a male-female form. The male object is *Objet-Dard*—in appearance flaccid and vaguely detumescent despite a raised veinlike element running along a curved ridge. This metal object, it seems,

was a brace from the mold in which the breast of the violated female nude of *Etant Donnés* had been shaped. *Objet-Dard* is marked by an oval plane at one extremity upon which are incised the words "objet dard." This pun bridges the notion of "art object" and "dart object," the word "dard" in French meaning dart. The dart aspect of the work, as Duchamp acknowledged, intensifies the phallic implications of this conundrum.

In my view, the implications inherent to *Objet-Dard* clarify a source of the iconography of early Jasper Johns dating from about 1955, when he first met Duchamp. The appearance of *Objet-Dard,* a work that on Johns' first encounter did not remotely look like an "object of art," led Johns to ask how such an object could have been imagined in the first place? Duchamp's reply, according to Johns, explained the derivation of the object from the mold referred to above.

The secondary meanings of *Objet-Dard* are even more elusive. What is the object of a dart? Clearly the answer is a Target, a central icon associated with Johns' painting from 1955 on. Thus, from the implicitly ironical attitude toward the pun and language in Duchamp's work, Johns made an imaginative leap which further transposed these implications into an oblique, conceptually multivalent iconography wholly different in type from the character of much American abstraction between 1950 and 1955. Johns' insinuating imagery displaced such glyphs as were then based on the prevailing fusion of Willem de Kooning and Franz Kline. Taking Duchamp's pun literally, at face value, Johns inaugurated an imagery of conceptual ambiguity, one that continues. The Pop artists, working in an ambient situation fed by many sources, were far less hyperbolic than Johns in their approach. To the degree that any were influenced by Johns, they took his work— and Rauschenberg's also—to emphasize primarily an iconography of conceptual sets that only incidentally engages the commonplace. But another generation of artists sees that it was the conceptual set that was as crucial as the imagery itself—target, American flag, map, numbers, measuring devices, and orthographic signs that identify primary colors.

The sheer perversity of Duchamp's *Objet-Dard,* shockingly unclas-

sifiable as art to an Abstract Expressionist taste, is even more paradoxical when the question "what is the object of a dart?" is answered by Johns' Target—an oddly specific response to a hypothetical query.

Johns rejects this iconographic connection. He claims he knew no French, though to mouth the word "dard" surely calls the English word "dart" immediately to mind. More viable is his assertion that he did not know of the three erotic objects until after the early Targets were completed. To be sure, there is the matter of Johns' personal acquaintance with Duchamp, a detail that must be accounted for, or even the access to Duchamp's mind and persona transmitted to Johns through Cage.

Be this as it may, the artist's mind, unlike that of the historian, does not thrive on niggling one-to-one details, but on making imaginative leaps and playing sudden hunches that throw the origins of the feat into relative unimportance. Even were Johns not fully cognizant of the potential of these three erotic objects in 1955, surely he was aware of some of their implications. What better confirmation of his fascination than that by 1960 he had personally acquired these works.

The intention of the cryptic *Female Fig Leaf* becomes clear on learning that it was modeled against the pudenda of the violated female figure of the *Etant Donnés,* on which Duchamp had worked so long in secrecy. Modeling against anatomy or anatomically suggestive fragments is a central feature of Johns' work that begins in 1955, and continues to this day. The *Target With Plaster Casts,* 1955, for instance, supports a register of boxes filled with colored anatomical fragments—lip, nose, ears, fingers, male sex organ—cast from the body of a friend of the artist.

The use of the body fragment, an essential reliance on graphic values, and an insistent intellectual clutch of paradox indicate that Johns, like Duchamp, evolves from the principles of French Symbolism. As Duchamp was the spiritual heir of Mallarmé, so Johns derives from Odilon Redon, in whose charcoal drawings and lithographs we find both the inspirational matter of Johns— fragments of human imagery, especially the floating or severed head—and his richly self-elaborating graphic technique. But beyond

these similarities of image and drawing is Johns' consistently ironic attitude toward such subject matter and technique. As interesting as it may be to note formal connections between artists, the issue is more resolved by the texture of Johns' mind itself. Who but Johns so consistently insinuates, so perversely warps the known?

Johns' relationship to Duchamp is one matter, and widely accepted. It serves to establish a model against which a wider and more contemporary mode of art can be discussed. Three aspects of Duchamp's work found response in the ranging horizontal and emotional climate of California art: 1) personal mythology; 2) a punning focus; and 3) modeling or casting itself as an irony as well as a method. The absorption of the folksy and homespun pun as typified in the Bay Area work of several artists, particularly Fred Martin, Jeremy Andersen and William Wiley, is the facet from which derives, in the first instance, Bruce Nauman's introduction to the pun. From such a local usage it was but one step further to explore the physically referential aspects of Duchamp's art, aspects that had been corroborated in the prestigious East Coast model afforded by Johns.

A telling motif, say, of Nauman's appreciation of linguistic circularity is the neon spiral, a motif employed by the artist in executing the early *Maxims*. Their shape obviously approximates the cyclical nature of the pun, as Johns' Targets duplicates it.

While the very title of Nauman's *Wedge Piece,* 1968, inevitably recalls Duchamp's *Wedge of Chastity,* seemingly the least rewarding of the three erotic objects, its appearence relates strongly to that work. The *Wedge of Chastity* presents a ragged metallic element, the male plug, driven into a matrix of dental plastic, the female receptacle. Nauman's *Wedge Piece* counters a vaginal chamfering (registered during the industrial fabrication of the wedges) against an elogated phallic shape. Moreover, the redness of the wedges corresponds in hue to the pinkness of the dental plastic used in Duchamp's piece. There is, then, a close coloristic and structural relationship between Duchamp's and Nauman's wedge variations.[1]

[1] In Germany, Nauman found two red wedges and inscribed the English word "like" on them. Our word for "like" has the same number of letters and incorporates the same letters

It is also important to note that the form of the wedge had been awarded credentials within Minimalism—the preeminent abstract-reductivist movement of our time—as a form in itself. Among the few alternatives open to abstract-reductivist form is commonly found the triangle—the wedge, the ramp, the corner, the "L." The icons of Minimalism are few—the square, the circle, and the triangle, as well as each of their spatial projections—cube and oblong, sphere and cylinder, pyramid and wedge. In the many Minimalist pieces executed by Robert Morris and Donald Judd, for example, we find "L" variations, wedge forms, ramps, and architectural elements that negotiate corner and walls. Imagine a situation that combines the circumlocutionary processes stemming from literary conceits, plus a value system primarily supportive of abstract art, then the sources and latitude of post-Minimalism become clearer.

Recent elaborations of this art manifested themselves in the rise of theatricality—the theater of the conceptual. The problem of drawing a mainstream formalist argument with regard to a conceptual theater, one that acknowledges its elements of dance, music, and behaviorism, lies in the difficulty of isolating those elements germane to the histories of dance, music, and behaviorism themselves, and those which have developed within a more contained view of painting and sculpture.

We witnessed, for example, as part of conceptual theater, work by the so-called body artist, Vito Acconci. He extrapolated the mythical type perfected by Duchamp—the androgyne—onto a

but in different sequence as the German word for wedge, *Keil*. On the basis of this "likeness" Nauman formulated the palindromic relationship between the words and shapes of the wedges.

This material was presented in my "Bruce Nauman: Another Kind of Reasoning." In a recent essay on the artist, this interpretation was rejected. Jane Livingston protested that at the time of the *Wedge Piece,* Nauman had never heard of Duchamp (Jane Livingston and Marcia Tucker, *Bruce Nauman: Work from 1965 to 1972*). Even were this assertion remotely possible, it is unacceptable because no serious art student glancing at the illustrations or reading the commentaries on Duchamp's work — rife in both specialized and popular magazines — could remain unaffected by Duchamp. In addition, Nauman worked in an atmosphere in which a multitude of Duchamp-inspired variations and dilutants were to be encountered in studio conversation, gallery cant, and media dispersal. An artist does not have to "know Duchamp" to know Duchamp's ideas. How many persons familiar in a general way with the notions of Freud or Marx have ever read Freud or Marx?

behaviorist examination of his own psychology, seen in *Seedbed*, a work developed during the period of 1970-72.

Despite scandalized outcries, *Seedbed* presents a bare *mise-en-scène*. Its setting is a ramp or wedge sloping up the corner of a gallery floor. Certainly it was not the external aspect of the work that proved provocative, but that the artist, fed by airholes drilled into the ramp's surface, isolated himself below the slanted floor and engaged in masturbation. The fantasy accompanying this act was faintly audible in the larger gallery space as it was transmitted through a loudspeaker in the corner of the chamber.

Seedbed takes as its metaphor one that Duchamp earlier had attributed to the *Large Glass*. *Seedbed*, like Duchamp's subtitle for the *Large Glass*, is "an agricultural machine"—Acconci's seed, so to speak, now being cast upon the floor.

The *Large Glass*—the work must here be referred to by its proper name *The Bride Stripped Bare by the Bachelors, Even*—records an ongoing series of physical changes, effected through the actions of complex mechanomorphic machinery. Owing to the functions of the mechanomorphs depicted on the glass, physical states are at one point seen as gaseous—the cloud, or liquid—the "love gasoline" dripped from the Bride in the upper portion of the glass into the realm of the Bachelors below. At length, the love gasoline falls into the *Nine Malic Molds* and therein presumably solidifies. Among still other possibilities, this altered physical matter may be pulverized by the *Chocolate Grinder*, as it once again may be turned into light energy while passing through the lenses of the *Optical Witnesses*.

In arcane lore, the person capable of enforcing the change of physical matter from one state to another is the alchemist or the androgyne—the latter being a fusion of male and female. He-She corresponds to a notion of God, that is, a coincidence of opposites. Throughout highly disparate cultures, such a person is often assigned the role of shaman or seer, the see-er of the future, like Tiresias of Greek tragedy, or the Seller of Salt, the Salt Merchant of kabbalism and alchemy.

By an exiguous and circumstantial argument the salt merchant appears to correspond to the medieval alchemist, i.e., the person

capable of effecting the change of matter from one physical state to another. The "salt" of the salt merchant may well be symbolized by the philosopher's stone of the alchemist—the esoteric catalyst without which such changes in matter cannot be made. The arcane knowledge, the gnosis needed to effect this change— say, for example, the secret name of God—and the actual enactment of these changes constituted for the alchemist, the kabbalist or the magus, *le grand oeuvre,* the great work of magic. Duchamp's *Large Glass* as completed by the *Etant Donnés* is his great work of magic and his life's work as well.

In French the Salt Merchant is called "Le Marchand du Sel," a transpositional pun on the four syllables of the name of Marcel Duchamp. Duchamp knew the name of the androgyne—Rose Sélavy (the secret name of God?) as well as the androgyne's appearance—the artist himself in transvestiture. Man Ray photographed Marcel Duchamp in such cross-garb in 1920, when perparing the punning label for the perfume bottle *La Belle Haleine*—beautiful breath, beautiful Helen. The label displays a photograph of Rose Sélavy, a punning name meaning "life is okay" or, "in the pink," or, "life is erotic [rose/eros]." She is the anima, the female side of Duchamp's nature.

All of this background is essential to an understanding of *Seedbed.* Acconci's earlier attempts to deal with the projection of an androgynous personality were realized through performances of such actions as the burning away of the artist's body hair, the tugging at his breasts, and the hiding of his penis between his legs. These performances indicate publicly that Acconci projected a notion of the androgyne that had earlier been set by Duchamp within his conception of his mythical alter ego, Rose Sélavy.

It is important to note the difference between the conceptual theater of Acconci's *Seedbed* and Dennis Oppenheim's *Adrenochrome* of 1973. *Adrenochrome,* like *Seedbed,* deals with the emission of chemicals—in Oppenheim's case, the chemical necessary to reconstitute the normal blood-cell structure of a schizophrenic—in Acconci's work, human sperm. *Adrenochrome* illuminates a particle of the chemical at the apex of a pyramid, while at the same time, a slide of the microscopic structure of the chemical is projected

against a gallery wall. Both *mises-en-scène* are lent credibility owing to a parallel support system for abstract forms, the ramp and the pyramid.

While both the above works were generated by personal crises, *Adrenochrome* remains a pro forma work that insists on a one-to-one relationship to the artist's biography. *Seedbed,* by contrast, is a highly nonformal and secretive work whereby the autobiographical element is transposed to the plane of myth on the basis of Duchamp's lore.

The ontological artist, therefore, as Duchamp had anticipated and indicated, is the one whose work is completed in the public psyche. It must be noted that the psyche is primed by a literature of myth. In the absence of this acculturation nothing appears to happen except the work itself and the viewer's subjective experience of it.[2]

The mythical personage of the androgyne, it seems to me, is the exteriorization of Duchamp himself, expressed through the surrogate adventure that began when the Nude Descended the Staircase, became the Bride, was Stripped Bare by the Bachelors—female and male personae who ultimately united in the androgyne as impersonated by Duchamp in transvestiture.

An important "proof" for this, apart from the visual evidence, derives from the French name of the *Large Glass: La Mariée mise à nu par les celibataires, même.* La MARiée mise a nu par les CELibataires— MAR-CEL, the first three letters of the French word for bride and the first three letters of the French word for bachelors comprise the letters of Duchamp's first name.

The by now obvious fact that Marchel Duchamp is both Bride and Bachelor at the same instant allows one to recognize something of a mythical core in, say, Vito Acconci's work, as well as to understand why Bruce Nauman may have used his name as a Readymade—*My Name As If It Were Bounced Off The Surface Of The Moon or My Name Enlarged Vertically 14 Times.*

[2] The recognition, therefore, of "public psyche" does not take place as a mystical necessity — the overtones of Jungian archetypes — but as a conclusion drawn from a liberal education. Were this not so, then I would be sponsoring an art of mysticism and intuition, qualities, if they exist, that are the paths of madness.

Similarly, as Duchamp had regarded the three sexual objects in terms of morphological transfer—most particularly the *Female Fig Leaf*—so too Nauman casts against his body in unanticipated ways. It was this aspect of Duchamp's work that licenses for us Nauman's move into behavioristic performance, video work, laser stereoptics, and architectural situations. At first, Nauman's attention focused on the external effect made by his body upon some malleable substance, as in the *Template of the Left Half of My Body at Ten Inch Intervals*. From this, Nauman was able to project an art in which no external object was actually formed but which internalized the process back into his body—intangible substances such as space, light, warmth, acting in time—were now reforming his body.

This shift between the mold and that which is molded has influenced much of the open and often seemingly unpurposeful aspects of the conceptual performance. In such instances the distinction between Acconci and Oppenheim may prevail. Those conceptual performances which allow for the consciousness of the mythic may be of a greater interest than those that are purely behavioristic.

Such a judgment is speculative. To insist on this distinction means that I posit a conceptual theater given value largely through an attachment to myth and legend. The converse may as easily be true. The question is still an open one. Conceptual theater may yet prove interesting precisely to the degree that it detaches itself from a mythological frame of reference.

Since literature of any kind has the effect of diminishing the abstractness of a work, a conceptual theater grounded, say, in myth would necessarily be weakened by this connection. But, in the same degree that myth may devalue abstraction, so too does autobiography. In the absence of myth and autobiography the conceptual performance becomes purely behavioral. This appears to be another reason why, in Conceptual art, the behavioral appears to bridge the ontological and epistemological branches of the movement: behaviorism is abstract conceptual theater.

When Nauman investigated the artistic possibilities of his body or his name as a Readymade, he drew away from an art based on

the pun and simple language toward what has been loosely called "phenomenology"—perhaps an abuse of the term, but one that nonetheless has entered art talk.

"Phenomenology," used this way, indicates a kind of physiological behaviorist activity and self-examination. What is it like to be? To do? To sense? To enact certain kinds of experiences and activities? Many of the experiences thus examined tend to be those attributed to inanimate things—residual Minimalism again—an underpinning derived from abstraction. What is it like to be immobile for long durations? To mechanically repeat physical activities? In such ways, artists as disparate as Nauman, Gilbert and George, Robert Morris, and Lynda Benglis can be bracketed, if only momentarily.

Moreover, Nauman regarded his body as a medium—trying to find in his body the very vehicle of his art—in the way that earlier artists had discovered the media of their art in watercolor, gouache, oil paint, etc. This may relate to Johns' connection between seeing and orality in many forms—speaking, masticating, ingesting.

This enlarging episode in recent art tied post-Minimalism into a loss of distinct species-types—painting and sculpture became "pictorial sculpture." Post-Minimalism is marked by a loss of typology—the rejection of stretcher supports, framing edge in painting, of base in sculpture, the loss of facture, and the loss of site. Until post-Minimalism, "Art" was indoors and "Nature" outdoors. In this connection Robert Smithson's Nonsites, Carl Andre's floor pieces and Richard Long's walking tours cannot be overestimated. Post-Minimalist elasticity meant that work could theoretically be placed anywhere.

With the loss of time-honored conventions of this kind—once art became part of an infinite continuum ranging from interior to exterior and species to species—painting and sculpture could quite naturally evolve toward and encompass theatricality. Nonetheless, the enactment, for example, of mechanical and repetitive actions and gestures still points to a formal continuity from Minimalism, despite the theatrical nature of such activity. To the painter or sculptor theatricality offered itself as an alternative to the loss

195

of belief in facture, in species-type, in retinality, and in site that had taken place.

Certainly, the *sine qua non* of art—traces of sensitively stroked surface executed with a paint-loaded brush—has been fundamentally undermined, perhaps irrevocably. While such activity is, can, and does remain art for many, other artists feel impelled to investigate looser modes and media, such as laser beam photography, video and film, behavioral phenomenology, the dance, storywriting and telling. The latter are all being explored as viable in their own right as alternatives to sensibility drawing and sensibility painting, and even as an alternative to the structures of thought of the pure Conceptualists.

In part this is why there has been such a resurgence of dance. Not necessarily dance practiced as a classically defined discipline, but rather as an art of rudimentary movement: walking as dance, amateur as dancer, another way of painting and sculpting—an alternative. Painting without painting, sculpture without sculpture. This may be a polemical generalization. That today we happen to see many dancers performing in ways suggestive of modes of painting and sculpture does not necessarily mean that the dancer is a painter or sculptor. When dance—and music too, for that matter—engages a wide reach in relation to painting and sculpture, it is tacitly assumed that this kind of dance or music is in some sense an expression *formed* by painting and sculpture rather than one that is *formative* of painting and sculpture. This is by no means a clear question today.

Robert Rauschenberg's connection as a dancer and stage designer to the Merce Cunningham Company is well known. Much of Robert Morris' early career was spent as a dancer working with Yvonne Rainer. Certainly, the prestige of Yvonne Rainer among post-Minimalists is high, both as dancer and filmmaker. Similarly, Trisha Brown's "Accumulations" dance of simple abstract movements is suggestive of many of the visual properties of our art. Yet despite such superficial bracketings and circumstantial inferences, the real question remains unanswered: Does recent dance come out of painting and sculpture or does sculpture and painting come out of dance?

In a parallel vein, about which I feel more equipped to speak, I question whether the emergence of "story art" evolves from the Happening, as a surrogate expression of the conceptual performance, or is informed by the abstract qualities of visual art. John Baldessari presents bitter parables, the morals of which ironically underscore the hollowness of art. Lawrence Wiener, like Kienholz before him, presents statements which are themselves projects and works. Vito Acconci and Dennis Oppenheim, among many, present strong performances in the contexts of behavioral phenomenology. Bill Beckley tells shaggy dog stories, while William Wegman opts for a clear, ironical humor. It is possible to see "story art" as a post-conceptual theater.

However, the methods of "story art" use modes still related to abstract form—halting speech, as if something solid and blocky were being formed in the mouth—terse, iconic words, stubby and solid; non sequiturs abound, breaking down the idea of story as narrative; memorization is used as a means of inducing a sense of rotelike immutability; repetition is used to establish a format of constant structure. These are some of the methods by which "story art" announces its connection to an abstract pictorial and sculptural mainstream, rather than to literature.

What of the artists who had typified the pure Conceptualists, the epistemological mainstream? Oddly enough one is witnessing a growing tendency toward more traditional conceptions of art typology. Even those artists who in the past exemplified research into the quantifying elements of art, who questioned the actual physical species of art through borrowed structural systems of knowledge—such artists now appear to be opting for an art of more familiar typologies. Ratification which once came from systems of mathematics or philosophy, is now deriving from nonverbal theories of structure, in which credibility becomes an act of faith in taste and sensibility rather than in cerebral verification systems.

The reintroduction of material processes in the work of Bochner and Rockburne, for example, may indicate a return, but to what? To the conception that art is not necessarily made with notions, but with materials—a position that parallels Richard Serra's notion

of sculpture as a distinct species type. This has always been true, but the shift is one of emphasis and context. It may be that such a return to the investigation of material may have been spurred by the open-endedness of theatricality itself, thus ratifying the cerebral radicality of this position.

Most important, this change or alteration may mean that the most forward and intellectually grounded choice in art may now opt for "granted," tangible aspects of painting and sculpture, choices made within typologically defined species. This, in turn, surely indicates that post-Minimalism as a movement has come full cycle—from species, to loss of species, to species regained—and in so doing, that a certain period notion style in American art may have ended.

Grateful acknowledgment is extended to
the following for permission to use their
photographic material:
Artforum Archive, Leo Castelli Gallery,
Paula Cooper Gallery, Bevan Davies, Droll-Kolbert
Gallery, Eva Hesse Estate, Milwaukee Art Center,
Museum of Modern Art (New York), Pace Gallery,
Betty Parsons Gallery, Max Protetch,
Ileana Sonnabend Gallery, John Weber Gallery.

Scuola Grafica Salesiana, Torino 1979